Outsider Art

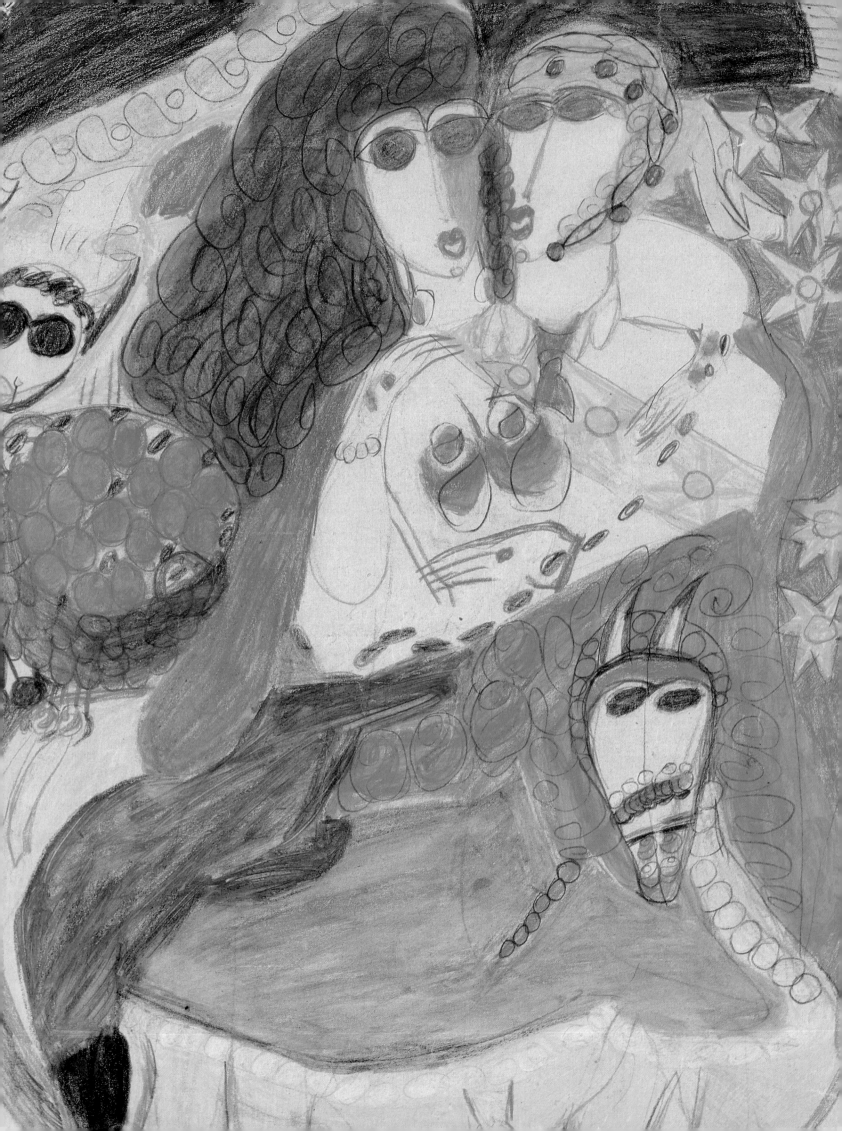

Outsider Art

Jean-Louis Ferrier

Cover Illustration
AUGUST KLOTZ
UNTITLED
Before 1928, gouache on paper,
32×23 cm (13×9 in).
Prinzhorn Collection, Heidelberg University.

Page 2
ALOÏSE
RODOLPHE D'AUTRICHE FRIBOURG
Detail. Before 1964,
coloured pencils on paper,
59.5×43 cm (24×17 in).
Musée cantonal des beaux-arts, Lausanne.

Editor: Jean-Claude Dubost
Desk Editor: Aude Simon
English translation: Murray Wyllie
Editorial Assistants: Geneviève Meunier and Claire Néollier
Cover design: Gérard Lo Monaco and Laurent Gudin
Graphic design: Marthe Lauffray
Iconography: Nils Warolin
Typesetting and Filmsetting: D.V. Arts Graphiques, Chartres
Photoengraving: Litho Service T. Zamboni, Verona

© FINEST SA / PIERRE TERRAIL EDITIONS, PARIS 1997
The Art Book Subsidiary of BAYARD PRESSE SA
English edition: © 1998
Publication number: 189
ISBN 2-87939-150-4
Printed in Italy

CARLO ZINELLI
UNTITLED
Detail. 1968, recto,
gouache and black pencil on paper,
70×50 cm (28×20 in).
*L'Aracine Collection, in deposit at the Musée
d'art moderne de la communauté
urbaine de Lille, Villeneuve-d'Ascq.*

Pages 6 and 7
CHOMO
PERSONNAGES
C. 1980, wire mesh
and painted plaster,
height 150 cm (60 in).
Achères-La-Forêt, Seine-et-Marne.

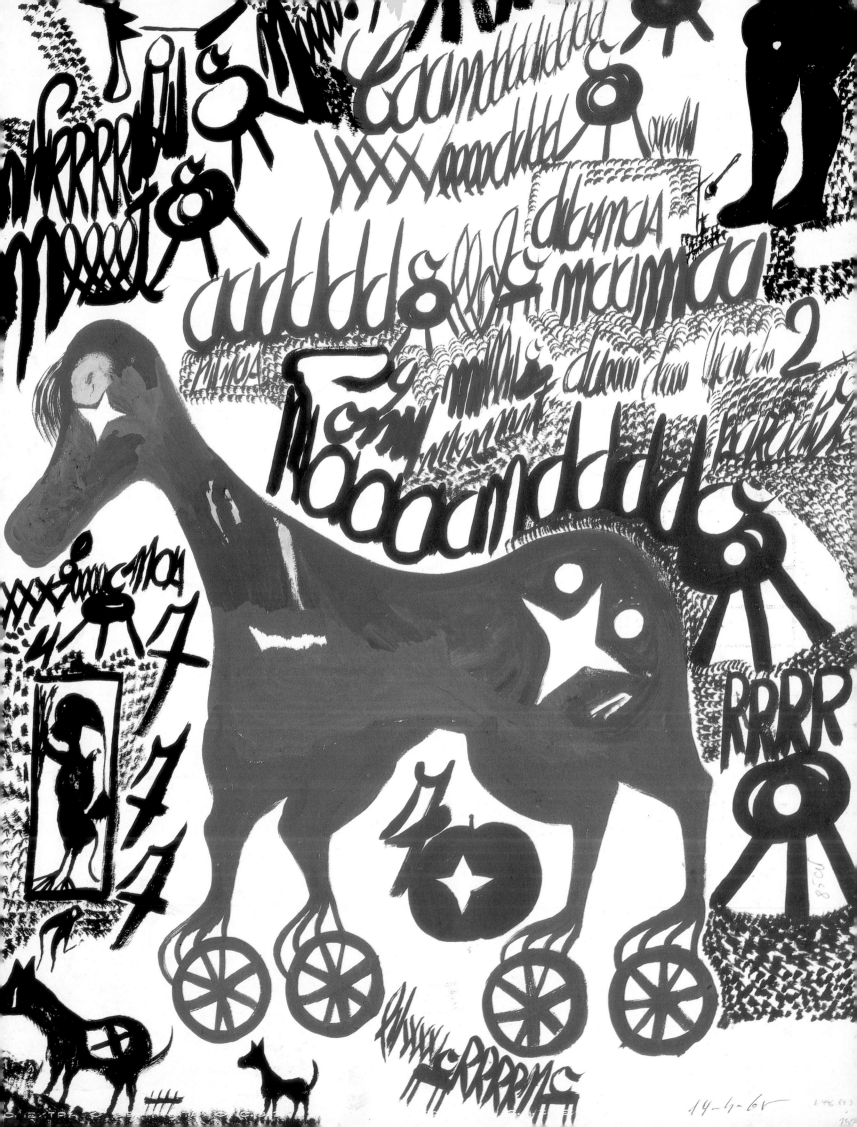

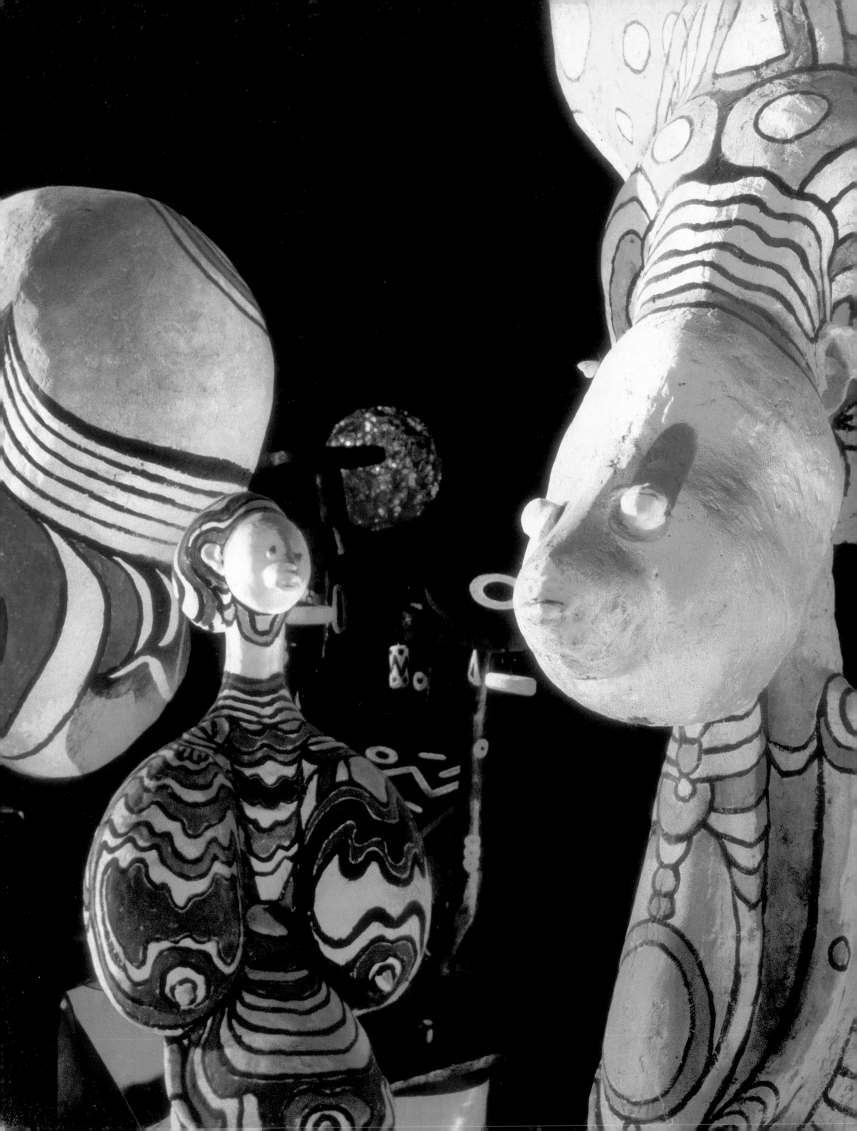

Contents

Beauty replete with meaning

The Romantics portrayed the madman as a heroic figure in secret communion with the forces of destiny. They thus paved the way for twentieth-century interest in the art of the mentally ill long before Paul Klee became the first modern artist to acknowledge its creative merit. In an article published in the review *Die Alpen* in 1912, Klee wrote: "When it comes to reforming present-day art, the works of the insane are more relevant than all our museums. To avoid simply copying the past, we have to go still further back". He had probably visited Dr Morgenthaler's little museum of works by patients at Waldau Psychiatric Hospital near Bern, the city where Klee had spent his youth. A few years earlier, Klee had noted in his *Diaries*: "We have reached a turning-point, I salute those who are to co-operate in the impending reformation".[1]

At a slightly later date, Max Ernst too became interested in pictorial work by the mentally ill, and we shall see how profoundly he was influenced by the graphic technique and delirious vision of one such artist, August Neter. Ernst was even toying with the idea of a book on psychotic art when, in 1922, Springer published psychotherapist Hans Prinzhorn's seminal study: *Bildnerei der Geisteskranken (The Artistry of the Insane)*.

The fact that Prinzhorn was a psychotherapist rather than a psychiatrist was crucial. Other doctors had already shown a clinical interest in artworks by the mentally ill, but Prinzhorn approached such works on their own terms, hoping to gain a better understanding of the process of artistic creation. When his book was published in 1922, he was thirty-six; he died eleven years later of typhoid fever. He had studied philosophy and art history and, subsequently, singing – a long-cherished project; he was a gifted baritone. When, however, his second wife developed psychiatric problems in the early days of their marriage, he took up medecine, seeking to "enter a profession where one is obliged to do good". Dr Willmanns, head of Heidelberg University Pychiatric Clinic, invited Prinzhorn to take charge of one of his pet projects: to build up a collection of works by the insane for the purposes

1. *The Diaries of Paul Klee 1898-1918*, edited with an introduction by Felix Klee, London 1965, p. 253.

of scientific study. Prinzhorn began working in 1919 and devoted himself to the task with such enthusiasm that the collection soon comprised four thousand works by four hundred different mentally ill artists from Germany, Switzerland, Austria and Italy, together with a wealth of written material.

Prinzhorn was a brilliant lecturer and this contributed significantly to the success of his book. His basic objective was to demonstrate that insane artists are, so to speak, artists in a natural state, uncorrupted by society. He believed their art sprang from the depths of the psyche and regarded the mentally ill as an elite who possessed insight into ultimate truths. He was influenced by the vitalist and metaphysical theories of Expressionism, the principal avant-garde movement in early twentieth-century Germany, and espoused Expressionist notions of the primeval, of spiritualisation, and of *Einfühlung* ("empathy"), along with their desire to rebel against traditional pictorial conventions. Above all, he shared their contempt for an over-simplified view of the world that reduced it to external appearances; this was the view to which Western art had subscribed since the Renaissance, to the detriment of individual expression. In other words, he stressed art's mental function, convinced that configurative power stemmed from the experience of life itself rather than from observation of the visible or virtuosity in pictorial reproduction. In his eyes, this was a reaction

ELSE BLANKENHORN
BANKNOTE
Before 1921, ink on paper,
11.5 × 18 cm (5 × 7 in).
Prinzhorn Collection, Heidelberg University.

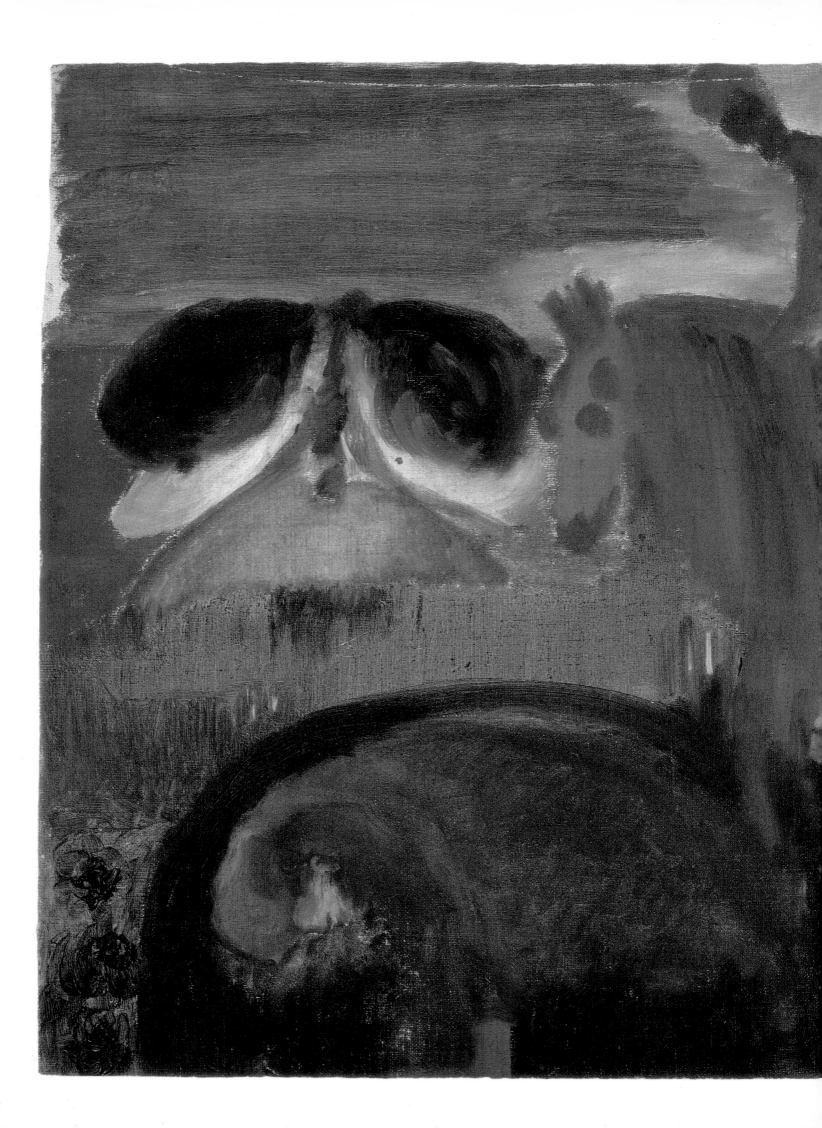

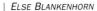

ELSE BLANKENHORN
RIDER
Before 1921, oil on canvas,
42 × 46.5 cm (17 × 19 in).
Prinzhorn Collection, Heidelberg University.

to the pathological side of a modern society in which the tentacular rationalism of preceding generations had stifled the finest artists.

It is a miracle that the collection has survived. When the Nazis came to power in 1933, they began systematically exterminating the mentally ill. The authors of the works assembled in Heidelberg were murdered, deported or put to death in euthanasia programmes. In July 1937, in Munich, Hitler held the first exhibition of "degenerate art" featuring works by most of the twentieth-century masters, including Picasso, Nolde and Kokoschka. Over the following years, the exhibition toured all the major German cities. The paintings were hung alongside works from the Prinzhorn collection in order to expose the insanity of modern art. Artists who persisted in their ways were accused of aspiring to the status of "idiots, cretins and paralytics", and threatened with sterilisation and imprisonment.

Prinzhorn's abundantly illustrated book had, however, been circulating among the European avant-garde prior to Hitler's seizure of power. Klee possessed a copy and made use of it when teaching at the Dessau Bauhaus in the 1920s. In 1923, he declared: "Do our works (accomplished as we hope that they are) really express harmony and tranquillity? Do they not rather express our own inner turmoil? Is harmonious composition anything more than a receptacle for this seething turmoil? (...) To prove my point, take an example you are all familiar with – Prinzhorn's excellent book! Just look at the religious subjects. They convey a depth and power of expression that I could never achieve. Truly sublime art[1]...". Leafing through *Artistry of the Insane*, it is easy to appreciate Klee's enthusiasm for the croaking dawn chorus captured by Adolph Schudel in *Toad Pond*, or the same artist's *Horses at the Drinking Trough* – two works which reveal close affinities with Klee's own technique – or, again, for Franz Pohl's remarkable *Exterminating Angel*. Kandinsky shared Klee's admiration.

Though the first French translation appeared only in 1984, Parisian Surrealist circles were also familiar with Prinzhorn's book. André Breton, as is well known, attached great importance to madness. In his first *Manifesto* he championed the cause of "the madness that we imprison" when it refuses to bow to social convention, and he admired the hallucinations and illusions of the insane. They drew, he felt, on the very well-springs of the imagination. André Masson owned a copy and cites the discussions he and his friends had about the works it reproduced. Masson had personal experience of madness: heavily wounded at the Chemin des Dames in 1917, he was invalided back from the front and spent almost two years in a psychiatric asylum.

1. Quoted in Thévoz Michel, *L'art brut*, Skira, Geneva, 1981, p. 16 (English translation: *Art Brut*, London and New York, 1995).

During the 1920s, his Rue Blomet studio was one of the centres of the Surrealist movement; painters, poets and writers met there, among them Joan Miró, Antonin Artaud, Michel Leiris, Georges Limbour and Georges Bataille. Limbour brought along his friend Jean Dubuffet, and it was there that Dubuffet, the future founder of the *Foyer de l'art brut*, subsequently rechristened *Compagnie de l'art brut*, first came across works by the mentally ill.

But Dubuffet's approach was that of an artist seeking his artistic identity, and notably different from that of Prinzhorn, whose goal was scientific. Moreover, Expressionism had, with Fauvism and Cubism, dealt its decisive blow to tradition, and its heyday was now past. Dubuffet, who twice abandoned painting before discovering his own orientation, had found his artistic way barred by the giants of modern art, Picasso, Braque and Matisse. Sensing the futility of confrontation, he decided to bypass them and discovered, in the works of the mentally ill, the art form that enabled him to achieve his aims. He did not, however, restrict himself to works by the insane, dwelling also on the work of untutored "outsiders" who knew nothing of museum art. As long as their eccentricity did not prevent normal life in society, these artists were not committed to asylums. Dubuffet coined the expression "art brut" ("raw art") to refer to "all sorts of productions – drawings, paintings, embroidery, modelled and sculpted figures, etc. – characterized by spontaneity and a pronounced inventiveness, owing as little as possible to conventional art and cultural clichés, and created by anonymous people outside professional artistic circles".[1]

True, the artists featured in the collection of three thousand items built up by Dubuffet over twenty-five years include a pastry-cook, a postman, a cobbler, a miner and a few other outsiders. But virtually all the works are by the mentally ill, some of whom, like the nowadays famous

1. Jean Dubuffet, *Prospectus et tous écrits suivants*, Paris, 1967, vol. 1, p. 201.

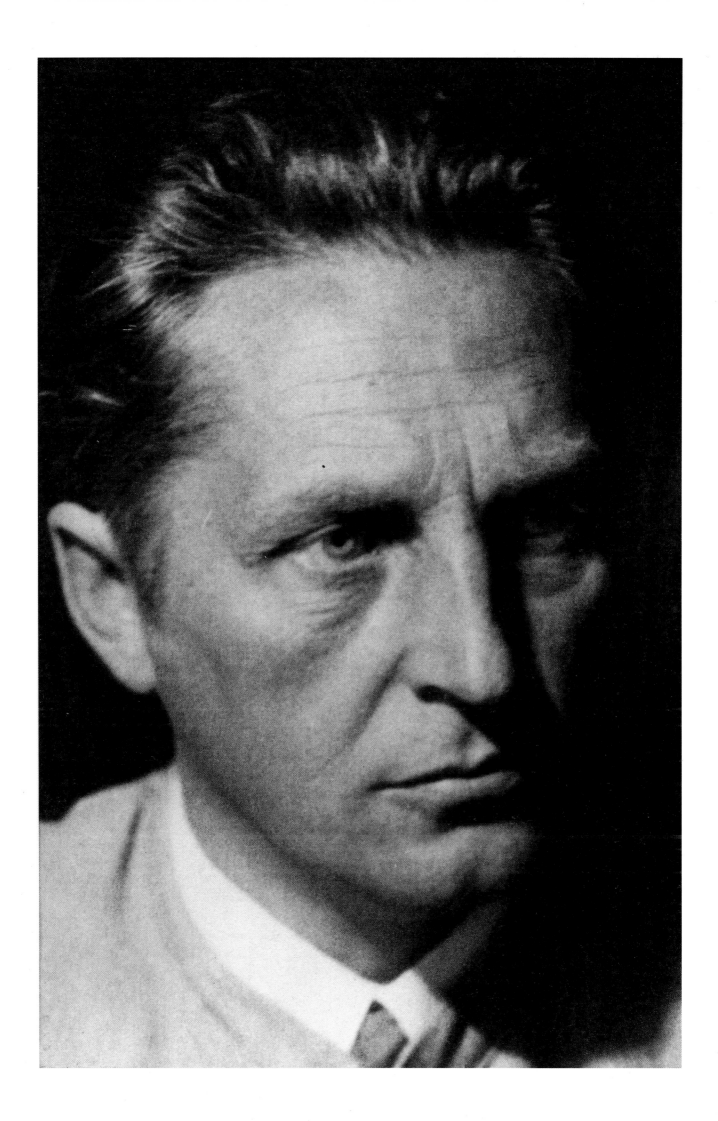

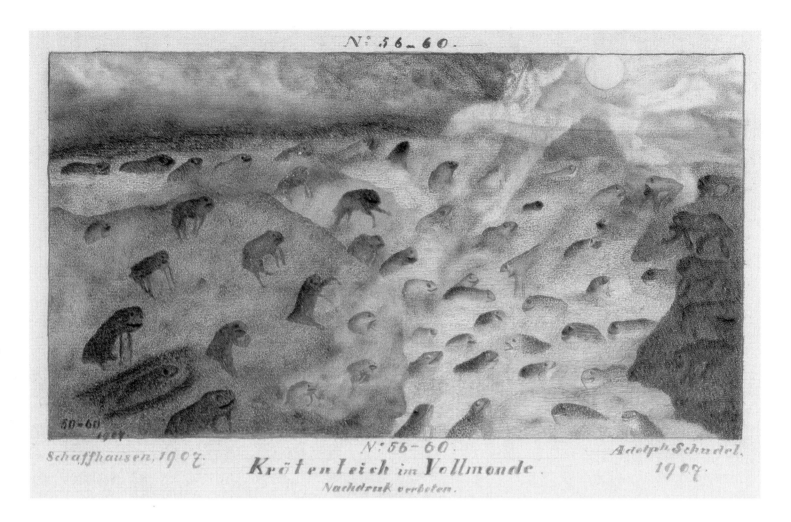

Wölfli or Aloïse, were highly prolific. The collection was first housed in Rue de Sèvres, Paris, then transferred to the spacious and luxurious home of Dubuffet's friend, the painter Alfonso Ossorio, in East Hampton in the U.S.A. Since 1972, it has been conserved in Lausanne as the *Collection de l'art brut* and is constantly being enriched by its current director, Michel Thévoz. More recently, other collections have been established, such as the Aracine collection built up by Madeleine Lommel, which currently includes three thousand works, and the smaller collection belonging to Céres Franco.

Precious and splendid fossils

Before the French Revolution, when Dr Philippe Pinel literally unshackled the inmates of the Paris Bicêtre and Salpêtrière hospitals, the living conditions of the insane – and the beggars, prostitutes, epileptics, idiots and crippled children confined in the same institutions – were unimaginably horrific. At the Bicêtre, which was reserved for women, raving inmates were confined in rooms no larger than cupboards. Naked or dressed in rags, their hands and feet fettered or bound with stout ropes, chained by the neck, they lay in their dark, unheated cells on bunks made of planks embedded in walls oozing with damp. They were fed on bread and water. At the Salpêtrière, where men were interned, conditions were similar, with this exception: the insalubrious cells were located at sewer level. Rats fleeing the rising waters of the

Seine would frequently enter the cells, biting and tearing at the faces and bodies of the madmen in their bedlam. Pinel substituted the less coercive strait-jacket for the inmates' chains. Nor was this his only reform. He thought that talking to the insane had a sedative effect, and thus became the forerunner of psychotherapy.

His *Traité médico-philosophique sur l'aliénation mentale, ou la manie* was a vehement repudiation of the then commonly-held view according to which the insane are little more than insensitive beasts, impervious to any attempt to understand or cure them. Instead, Pinel advocated "moral treatment" of the mentally ill. His careful observation and humane treatment of his patients led him to take their artistic production seriously. The American Dr Benjamin Rush, the first person to collect works by the insane, subsequently voiced similar views: "In one part of the brain, which is supernaturally developed yet not morbid", wrote Rush in 1812, "the mind occasionally discovers not only unusual strength and acuteness, but also certain hitherto unrevealed talents... The illness which develops these marvelous new talents and functions of the mind may be compared to an earthquake which, by convulsing the upper layers of our globe, throws up to the surface precious and splendid fossils, the existence of which was utterly

ADOLPH SCHUDEL
THE TOAD POND
1907, lead pencil,
14.3 × 21.9 cm (6 × 9 in).
Prinzhorn Collection, Heidelberg University.

ADOLPH SCHUDEL
HORSES AT THE WATER TROUGH
1907-1908, lead pencil,
21.9 × 27 cm (9 × 11 in).
Prinzhorn Collection, Heidelberg University.

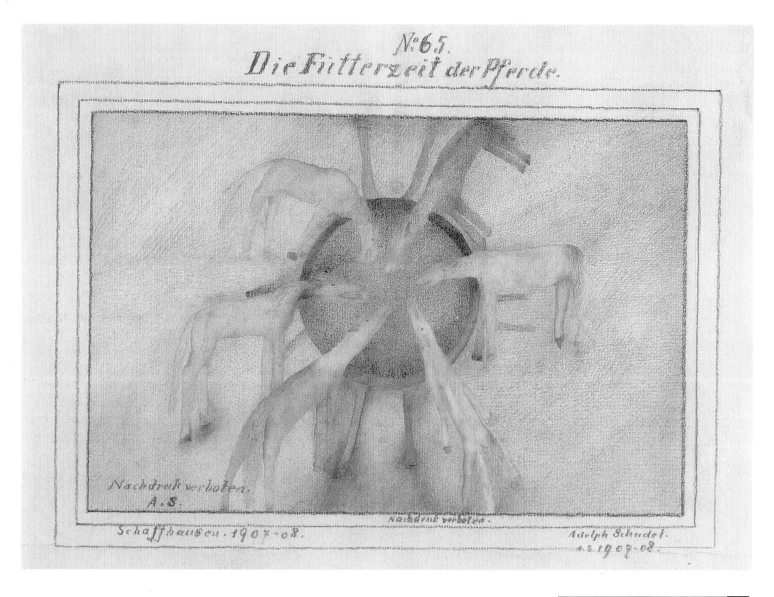

RICHARD NISBETT
MAP OF THE WORLD
N.d., pencil and watercolour on paper,
49.5 × 61 cm (20 × 24 in).
Historical Society of Pennsylvania, Philadelphia.

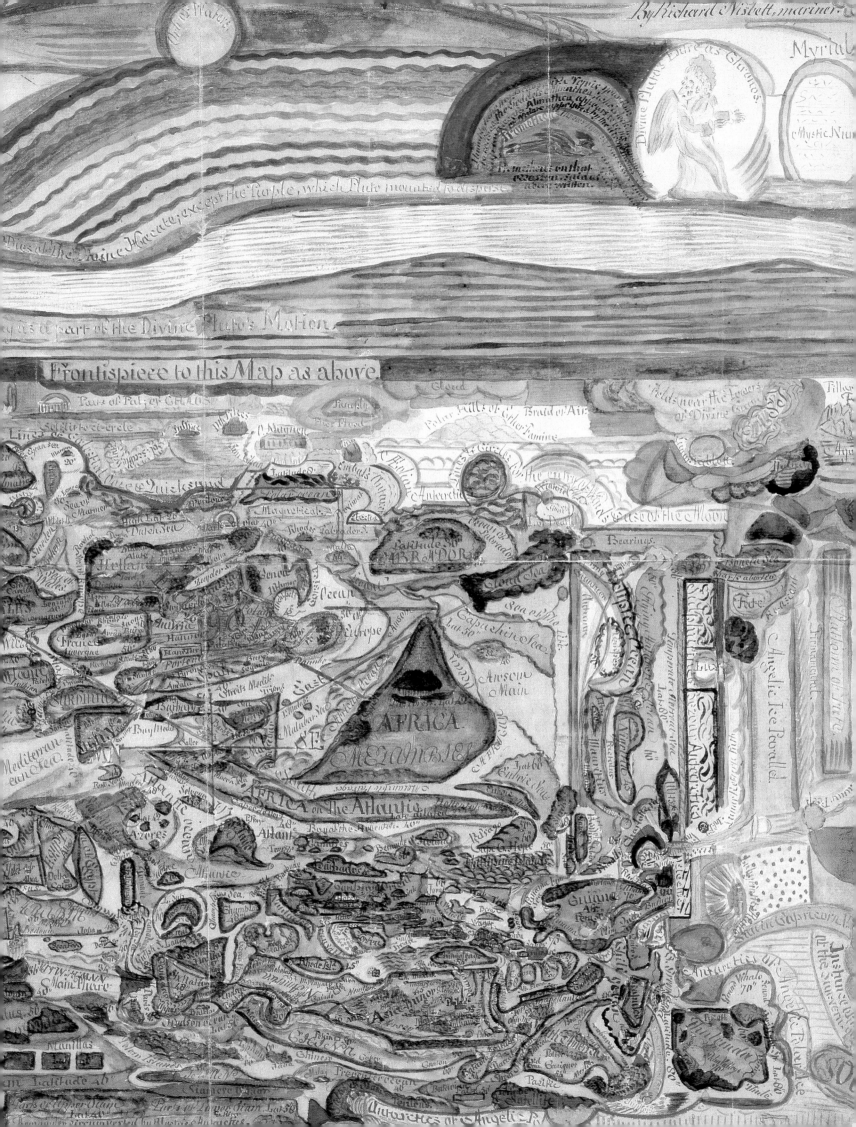

unsuspected by the owners of the land in which they were previously buried".[1]

The insights of Pinel and Rush were not, however, immediately taken up by other psychiatrists. Aloïse's earliest drawings were dashed off in the asylum toilets on scraps of paper without her nurses' knowledge; when the doctors discovered what she was up to, they destroyed many of her works. Her fame as an artist was acquired much later. On the other hand, in our own day, Dr Navratil has for a number of years been conducting a novel experiment at Gugging in Austria, inviting his patients to work on pictures and documents and setting up an "Artist's House" for those among them who display creative talent.

In the closing years of the twentieth century, however, and notwithstanding widespread public interest in Art Brut and psychotic art, the battle is far from won. In a recently published collective work, Dr Thuillier, a neuro-psychiatrist and pharmacologist at Sainte-Anne Hospital in Paris, has rejected the idea that works by psychiatric patients show any artistic merit.[2] In his opinion, they are mere scribbles: confused, random drawings by people incapable of producing a clear picture of the objective world. This incapacity he attributes to psychotic artists' lack of the basic techniques involved in real painting – mastery of perspective, blending of colours, use of chiaroscuro and so on. At best, he regards them as primitive artists – in his view, a pejorative term – comparing their art to that of cave-dwellers. This, paradoxically, is a highly flattering judgement, as nowadays few would consider the prehistoric wall paintings at Lascaux inferior to Michelangelo's ceiling in the Sistine Chapel. A decisive factor, to Thuillier's mind, is that the mentally ill, unlike professional artists, do not experiment but merely produce their works spontaneously. In the case of the most outstanding among them, this is simply wrong.

Adolph Schudel, whose frogs and horses in the Prinzhorn collection so enthralled Klee that he preferred them to his own work, had been a photographer; his drawings reveal the characteristic hazy outline of the photographic retouching he had practised before being interned. Franz Pohl, a former wrought-iron craftsman, was a consummate draughtsman; far from being a handicap, his mental disorder – as we shall see – actually stimulated and intensified his means of expression. The catatonic Else Blankenhorn was an accomplished painter. And to return to Aloïse, it will be seen that, although self-taught when she began to draw in secret, she was a born colourist and spent her life perfecting her pictorial approach.

Obviously, not all mentally disordered and outsider artists are geniuses, but neither are all mainstream cultural artists, as a visit to any art gallery makes clear. Between three and five per cent of the patients in any psychiatric institution possess some degree of artistic talent, the same proportion found in a "normal" population. Moreover, Dr Thuillier's judgement is based implicitly on the criteria of late

1. Benjamin Rush, *Medical Inquiries and Observations upon the Diseases of the Mind*, Philadelphia, 1812. Quoted in: Caroline Douglas, *La beauté insensée*, Palais des Beaux-Arts, Charleroi, 1995, p. 61.
2. *La folie*, Collective Volume, Collection "Bouquins", Laffont, Paris, 1996, pp. 366-373.

nineteenth-century academic painting, the last outcrop of a tradition nowadays, by common consent, regarded as a mere curiosity.

True, the romantic portrayal of the insane as heroic figures in secret communion with the forces of destiny is no longer fashionable, and Prinzhorn's over-idealistic theories are in certain respects outmoded. Dr Inge Jàdi, the curator of the collection, approaches the question of psychotic art in the light of recent psychiatric knowledge, and views both Dr Thuillier's conservatism and the abusive aestheticisation of Art Brut in a critical light.[1] Many fallacies, she explains, arise from a misunderstanding of the nature of psychosis – an agonizing breakdown which, at the same time, liberates an immense creative potential. The psychotic's vision of the world, similar to our own, suddenly founders and is replaced by archaic schemas. The work of psychotics exposes the peril and vulnerability inherent in every human psyche. This explains why we relate to, and are impressed by them: not because they are strange or incongruous but because in an obscure way they reveal things about ourselves. Similarly, the pictorial activity of pyschotics should be understood as their attempt to re-centre their shattered, dislocated egos: who could fail to realize that this brings us to the heart of the meaningful creative act – the hallmark of all artistic activity? Dr Jàdi gives a splendid account of the case of Heinrich Joseph Grebing, a Magdeburg shopkeeper committed in 1906 and murdered by the Nazis in 1940. Grebing's life was suddenly shattered. Estranged from society, he obsessively sought to piece together his dislocated existence by drawing up all sorts of lists and chronologies, including a perpetual almanac featuring precisely-calculated astronomical tables and a calendar of executioners and murderers. His was a speculative attempt to incorporate the stars into a vast, all-embracing, cosmic system designed to ward off mortal danger. Alas, it failed. Even more significantly, he used to produce meticulously calligraphed sheets of numbers and letters in various colours of Indian ink; then, by crossing something out at the foot of the page, he would inadvertently ruin his beautifully arranged table, cancelling out his attempt to restore order to his being and forcing him to begin all over again...

Dubuffet described the life and work of many of the artists featuring in his collection in his *Cahiers de l'art brut*. He too emphasized the primordial importance of art by the mentally ill, though he heatedly remarked that there was no such thing as the art of the insane any more than there is an art of dyspeptics or of people with knee complaints. "The psychological mechanisms", he wrote, "involved in all art are apparently such that we have either to categorize them once and for all as pathological and regard all artists as psychopaths, or expand our conception of what is healthy and normal to such an extent that it encompasses insanity as a whole."[2] A judgement which should put paid to the controversy about Art Brut and to the accusation that a cultivated artist like Dubuffet himself was wrong to ape the art of the mentally disordered.

1. *La beauté insensée, op. cit.,* pp. 45-56.
2. Jean Dubuffet, *op. cit.,* vol.1, p. 218.

Joseph Grebing
patient at Heidelberg
Psychiatric Clinic.

Aloïse
The Birth of Nicolas I
Rumine Palace
Detail. Before 1964,
coloured pencils on paper,
101.5 × 71.5 cm (41 × 29 in).
Musée cantonal des beaux-arts, Lausanne.

751 Z	801 S	851	31 M	951 M	1001 M	1051 M	1101 D	1151 D	1201 F	1251 F	1301 Z	1351 Z	1401 M	1451 M	1501 D	1551 D	1601
752 S	802 M	852 M	902 Z	952 Z	1002 D	1052 D	1102 F	1152 F	1202 Z	1252 Z	1302 S	1352 M	1402 D	1452 D	1502 F	1552 F	1602
753 Z	803 Z	853 M	903 M	953 D	1003 F	1053 Z	1103 Z	1153 S	1203 S	1253 M	1303 M	1353 F	1403 F	1453 Z	1503 Z	1553 S	1603
754 M	804 M	854 D	904 D	954 F	1004 Z	1054 S	1104 S	1154 M	1204 M	1254 Z	1304 Z	1354 Z	1404 Z	1454	1504 D	1554 M	1604
755 D	805 F	855 F	905 Z	955 Z	1005 M	1055 M	1105 Z	1155 Z	1205 M	1255 M	1305 D	1355 S	1405 M	1455 M	1505 D	1555 Z	1605
756 F	806 Z	856 Z	906 S	956 S	1006 Z	1056 Z	1106 M	1156 M	1206 D	1256 D	1306 F	1356 M	1406 Z	1456 Z	1506 M	1556 M	1606
757 S	807 S	857 M	907 M	957 Z	1007 M	1057 D	1107 D	1157 F	1207 F	1257 Z	1307 Z	1357 M	1407 M	1457 D	1507 D	1557 F	1607
758 M	808 M	858 Z	908 Z	958 M	1008 D	1058 F	1108 F	1158 Z	1208 Z	1258 S	1308 S	1358 D	1408 D	1458 F	1508 F	1558 Z	1608
759 Z	809 M	859 M	909 D	959 D	1009 Z	1059 Z	1109 S	1159 S	1209 M	1259 M	1309 Z	1359 F	1409 Z	1459 Z	1509 S	1559 S	1609
760 M	810 D	860 D	910 F	960 F	1010 S	1060 S	1110 M	1160 M	1210 Z	1260 Z	1310 M	1360 Z	1410 S	1460 S	1510 M	1560 M	1610
761 F	811 F	861 Z	911 Z	961 S	1011 M	1061 Z	1111 Z	1161 M	1211 M	1261 D	1311 D	1361 M	1411 M	1461 Z	1511 Z	1561 M	1611
762 Z	812 Z	862 S	912 S	962 M	1012 Z	1062 M	1112 M	1162 D	1212 D	1262 F	1312 F	1362 Z	1412 Z	1462 M	1512 M	1562 D	1612
763 S	813 M	863 M	913 Z	963 Z	1013 D	1063 D	1113 F	1163 F	1213 Z	1263 Z	1313 S	1363 M	1413 D	1463 D	1513 F	1563 F	1613
764 M	814 Z	864 Z	914 M	964 M	1014 F	1064 F	1114 Z	1164 Z	1214 S	1264 S	1314 M	1364 D	1414 F	1464 F	1514 Z	1564 Z	1614
765 M	815 M	865 D	915 D	965 F	1015 Z	1065 S	1115 S	1165 M	1215 M	1265 Z	1315 Z	1365 M	1415 Z	1465 S	1515 S	1565 M	1615
766 D	816 D	866 F	916 F	966 Z	1016 S	1066 M	1116 M	1166 Z	1216 Z	1266 M	1316 M	1366 S	1416 S	1466 M	1516 M	1566 Z	1616
767 F	817 Z	867 Z	917 S	967 S	1017 Z	1067 Z	1117 M	1167 M	1217 D	1267 D	1317 F	1367 M	1417 Z	1467 Z	1517 M	1567 M	1617
768 Z	818 S	868 S	918 M	968 M	1018 M	1068 M	1118 D	1168 D	1218 F	1268 F	1318 Z	1368 Z	1418 M	1468 M	1518 D	1568 D	1618
769 M	819 M	869 Z	919 Z	969 M	1019 D	1069 F	1119 F	1169 F	1219 Z	1269 S	1319 S	1369 D	1419 D	1469 F	1519 F	1569 Z	1619
770 Z	820 Z	870 M	920 M	970 D	1020 F	1070 Z	1120 Z	1170 S	1220 S	1270 M	1320 M	1370 F	1420 F	1470 Z	1520 Z	1570 S	1620
771 M	821 D	871 D	921 F	971 F	1021 S	1071 S	1121 M	1171 M	1221 Z	1271 Z	1321 M	1371 Z	1421 S	1471 S	1521 M	1571 M	1621
772 D	822 F	872 F	922 Z	972 Z	1022 M	1072 M	1122 Z	1172 Z	1222 M	1272 M	1322 D	1372 S	1422 M	1472 M	1522 Z	1572 Z	1622
773 Z	823 Z	873 S	923 S	973 M	1023 Z	1073 M	1123 M	1173 D	1223 D	1273 F	1323 F	1373 Z	1423 Z	1473 M	1523 M	1573 D	1623
774 S	824 S	874 M	924 M	974 Z	1024 M	1074 D	1124 D	1174 F	1224 F	1274 Z	1324 Z	1374 M	1424 M	1474 D	1524 D	1574 F	1624
775 M	825 Z	875 Z	925 M	975 M	1025 F	1075 F	1125 Z	1175 Z	1225 S	1275 S	1325 M	1375 D	1425 F	1475 F	1525 Z	1575 Z	1625
776 Z	826 M	876 M	926 D	976 D	1026 Z	1076 Z	1126 S	1176 S	1226 M	1276 M	1326 Z	1376 F	1426 Z	1476 Z	1526 S	1576 S	1626
777 D	827 D	877 F	927 F	977 Z	1027 S	1077 M	1127 M	1177 Z	1227 Z	1277 M	1327 M	1377 Z	1427 S	1477 M	1527 M	1577 Z	1627
778 F	828 F	878 Z	928 Z	978 S	1028 M	1078 Z	1128 Z	1178 M	1228 M	1278 D	1328 D	1378 M	1428 M	1478 Z	1528 Z	1578 M	1628
779 Z	829 S	879 S	929 M	979 M	1029 M	1079 M	1129 D	1179 D	1229 F	1279 F	1329 Z	1379 Z	1429 M	1479 M	1529 D	1579 D	1629
780 S	830 M	880 M	930 Z	980 Z	1030 D	1080 D	1130 F	1180 F	1230 Z	1280 Z	1330 S	1380 M	1430 D	1480 D	1530 F	1580 F	1630
781 Z	831 Z	881 M	931 M	981 D	1031 F	1081 Z	1131 Z	1181 S	1231 S	1281 M	1331 M	1381 F	1431 F	1481 Z	1531 Z	1581 S	1631
782 M	832 M	882 D	932 D	982 F	1032 Z	1082 S	1132 S	1182 M	1232 M	1282 Z	1332 Z	1382 Z	1432 Z	1482 S	1532 S	1582 M	1632
783 D	833 F	883 F	933 Z	983 Z	1033 M	1083 M	1133 M	1183 Z	1233 M	1283 M	1333 D	1383 S	1433 M	1483 M	1533 Z	1583 Z	1633
784 F	834 Z	884 Z	934 S	984 S	1034 Z	1084 Z	1134 M	1184 M	1234 Z	1284 D	1334 M	1384 M	1434 Z	1484 Z	1534 M	1584 M	1634
785 S	835 S	885 M	935 M	985 Z	1035 M	1085 D	1135 D	1185 F	1235 F	1285 Z	1335 Z	1385 M	1435 M	1485 D	1535 D	1585 F	1635
786 M	836 M	886 Z	936 Z	986 M	1036 D	1086 F	1136 F	1186 Z	1236 Z	1286 S	1336 M	1386 D	1436 D	1486 F	1536 F	1586 Z	1636
787 Z	837 M	887 M	937 D	987 D	1037 Z	1087 Z	1137 S	1187 S	1237 M	1287 M	1337 F	1387 F	1437 Z	1487 Z	1537 S	1587 S	1637
788 M	838 D	888 D	938 F	988 F	1038 S	1088 S	1138 M	1188 M	1238 Z	1288 Z	1338 Z	1388 Z	1438 S	1488 S	1538 M	1588 M	1638
789 F	839 F	889 Z	939 Z	989 S	1039 M	1089 M	1139 Z	1189 M	1239 M	1289 D	1339 S	1389 M	1439 M	1489 Z	1539 Z	1589 M	1639
790 Z	840 Z	890 S	940 S	990 M	1040 Z	1090 M	1140 M	1190 D	1240 D	1290 F	1340 M	1390 Z	1440 Z	1490 M	1540 M	1590 D	1640
791 S	841 M	891 M	941 Z	991 Z	1041 D	1091 D	1141 F	1191 F	1241 Z	1291 Z	1341 M	1391 M	1441 D	1491 D	1541 F	1591 F	1641
792 M	842 Z	892 Z	942 M	992 M	1042 F	1092 F	1142 Z	1192 Z	1242 S	1292 S	1342 D	1392 D	1442 F	1492 F	1542 Z	1592 Z	1642
793 M	843 M	893 D	943 D	993 F	1043 Z	1093 S	1143 S	1193 M	1243 M	1293 Z	1343 F	1393 Z	1443 Z	1493 S	1543 S	1593 M	1643
794 D	844 D	894 F	944 Z	994 Z	1044 S	1094 M	1144 M	1194 Z	1244 Z	1294 M	1344 Z	1394 Z	1444 S	1494 M	1544 M	1594 Z	1644
795 F	845 Z	895 Z	945 S	995 S	1045 Z	1095 Z	1145 M	1195 M	1245 Z	1295 D	1345 M	1395 M	1445 Z	1495 Z	1545 M	1595 M	1645
796 Z	846 S	896 S	946 M	996 M	1046 M	1096 M	1146 D	1196 D	1246 F	1296 F	1346 Z	1396 Z	1446 M	1496 M	1546 D	1596 D	1646
797 M	847 M	897 Z	947 Z	997 M	1047 D	1097 F	1147 F	1197 Z	1247 Z	1297 S	1347 M	1397 D	1447 D	1497 F	1547 F	1597 Z	1647
798 Z	848 Z	898 M	948 M	998 D	1048 F	1098 Z	1148 Z	1198 S	1248 S	1298 M	1348 D	1398 F	1448 F	1498 Z	1548 Z	1598 S	1648
799 M	849 D	899 D	949 F	999 F	1049 S	1099 S	1149 M	1199 M	1249 Z	1299 Z	1349 Z	1399 Z	1449 S	1499 S	1549 M	1599 M	1649
800 D	850 F	900 F	950 Z	1000 Z	1050 M	1100 M	1150 Z	1200 Z	1250 M	1300 M	1350 S	1400 S	1450 M	1500 M	1550 Z	1600 Z	1650

JOSEPH GREBING
UNTITLED
Before 1940, ink on paper,
22.1 × 14 cm (9 × 7 in).
Prinzhorn Collection, Heidelberg University.

All-encompassing culture

There remain, however, the twin problems of defining the relationships between psychotic art and culture (indeed, of determining whether such relationships actually exist), and trying to establish how psychotic art differs from "cultural" or mainstream art.

Under the impetus of Expressionism, Prinzhorn sought to discover "painting in its natural state" in the work of psychotic artists. Of course, such an approach was misguided: as we all know, every new-born child is enmeshed in a human network of words and gestures which will eventually lead it to speak, draw and walk, and this obviously applies to psychotic artists too. All psychiatrists also agree that because such artists are involved in an activity which interests and receives encouragement from their doctors, and because they meet people who come to enquire about, view, and occasionally purchase their work, they form a special category in relation to other psychiatric patients. Such factors confer a unique status within the social environment of the asylum and present many analogies with the social status of mainstream artists, who themselves exhibit and sell their works and are subject to praise and criticism. In addition, there is the previously mentioned fact that some psychotic artists have received formal training prior to their being committed.

Dubuffet goes further. He accuses the arbiters of taste past and present – patrons and historians of art – of acknowledging only a small number of artists, from Raphael to David and Manet, whose works, in Dubuffet's opinion, are shallow and narrow-minded. The arbiters have, says Dubuffet, taken care to exclude anything which smacks to them of excess. He echoes the diatribe in Marinetti's *Futurist Manifesto* calling for museums to be closed down, asserting for his own part: "People go to them like families visiting a cemetery on a Sunday afternoon, tiptoeing and whispering".[1] Without dwelling on the paradox that Dubuffet is one of the few contemporary artists for whose works museum curators are prepared to pay fabulous sums, I would stress that nothing could have prevented Art Brut from becoming museum, or even in some cases, mainstream art. There are indeed artists who produce Art Brut professionally, the way others produce still lifes or modern academic portraits. To my mind, the most typical example of this is Francis Marshall who, in the 1970s, produced a series of obese dolls made out of cloth remnants stuffed with rags and tied up with string. He had a fervent admirer in the French Ministry of Culture, and ended up teaching at Le Havre Art School.

To solve the dilemma, one might well argue, following on from Breton, that the only authentic works are those created by "the mad whom we imprison". But the criterion of confinement is not definitive; the boundaries are not so clear-cut. To conclude this present introduction, I shall consider two famous examples.

The first is that of Antonin Artaud who, from the age of nineteen, underwent several periods of confinement in psychiatric institutions

August Klotz |
Wurmlöcher usw.
Before 1928, watercolour,
33 × 25 cm (13 × 10 in).
Prinzhorn Collection, Heidelberg University.

1. *Ibid.*, p. 49.

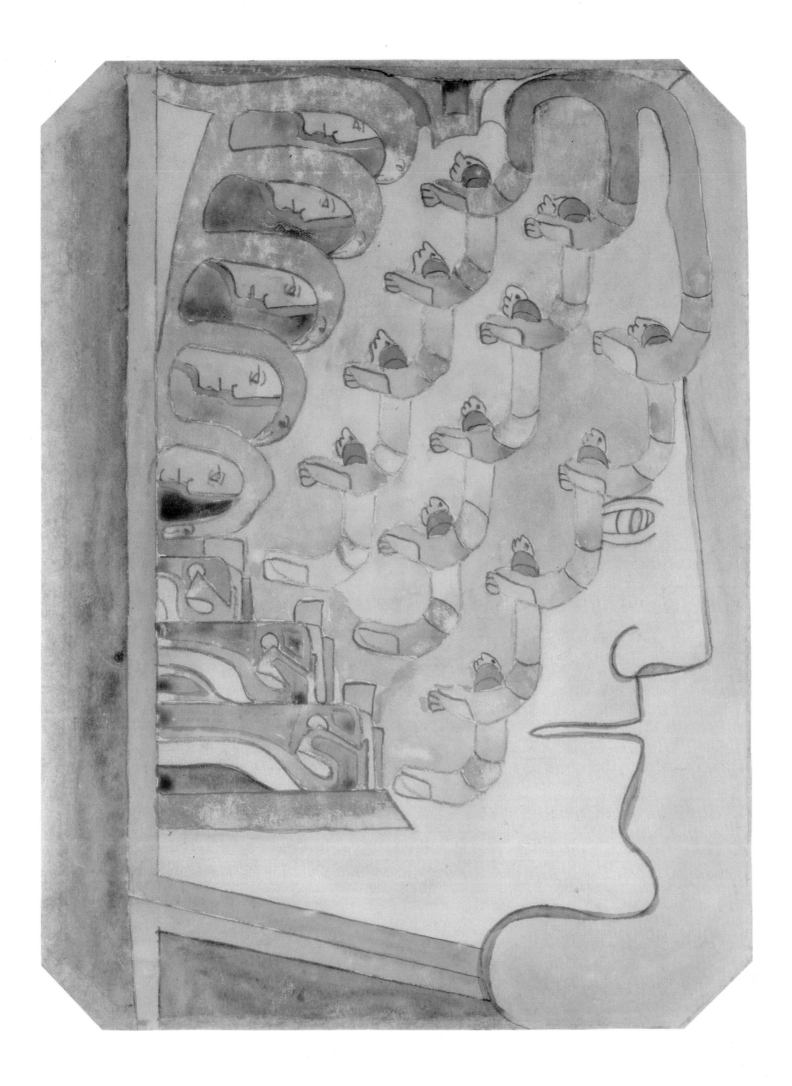

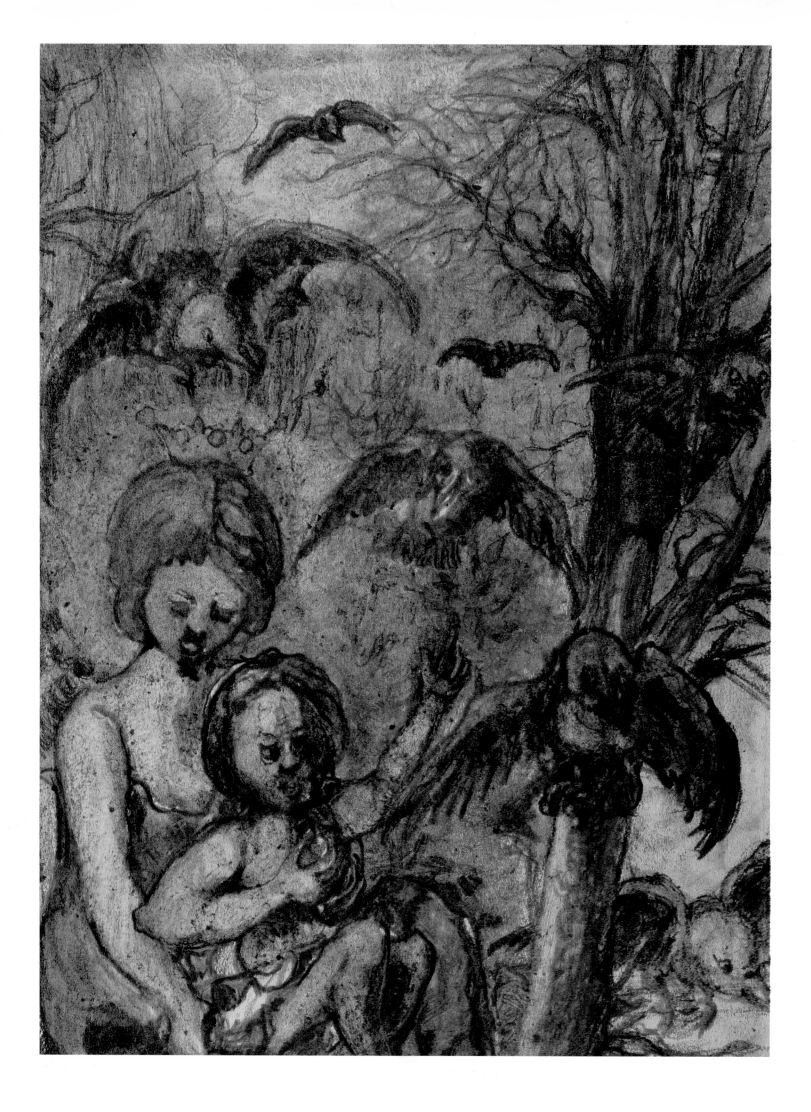

and died at Ivry-sur-Seine Asylum in 1948. Artaud suffered from mental illness and, with intermittent respites, his condition steadily deteriorated; his fine features became increasingly taught and ravaged as he foundered into insanity. There are pitiful photos showing him stabbing the point of a pencil or knife into a precise spot on his spinal column to ward off the pain inflicted by his body. His case is complex. A brilliant artist – an actor, director, theoretician, draughtsman and poet – his innermost nature led him relentlessly to the brink of the abyss. On one celebrated occasion, the "Tête-à-tête with Antonin Artaud" on 13 January 1947 at the Théâtre du Vieux-Colombier in Paris, where he was due to deliver a lecture to the Parisian literary and artistic set, he remained utterly silent throughout, convinced that nobody could possibly understand what he had to say since "the only language society and the public understand is that of bombs, machine-guns, barricades and all that ensues". This was madness at a critical stage, cut off from the outside world, wrapped up in itself, and incapable of communication.

Yet, with the possible exception of his "talismans" – roughly sketched faces on charred and perforated exercise-book paper which he used as protection from the omnipresent enemies intent upon murdering him – none of his artistic output is, or can be, categorized as psychotic. Just as his poetry is an integral part of twentieth-century French literature, his drawings – occasionally embellished with colour – represent modern art at its most accomplished. In his youth, he studied drawing and, though, hunched over the table on which his sheet of paper lay, he sought to wrest from them "a torment, a latent sorrow hanging over them", his work shows clear affinities with Schiele or Giacometti.

Conversely, the mediumistic paintings of Augustin Lesage, a simple, affable man who was never committed to an asylum, represents, in both ambition and style, a kind of epitome of Art Brut. Born in 1876, in Saint-Pierre-les-Auchel in the Pas-de-Calais, Lesage, like all his male forebears, had become a miner on leaving primary school and married a miner's daughter. Totally unfamiliar with the world of art, he had never displayed the slightest artistic bent and, apart from a visit to the Palais des Beaux-Arts in Lille during his military service – a visit which aroused no particular interest on his part – had never been to a museum. He was thirty-five years old and working at the coal face when he twice heard a voice telling him: "One day you will be a painter". Some eight to ten months later, during a spiritualist séance, the voices once again manifested themselves and gave him the following message: "Fear not and follow my advice. Yes, one day you will be a painter and your works will be submitted to science. At first, you will find that ridiculous. It is we who shall draw via your hand". The spirits then gave him the address of a shop in Lille where he would find the materials he required to practise his art.

Lesage went to the shop and, guided by the spirit voices, selected brushes and tubes of colours. He wanted to begin with small formats, but a misunderstanding arose regarding the materials that he had

FRANZ POHL
VIRGIN WITH CROWS
Before 1940, coloured pencils,
40 × 29 cm (16 × 12 in).
Prinzhorn Collection, Heidelberg University.

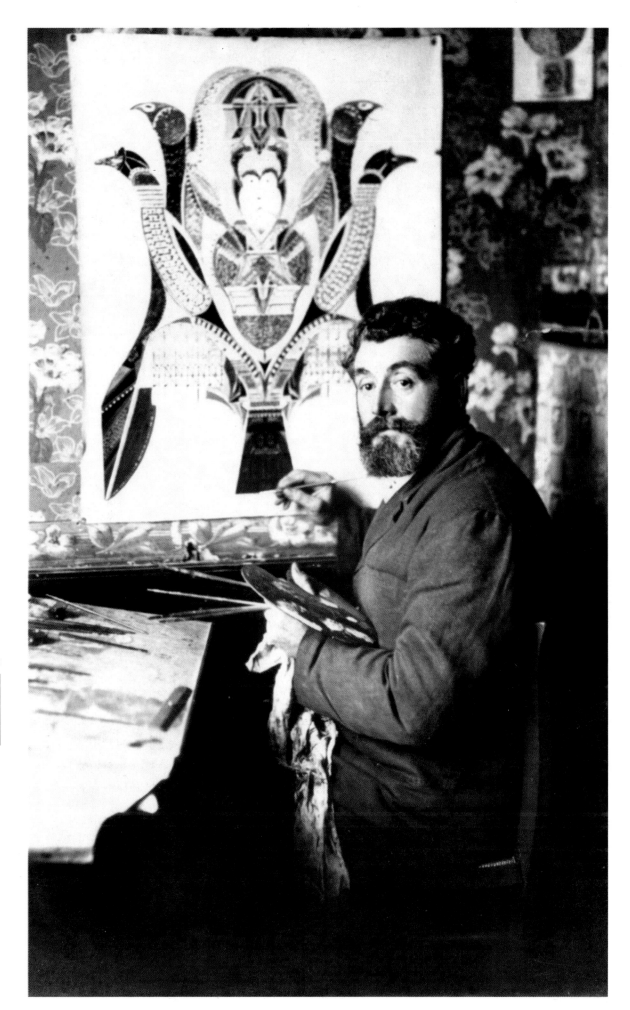

AUGUSTIN LESAGE
The former miner
gave up his job
in 1925
to devote himself
to painting.

AUGUSTIN LESAGE
**THE MYSTERIES
OF ANCIENT EGYPT**

1930, oil on canvas,
144 × 112 cm
(58 × 45 in).

*L'Aracine Collection, in deposit
at the Musée d'art moderne
de la communauté urbaine de Lille,
Villeneuve-d'Ascq.*

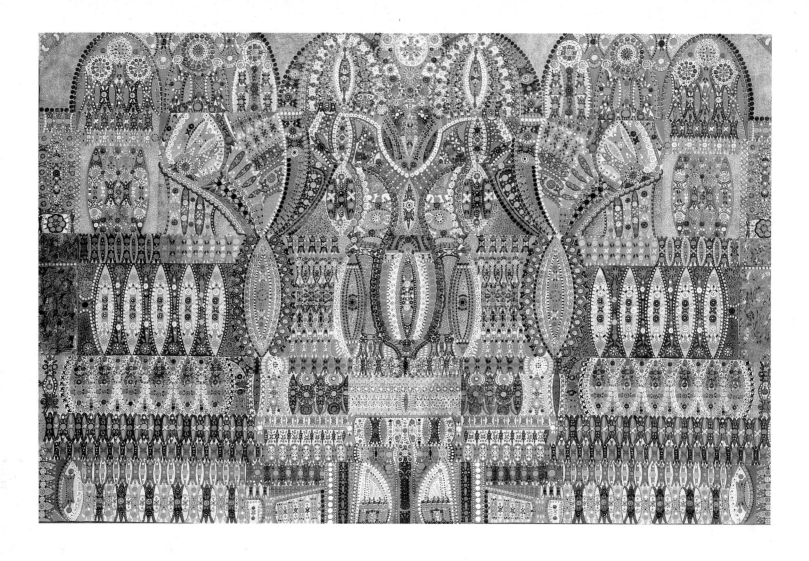

ordered and, a few days later, he received by rail a ten-foot square canvas. He was about to cut it up into smaller sections when a new message instructed him: "Don't cut up the canvas. It will do. All will be fulfilled. Follow our instructions and we shall fill it to perfection. Start painting". Lesage confidently attached the canvas to a wall, prepared his paint, and began in the top right-hand corner. Following no preconceived theme, he gradually progressed, meekly allowing the spirits to guide his hand. It took him over a year to complete the painting, working on it every evening and every Sunday to the despair of his family.

Although this first work displays no unity of composition, the component elements are perfectly organized and juxtaposed like so many delicately painted miniatures. Massed architectural motifs – portals, columns, decorated panels, and friezes featuring tiny figures – stand side by side, like vestiges from long-buried civilizations. In no way imitative, the painting's thematic treatment and layout nevertheless suggest a Far-Eastern influence, calling to mind embroidered silks or carpets. Lesage, who had no inkling as to the source of his inspiration, executed a great many similar works. Using a pencil and ruler, he would begin by tracing a large vertical line dividing the canvas into two equal parts and would then draw a few horizontals at different levels to

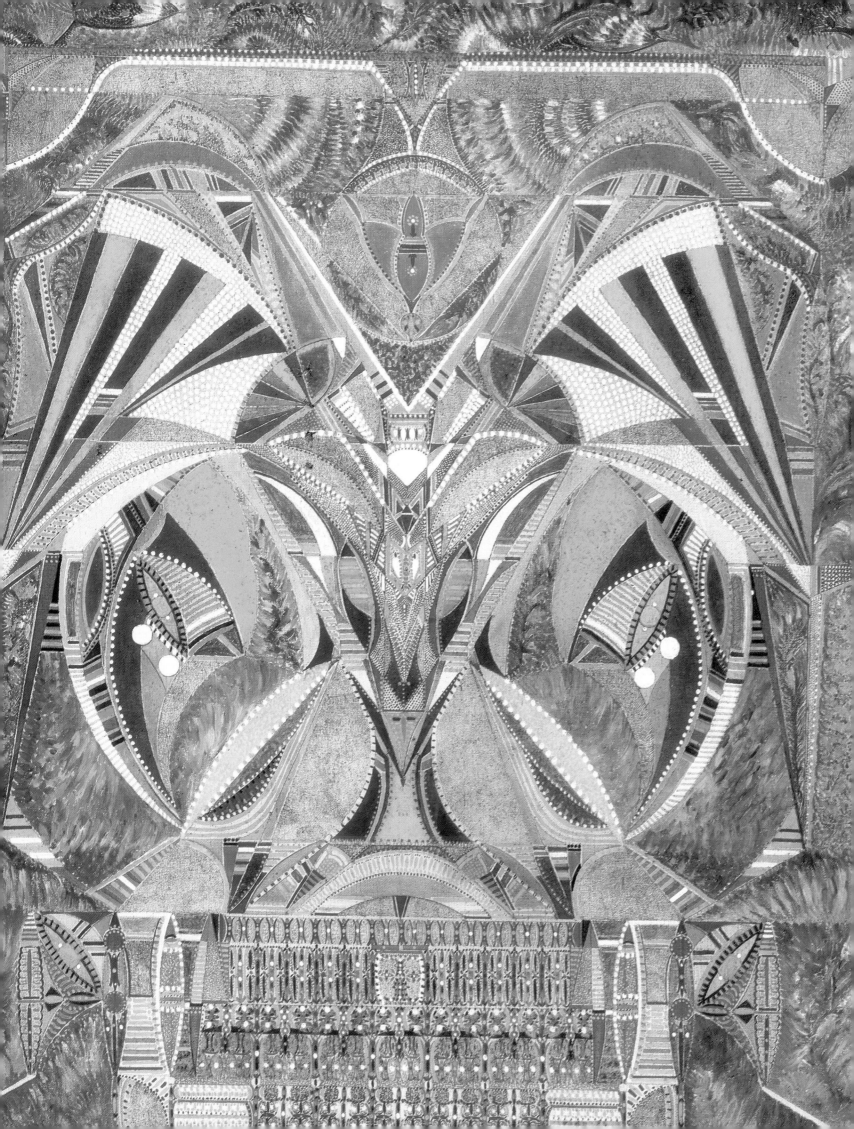

delineate the space before setting to work. He often introduced scarabs, birds and hieroglyphic inscriptions. He confessed that he was unable to paint without guidance, and the way in which his work draws unwittingly on the depths of his subconscious provides a classic illustration of Jungian theory, according to which each of us possesses inherited archetypes linking us to the human past as a whole.

Whatever the complex – and in each instance specific – relationship of "outsider" and psychotic artists to the cultural mainstream, the notion of "mental art" is applicable to both. Their common characteristic, as Prinzhorn noted, is to ignore the outside world and to concentrate in their works on expressing their inner perceptions. In this respect, they are also "primitives", according to Worringer's definition of the term: twentieth-century primitives.

1. Extraordinary men at work

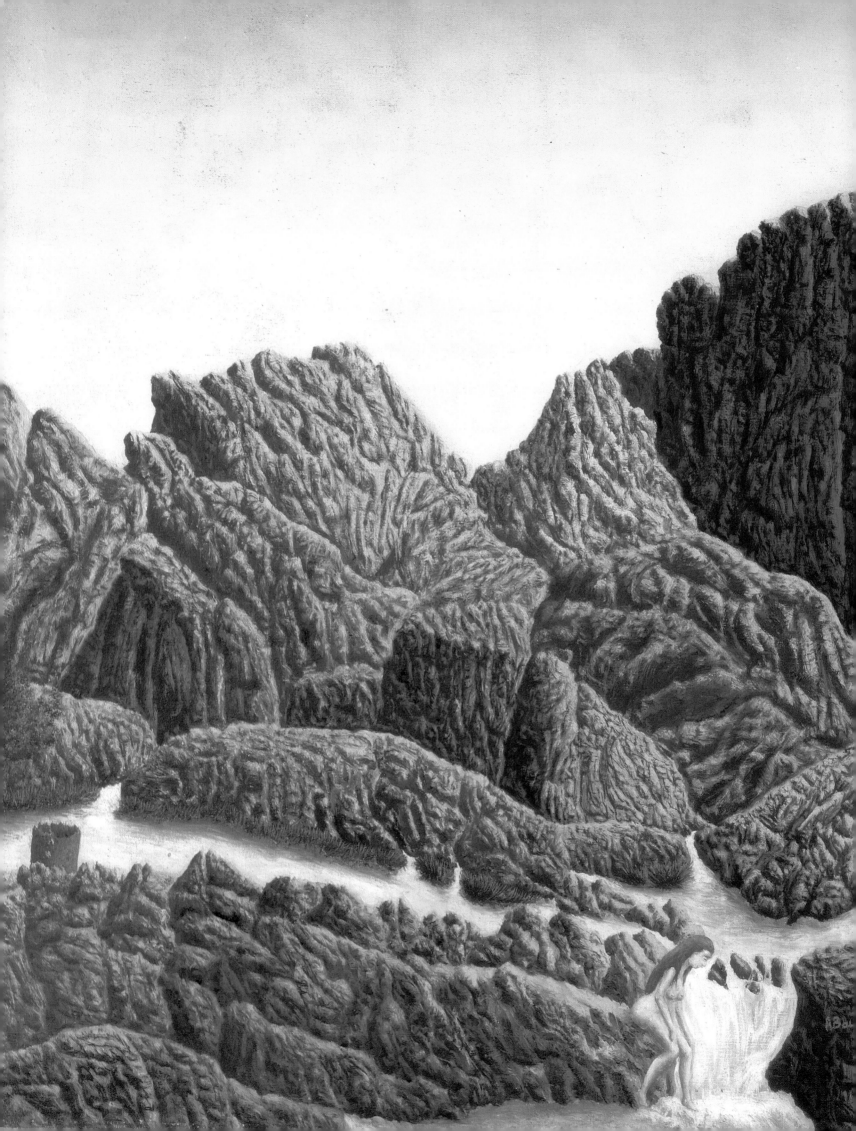

ANDRÉ BAUCHANT

THE STYX

Detail. 1939, oil on canvas,
97 × 142 cm (39 × 57 in).

Collection Masurel, Musée d'art moderne de la communauté urbaine de Lille, Villeneuve-d'Ascq.

Had Henri Rousseau – "Douanier Rousseau" – not been some thirty years older than Lesage and had he not been "discovered" at the turn of the century by Picasso and Apollinaire, in all likelihood he too would have been pigeon-holed as an Art Brut painter. Like Augustin Lesage, Rousseau was self-taught and had a humble job. A Toll Department clerk at the Porte de Vanves in Paris until he took early retirement to devote himself entirely to painting, his work consisted in checking the waggon-loads of merchandise entering and leaving the city. Like Lesage, he believed in spirits and claimed that his hand was guided, in particular, by that of his dearly beloved wife Clémence, whose death had left him inconsolable. Finally, like Lesage, he was a simple, affable man.

Rousseau died in 1910. Nowadays his work enjoys the seal of official approval, but this was not at all the case during his lifetime. Contemporary critics saw nothing in his jungle scenes, inspired by the hothouses at the Jardin des Plantes (the Paris zoological and botanical gardens), but green "tubing" and "salad", while the public guffawed at his wild beasts. The sumptuously dream-like quality of his canvases violated the contemporary academic canons, which tended toward portly gods and buxom goddesses, and he was therefore considered demented. Shortly before his death, he was implicated in a forgery case and threatened with imprisonment. His defence lawyer came up with the idea of submitting one of his paintings, *Merry Jesters*, as evidence; it depicted a pair of monkeys in the jungle squabbling over a bottle of milk. The court was reduced to tears of laughter. Anyone responsible for such a monstrosity could only be a "nutcase". Rousseau got off with a two-year suspended sentence, saved by his art.

Fame came much later, in 1937. In that year the flamboyant Andy-Farcy, curator at Grenoble Museum, aided by art dealer Wilhelm Uhde, arranged for the exhibition of some two hundred naive paintings, including twenty-one works by Rousseau, in Paris and then Zurich. Among these "Sunday painters", as they were then known, were Séraphine and André Bauchant. Séraphine worked as a domestic servant in Senlis for friends of Uhde's. Having "discovered" her, he took her into his own service and provided her with canvases and paints. Her parents were impoverished peasants and practically nothing is known about the origins of her artistic vocation. Her paintings, executed with astonishing sureness of touch, feature enigmatic compositions of flowers, leaves and exotic fruit, with eyebrow-like

SÉRAPHINE DE SENLIS

THE TREE OF PARADISE

Detail. C. 1929, oil on canvas,
195 × 130 cm (78 × 52 in).

Musée national d'art moderne, Paris.

stamens, lip-like petals and the occasional eye peeping out from amidst the corollae. Haunted by religious visions, Séraphine was eventually committed to Clermont asylum, where she died in 1930.

André Bauchant too was born too early to be categorized as an Art Brut painter. A horticulturalist and nurseryman from Tours, his earliest works were painted as a tribute to the fertile soil of his native region. He was incapable of accurate perspective drawing, unable to render light and shade and, moreover, had a somewhat inexpert hand. Midway between landscape and still life, his visibly ripening apples and pears, and trees whose sap almost palpably wells to the topmost bough make him an artist of the first rank. He is particularly inspired when drawing on Greek and Roman mythology, which had fired his imagination as a schoolboy. His entire œuvre is pervaded by mythical elements and constant references to classical antiquity, nowhere more so than in *The Styx*. The painting represents the river said to wind round the infernal regions, its banks haunted by the wandering spirits of the unburied. Bauchant depicts it as a raging torrent cascading through a stark, rocky landscape. Rarely has the inevitability of death been so powerfully represented.

ANDRÉ BAUCHANT
FLOWERS AND FRUIT
1957, oil on canvas,
79 × 105 cm (32 × 42 in).
Musée national d'art moderne, Paris.

ANDRÉ BAUCHANT
STRAWBERRY PICKING
Detail. 1940, oil on canvas,
65 × 54 cm (26 × 22 in).
Collection Masurel, Musée d'art moderne de la communauté urbaine de Lille, Villeneuve-d'Ascq.

Auguste Forestier
Eagle
Before 1958, miscellaneous
techniques on wood,
65 × 22 cm (26 × 9 in).
*L'Aracine Collection, in deposit
at the Musée d'art moderne de la communauté
urbaine de Lille, Villeneuve-d'Ascq.*

page 39
Auguste Forestier
Untitled
Before 1958, miscellaneous
techniques on wood,
65 × 62 cm (26 × 25 in).
*L'Aracine Collection, in deposit
at the Musée d'art moderne de la communauté
urbaine de Lille, Villeneuve-d'Ascq.*

page 40
Josef Wittlich
The Queen
Before 1982,
gouache on paper,
102.5 × 72.8 cm (41 × 29 in).
*L'Aracine Collection, in deposit
at the Musée d'art moderne de la communauté
urbaine de Lille, Villeneuve-d'Ascq.*

page 41
Josef Wittlich
The King
Before 1982,
gouache on paper,
101 × 73 cm (40 × 29 in).
*L'Aracine Collection, in deposit
at the Musée d'art moderne de la communauté
urbaine de Lille, Villeneuve-d'Ascq.*

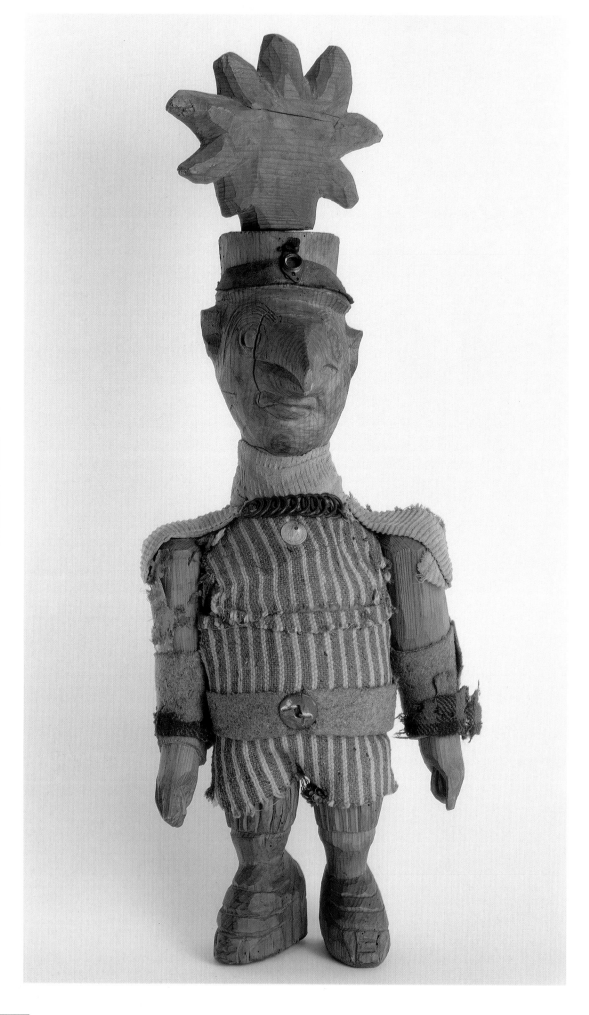

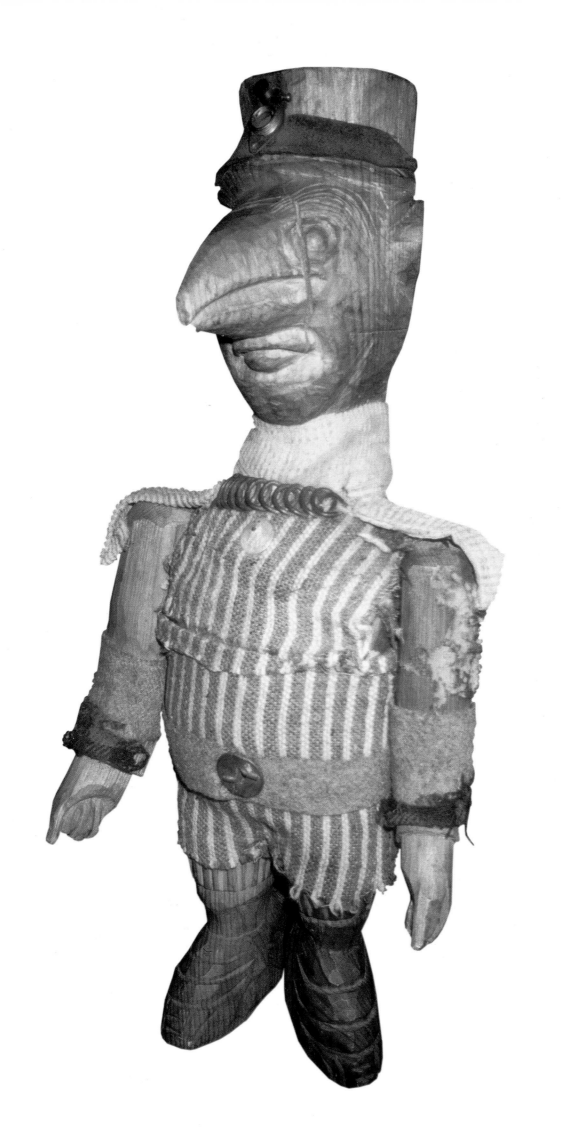

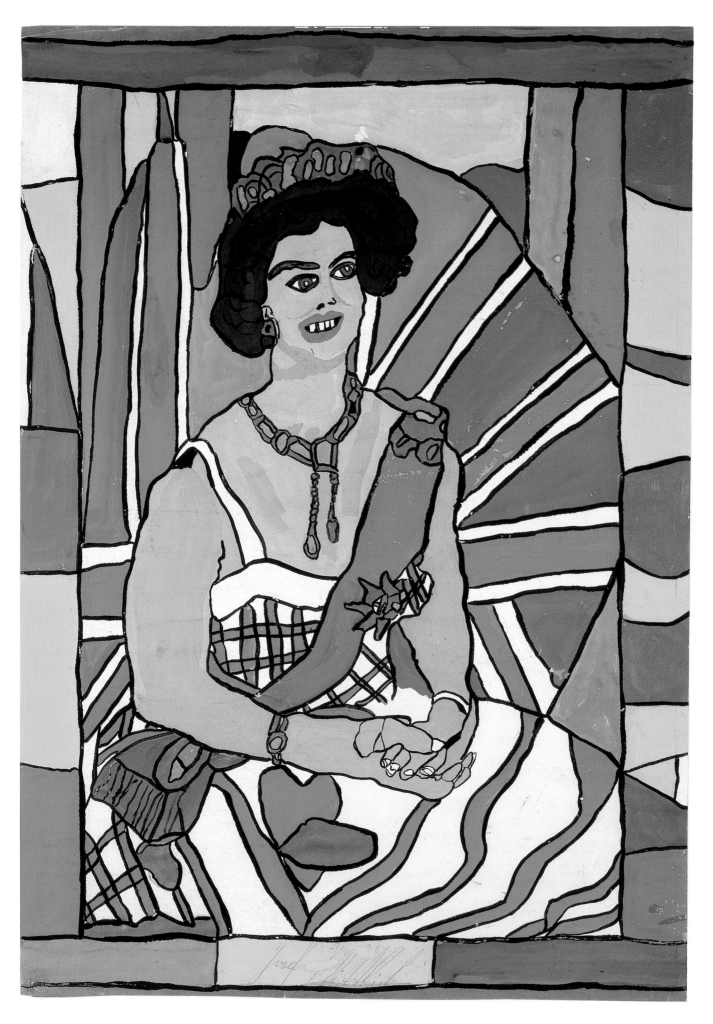

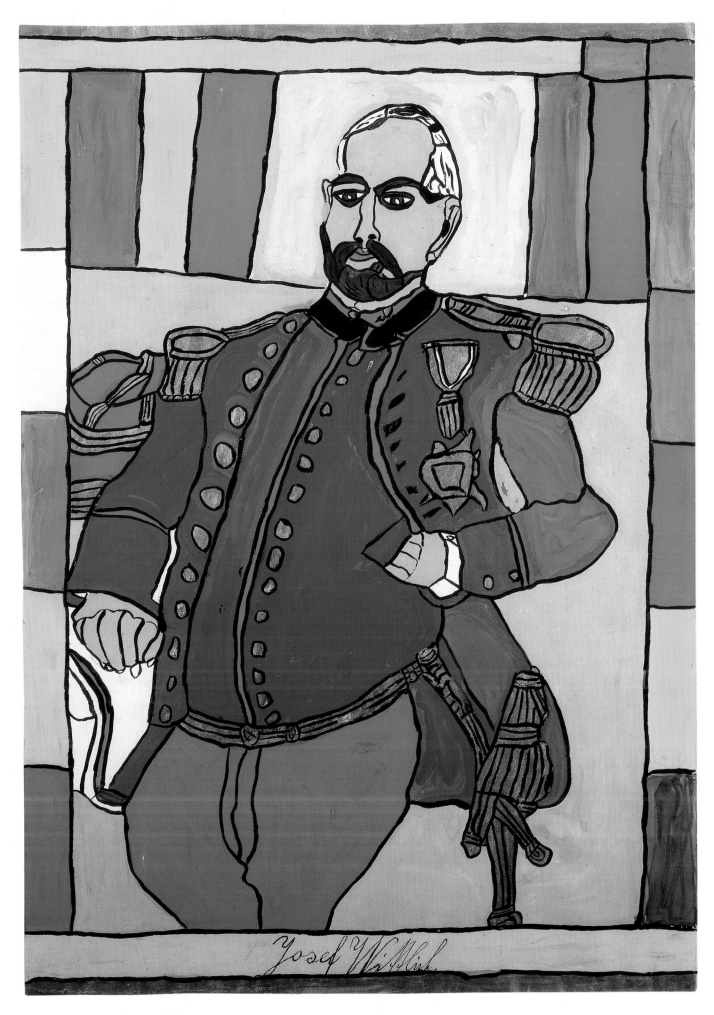

Josef Wittlich

Naive Art? Art Brut? Psychotic Art? Insofar as naive artists have not experienced psychological breakdown and turmoil, their art is often seen as an expression of joy. Furthermore, oils are generally their preferred medium, whereas practitioners of Art Brut use anything which comes to hand: waste paper or cardboard, old rags, old boxes and crates. Yet, once again, it is difficult to establish precise distinctions. The problem is not simply one of dates. Works displaying all the characteristics of Art Brut do exist. But the various genres overlap, and often the artists involved are versatile. Auguste Forestier, for instance, whose disturbing sculpted monsters with human teeth are a combination of animal and vegetable elements, also made charming toys, which the doctors and nurses in the asylum where he was interned used to purchase for use as Christmas presents. In more recent times, Josef Wittlich has been labelled an Art Brut artist, but his case too is an ambiguous one.

Wittlich was born on 26 February 1903 in Gladbach, in the Rhineland-Palatinate. On his mother's death, he was left in the care of his brutal father and a hostile stepmother who doted on her own child who was mentally ill. Early on in life he turned to drawing to alleviate his miserable existence. A farm worker before being drafted into the Todt labour organisation, he was taken prisoner by the Russians during the

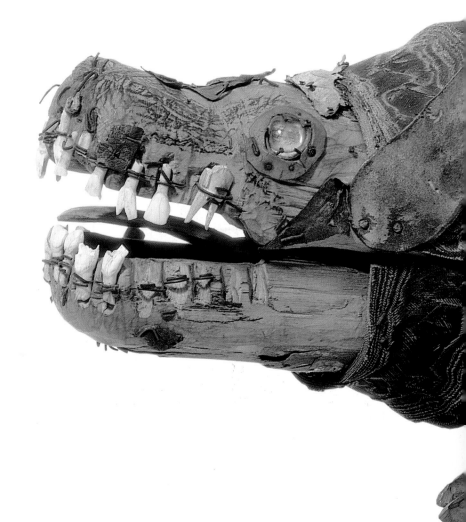

Second World War and was subsequently employed in a pottery works in Höhr-Grenzhausen where he began to practise painting assiduously. Nicknamed *Juppchen* ("small Josef") by workmates familiar with his paintings, samples of which adorned the factory walls alongside pin-up photos, he displayed unquestionable pictorial talent yet remained incapable of explaining his remarkable sense of colour. Towards the end of his life, when he was relatively well-known, he answered all questions about his work with the simple reply: "It's nice, isn't it!" Wittlich's themes were drawn not from life but directly from imagery; this included reproductions of academic paintings – notably battle scenes –, photos of the pope, generals, princely couples and film stars, and advertisements for womens' fashion. These humble iconographic sources were transfigured by rigorous formalisation. Often, his technique is akin to that of the comic strip. Since his paintings deal with warlike violence, sexual angst and the aggressiveness of modern life, his work has been seen as a naive version of Pop Art. On the other hand, his pictures portray resplendent generals and ladies, and his soldiers give battle for exclusively colouristic reasons. Wittlich worked in gouache on paper. Unable to afford real frames, he surrounded his motifs with a painted substitute composed of red, yellow and green segments, as if to magnify them and shield them from the outside world. These painted frames are in themselves an illustration of his outstanding talent as a colourist.

AUGUSTE FORESTIER
THE BEAST OF GÉVAUDAN
Before 1958, wood assemblage with teeth,
33 × 89 × 20 cm (13 × 36 × 8 in).
L'Aracine Collection, in deposit at the Musée d'art moderne de la communauté urbaine de Lille, Villeneuve-d'Ascq.

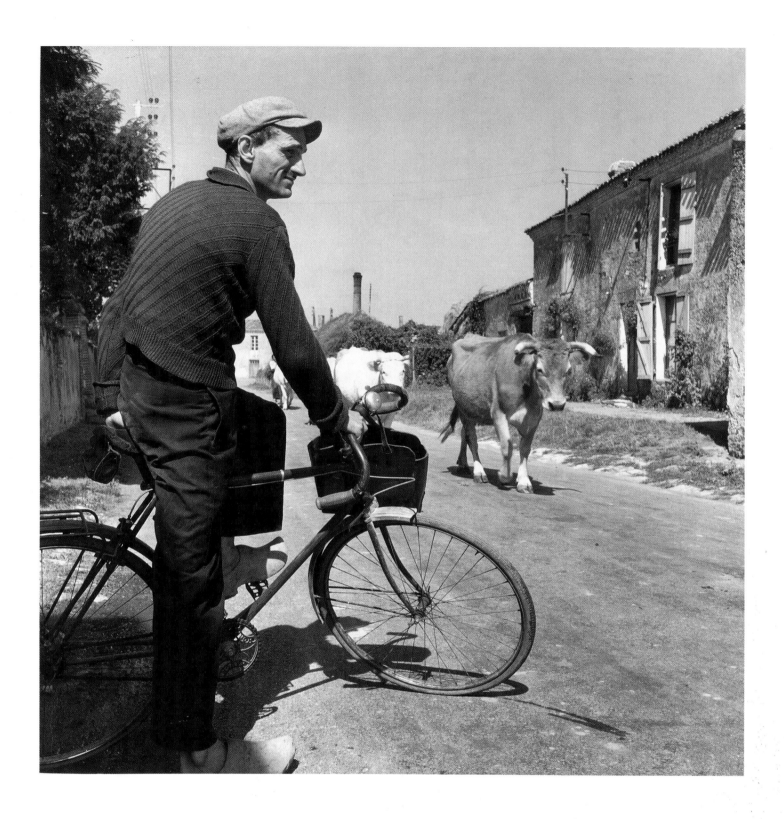

GASTON CHAISSAC

photographed
by Robert Doisneau
in 1952.

Portraying life's precarity

Gaston Chaissac, whom Dubuffet liked to call "the cobbler of Sainte-Florence-de-l'Oie" – referring to the village in the Vendée where Chaissac lived for many years – is one of the most debateable recruits to the Art Brut banner. Apart from the fact that he was an unemployed cobbler living in a remote country village, and dressed like a farmhand, invariably sporting a tattered cloth cap and heavy clogs as he cycled off to shop with his bag slung from the handlebars of his bike, the polychrome objects he produced were the essential pretext for the Art Brut label. In the 1950s, he acquired a reputation as an "outsider artist"

because his painted stones, totems constructed from coloured planks, painted oxen shoulder blades and grotesque faces, the forms of which were traced from accidental or deliberate dents in old wash tubs, basins and pails, all seemingly partook of an aesthetic of recycled or found objects. This opinion was reinforced by the fact that, in 1949, he had taken part in the exhibition entitled *L'art brut préféré aux arts culturels* held in the basement of the Drouin gallery in Paris. His painting and sculpture appear spontaneous, yet Chaissac claimed: "In my own way, I've perhaps studied more than any Prix de Rome winner".

Although not mad himself, he was haunted by the fear of madness: his elder brother was mentally ill and, in his youth, Chaissac dreaded a similar fate. Born in Avallon in 1910, he was of frail health and, unfit for work, he was shunted from hospital to sanatorium. He might never have become a painter had he not, in 1937, met Otto Freundlich and his partner Jeanne Kosnick-Kloss, who encouraged him to draw. Later, during the war, he met Albert Gleizes, then still basking in his renown as a Cubist. Introduced to the world of art by these friends, Chaissac never looked back.

Freundlich, a German by origin, was an extremely generous man who had settled permanently in Paris in 1924. During the Nazi occupation

Gaston Chaissac
Untitled
1944, indian ink
on cardboard,
9.5 × 6.5 cm (4 × 3 in).
*Musée de l'abbaye Sainte-Croix,
Les Sables-d'Olonne.*

Gaston Chaissac
Untitled
1956, enamel paint
on sheet metal,
Diameter 60 cm (24 in).
*Musée de l'abbaye Sainte-Croix,
Les Sables-d'Olonne.*

GASTON CHAISSAC
UNTITLED
1938, Indian ink on paper,
24.7 × 32.4 cm (10 × 13 in).
Musée de l'abbaye Sainte-Croix,
Les Sables-d'Olonne.

GASTON CHAISSAC
ABSTRACT COMPOSITION
1957-1958, oil on hardboard,
122 × 120 cm (49 × 48 in).
Galerie Louis Carré & Cie, Paris.

of France he was deported and died at Lublin-Majdanek concentration camp in 1943. A member of the "Cercle Carré" group and, later, of "Abstraction-Création", he was an abstract painter at a time when abstract art enjoyed scant public or critical approval. His work, featuring a variety of geometric figures, is characterized by the subtle gradation of large swathes of pure colour, producing a powerful and radiant effect. Freundlich and his wife had their studio in the Rue Barbusse building where Chaissac was temporarily lodging with one of his brothers, and they met in the courtyard. With Freundlich's help, Chaissac acquired a basic grounding in artistic techniques in a matter of months. After a few initial compositions inspired by his mentor's work, he broke free of Freundlich's influence; he already had a clear idea of his own very personal art.

Chaissac was a prolific letter writer and, after the war, published a selection of his correspondence in which he defined himself as a "modern rustic painter", thus enabling himself to distance his own work from both Art Brut and sophisticated Parisian artistic circles. The reviews in which his texts appeared –the *Nouvelle Revue Française* and the *Cahiers de la Pléiade* – were not exactly agricultural gazettes, but his letters have an unmistakeably authentic tone. They describe, for instance, Chaissac marvelling at a stunted cherry tree which has taken root in a wall and managed to survive in the sun-baked mortar, or his half-amused exasperation when a cow munches up the peas in his kitchen garden. They also touch upon topics utterly foreign to city-dwellers, such as sorcery, druids, or the baptism of poultry.

GASTON CHAISSAC
COMPOSITION WITH SNAKE
1951, oil on pasted paper on plywood,
50 × 65 cm (20 × 26 in).
Musée de l'abbaye Sainte-Croix,
Les Sables-d'Olonne.

GASTON CHAISSAC
UNTITLED
Detail. 1957-1959, oil on hardboard,
140.5 × 122 cm (56 × 49 in).
Musée de l'abbaye Sainte-Croix,
Les Sables-d'Olonne.

Chaissac also gives interesting details about his own technique. He worked very quickly, sometimes following the impressions made by vegetable peelings or broken crockery placed beneath the surface on which he was working, sometimes using his left hand to accentuate the effect of clumsiness. Such tactics were intended to cultivate an "unlearning" which allowed him to avoid cliché.

The paintings themselves encompass the entire range of interplay – or conflict – between expertise and ineptitude. Occasionally abstract, portraying groups of people or solitary figures, they are composed of flat blocks of pure colour surrounded and separated by black lines and depict an impoverished humanity whose expressions are torn between surprise and sorrow at their own predicament. In some of his works, Chaissac partially fills the surface with cut-out and pasted wallpaper, the floral motifs of which heighten the sense of obsolescence and neglect. There is nothing joyful about being born into this world. His *Christ*, shown laughing on the Cross, is a reminder that the human condition is not tragic but ludicrous. In his letters, Chaissac writes about the old village houses with their walls of irregular, rough-hewn

stone in which the cement forms random patterns. The description might equally apply to his paintings, in which the bodies, limbs, and faces – or masks – belong to a kind of rubblestone masonry, their irregular surfaces precariously poised and threatening to tumble down at any moment.

Other works focus on a teeming vegetable and zoomorphic universe like that of *Composition with Snake*, in which the black outline forms interlinking rings. As one critic has remarked: "Traditionally related to the biblical creation myth, snakes were a common sight in Chaissac's native Morvan region and conjured up many childhood memories. With their lithe, mottled appearance, they chimed in perfectly with the painter's cosmic vision of metamorphosis".[1] Invested with archetypal significance, they provided a natural starting point for his artistic exploration. In this painting, as in others dating from the years 1945-1950, the contrasting blocks of colour are no longer precisely delineated. Instead, the twisting black line intersects the canvas to form open compositions "in which the willowy arabesque matches the soft hues of earth and water"[2].

Chaissac's stylistic evolution can be charted in the progressive changes which occur in his drawings. The earliest, teratological in inspiration, depict weird, monstrous beasts spawned by teeming imaginary cells seemingly capable of infinite proliferation like propagating organic tissue. Here, the graphic construction is solid, indeed massive, and reminiscent of mediaeval teratology. Then come creatures with interwined bodies and, finally, fragmentary, shapeless, bisected heads. Chaissac was well acquainted with Picasso's work and owned reproductions of portraits by the Spaniard, who was already delving deep into the human face to lay bare its secrets. "When will you be along for your extraction?" Picasso once asked a friend who wanted his portrait painted. There is something analogous in Chaissac's drawing: he also sets out to "extract" faces. The broken pieces of crockery from which he takes impressions become shattered noses, marrow peelings are turned into drooping mouths, and broken pitcher shards are transformed into dislocated skulls. Eschewing all superficial resemblance, he portrays that living relic of ancestral humanity, the peasant – a nowadays virtually extinct species but one which the war years had once again propelled to the fore of events in France – with his backbreaking toil, hardships, tribulations and hunger.

Chaissac's abstract compositions reveal a painter who can handle line and colour with consummate skill. But they account for a very small portion of an oeuvre entirely devoted to the portrayal of life's precarity. In the early 1960s, they inspired Dubuffet as he began to paint his extensive Hourloupe series. Chaissac's initial reaction was to regard these as a mere hoax, or a close friend's way of paying tribute to his own work. Then as the series expanded in increasing splendour, the naive and confiding Chaissac gave way to outraged anger at finding himself thus plundered of his most intimate expression.

GASTON CHAISSAC

RED FACE

1962, gouache
and wallpaper collage on paper,
64 × 50 cm (26 × 20 in).

*Musée de l'abbaye Sainte-Croix,
Les Sables-d'Olonne.*

1. *Gaston Chaissac*, musée de l'abbaye Sainte-Croix, Les Sables d'Olonne, Exhibition Catalogue, 1993, p. 58.
2. *Ibid.*

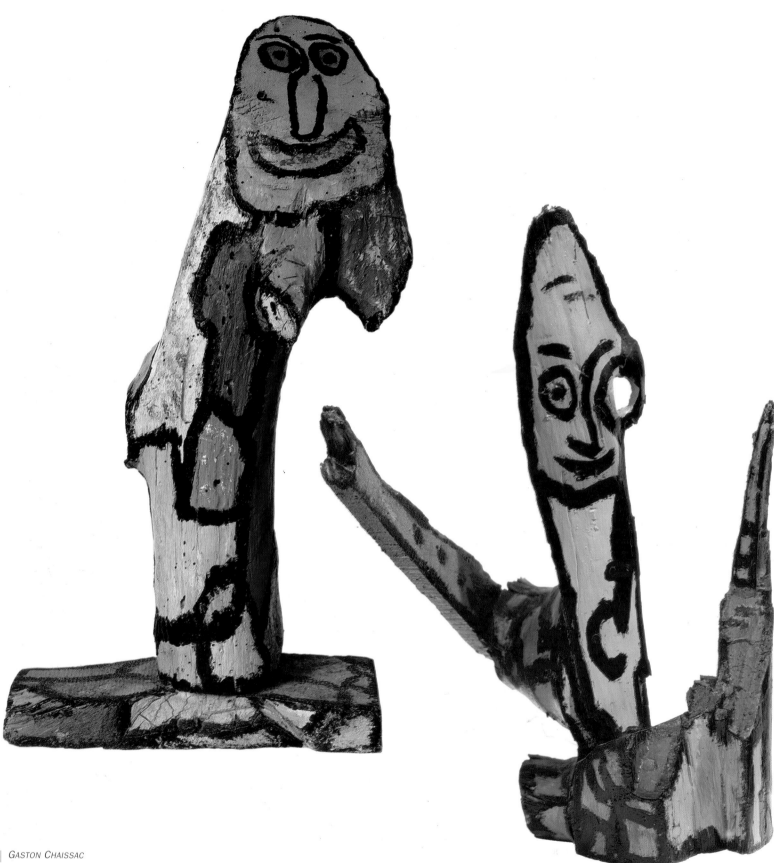

Gaston Chaissac
Untitled
1960, oil on tree stump,
54 × 29 × 11.5 cm (22 × 12 × 5 in).

Musée de l'abbaye Sainte-Croix,
Les Sables-d'Olonne.

Gaston Chaissac
Figure, Small Totem
1954, oil on wood,
height 39.5 cm (16 in).

Private Collection, Zurich.

Page 53, left
Gaston Chaissac
Figure Wearing a Boater
1954, oil on wood,
height 41.5 cm (17 in).

Private Collection, Zurich.

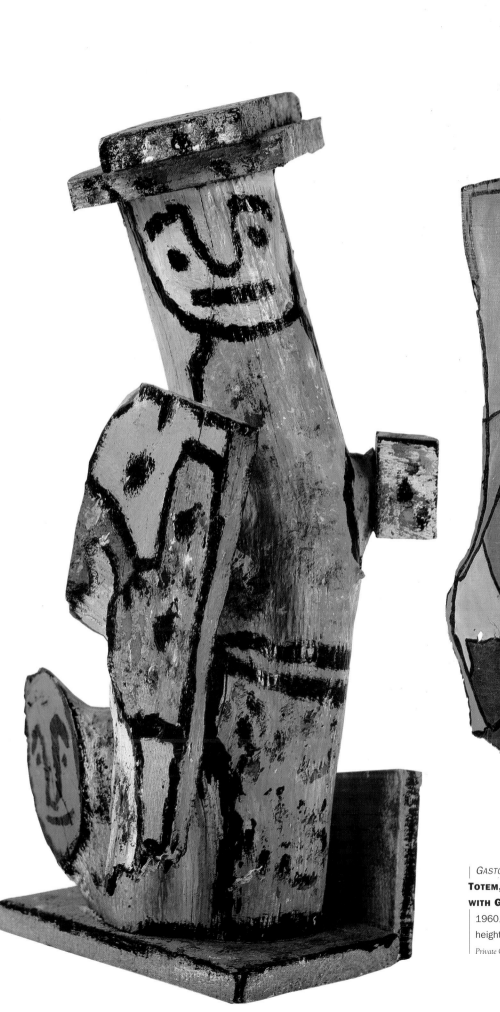

GASTON CHAISSAC
TOTEM, FIGURE WITH GREEN FACE
1960, oil on wood,
height 161 × 42 cm (64 × 17 in).

Private Collection, Zurich.

GASTON CHAISSAC
Y A D'LA JOIE, or ANATOLE
1960, oil on wood,
194 × 29 cm (78 × 12 in).

Musée de l'abbaye Sainte-Croix,
Les Sables-d'Olonne.

In the beginning was the eye

Antonio Ligabue (pronounced Ligabu*ay*), an uneducated, mistrustful, vindictive man with a gruff, unceremonious manner of speech, remained utterly indifferent to the twentieth-century art and culture of which his work forms an integral part. He was born in Zurich on 18 September 1899 to a mother who had emigrated from Friuli in Italy and an unknown father. Two years later, however, his mother married a fellow Italian emigrant, Bonfilio Antonio Laccabue, who adopted the child and gave him his own name, subsequently altered to Ligabue. Although little Antonio did very badly at school, he was gifted with a natural talent for drawing, a fact which his teachers noted but to which they attached no particular importance. A constant runaway, involved in endless fights and brawls, he was deported from Switzerland "as a public safety precaution and on grounds of vagrancy". Accompanied by two carabinieri, he was escorted by rail to his adoptive father's home village of Gualtieri in Emilia Romagna in the Po valley.

The twenty-year-old Ligabue had no intention of rotting in jail. No sooner was he locked up than he escaped, sleeping in haylofts and stables before taking off to the woods where he built a cabin and lived as a recluse. He was an uncouth, unsociable character, nicknamed "the Kraut" by the local Gualtieri people because, having spoken Swiss German at school, he expressed himself in a garbled mixture of Italian and German. When Italy was liberated, he narrowly escaped being shot for acting as an interpreter to the German troops who had been sent in to shore up Mussolini's army in 1943. His earliest works consisted of signboards painted for little circuses or fairground shooting stalls to earn a meagre pittance and his first contract stipulated the delivery of one painting in return for ten meals. Following this, he used to barter his work for motorcycles, building up a collection of a dozen machines which he drove without a licence. "I'm off to make love", he would say, as he entered the garage where the bikes were carefully lined up, covered in sheets. When painting, he sometimes ritually donned a woman's dress which he slipped on over his own clothes. Towards the end of his life, when he had become rich and, thanks to the journalists, famous, he owned several cars and hired a chauffeur – to his mind, the token of a successful career. But a concomitant of success was intermittent spells at Gualtieri asylum, where he died on 27 May 1965.

Notoriously filthy, he claimed to come of aristocratic stock and, believing that an aquiline profile would corroborate this pretension, battered his nose into suitable shape with a stone. Moreover, his forehead and temples – the seat of evil forces – were habitually covered with self-inflicted wounds and his permanently bloodied face was a frightening sight. Aware of the fact, and fearing the panic-stricken reaction of women, he shunned their presence to spare them having to flee his. Marzio Dall'Acqua, author of the finest biography of Ligabue, thought this behaviour reflected magical beliefs. In his opinion, Ligabue's

ANTONIO LIGABUE
SELF-PORTRAIT
Detail. Before 1965,
oil on plywood,
52 × 36 cm (21 × 14 in).
Private Collection, Gualtieri.

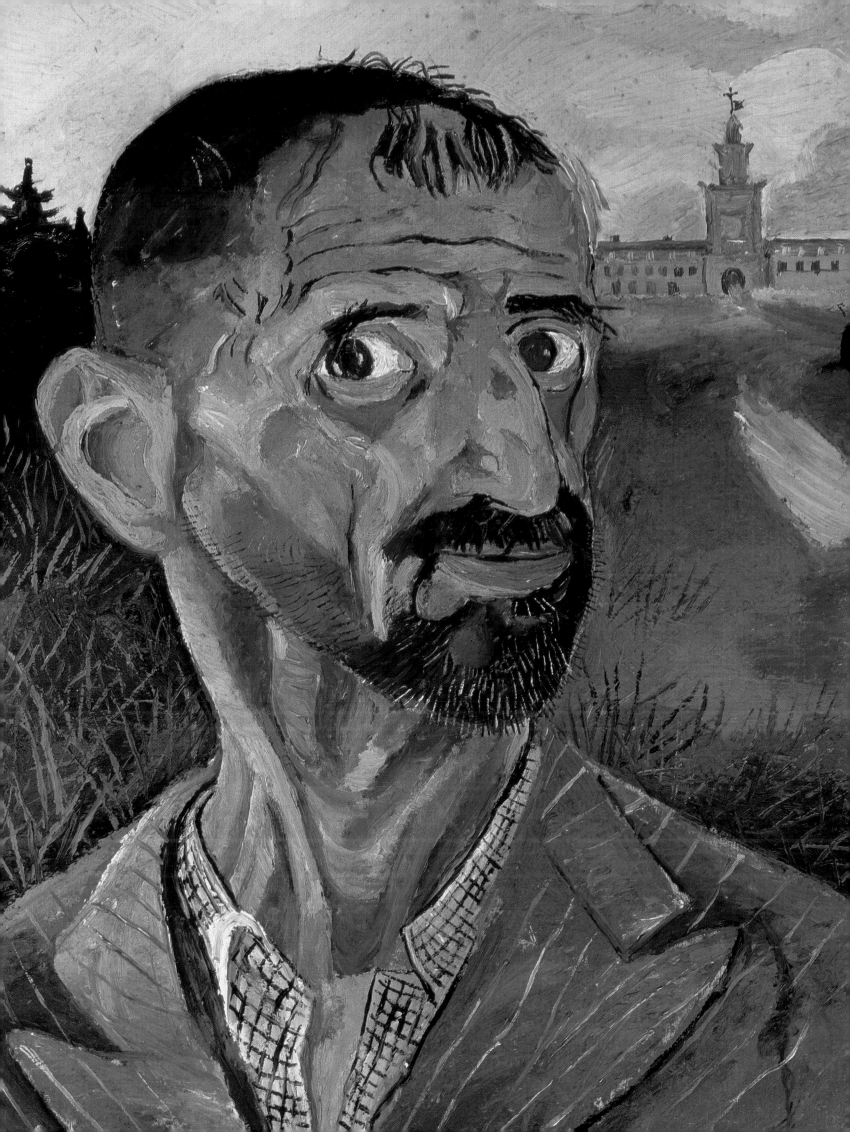

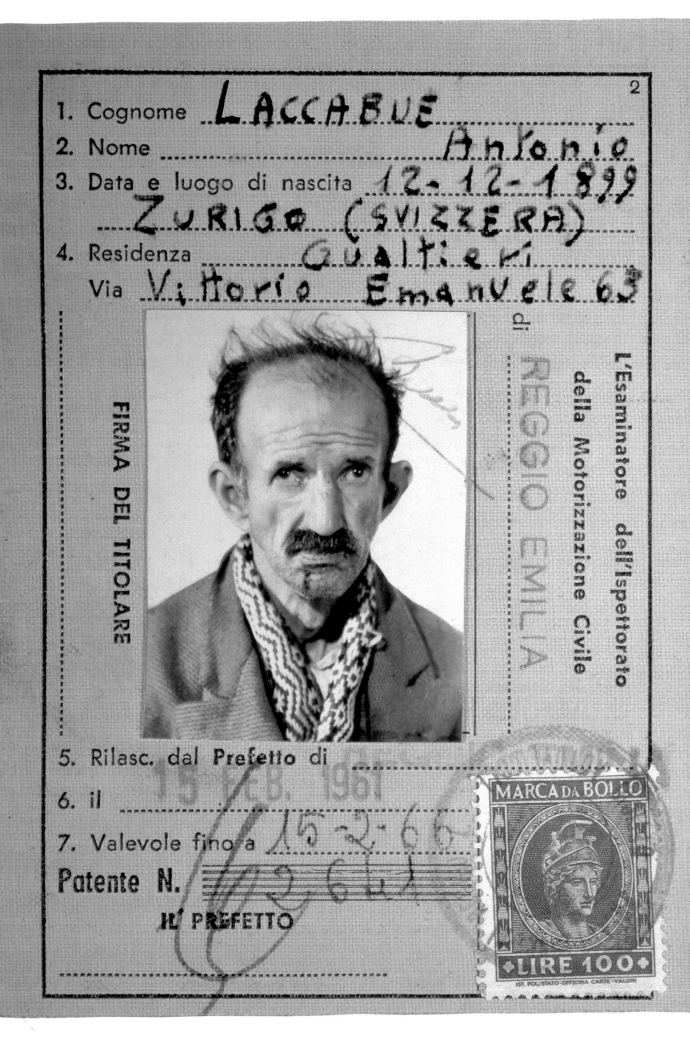

2

1. Cognome LACCABUE

2. Nome Antonio

3. Data e luogo di nascita 12-12-1899 ZURIGO (SVIZZERA)

4. Residenza Gualtieri

Via Vittorio Emanuele 63

di REGGIO EMILIA

L'Esaminatore dell'Ispettorato della Motorizzazione Civile

FIRMA DEL TITOLARE

5. Rilasc. dal Prefetto di

6. il 15 FEB. 1961

7. Valevole fino a 15-2-66

Patente N.

IL PREFETTO

MARCA DA BOLLO

LIRE 100

IST. POL. STATO-OFFICINA CARTE-VALORI

VEICOLI PER I QUALI LA PATENTE E' VALIDA 4

A | n. 3371/4RE del 9-12-60

Motoveicoli di peso a vuoto fino a 400 Kg.

B | n. del

Autocarri e autoveicoli uso spec. o trasp. specif. peso comples. pieno carico fino a 3500 Kg.; autoveicoli trasp. promiscuo e autovetture, train. rimor. legg.; motov. peso a vuoto sup. a 400 Kg.

C | n. del

Autocarri, autoveicoli per uso speciale o trasporti specifici, di peso complessivo a pieno carico superiore a 3500 Kg. e trattori stradali, anche se trainanti un rimorchio leggero.

D | n. del

Autobus, anche se trainanti un rimorchio leggero

E | n. del

Autoveicoli appartenenti alla cat. B, C o D, per le quali il cond. è abilit., quando train. rimor. che non sia legg.; autosnodati quando il condut. sia abilit. per autoveicoli apparten. cat. C o D.

F | n. del

Motocicli, motocarrozzetta ed autovetture per mutilati o minorati fisici adattati in relazione alla loro infermità.

ANTONIO LIGABUE
The artist's driving licence photograph.

foul-smelling body, encrusted with mucus and filth, acted as a shield for the vital forces he was duty bound to protect; the saliva which he mixed into his paint was intended to ward off ill-fortune; his self-mutilation, in which he was simultaneously executioner and victim, aroused in others a hatred, repugnance and disgust which elevated it to a sacrificial act.

On the subject of Ligabue's paintings, Dall'Acqua comments magnificently: "In the beginning was the eye. And, similarly, in all his figures the image was constructed around the central feature of the eye as prime mover and sun: absorbed and projected light. In his portraits in particular, Ligabue always added a spot of white to the iris, to show the reflection of this light; at times, the spot all but engulfs the pupil. Terrified, aggressive, cold, commanding eyes intended to magnetise, exorcise and block out reality, abolishing all distance between the animal and the human stare, brimming with attentive wonder. Their intensity and secret anxiety animate the facial muscles and give body to every fibre. These eyes seem to follow the spectator's movements with an almost trompe-l'œil effect, but this is no baroque affectation. It enables the eyes to dominate the entire canvas".[1]

In the portraits – particularly the self-portraits – the eyes are indeed fascinating: they gaze leftwards while the face is turned slightly to the right. The post-mortem inventory of Ligabue's meagre belongings revealed that his bedroom was full of mirrors. Apart from his wardrobe mirror, another huge mirror stood on a chest of drawers, a third on a dressing table, and others may have hung on the walls. Around his neck he wore a tiny mirror which reflected the waters as he walked along the banks of the Po. Though at the centre of a complex interplay of reflections wherever he was, when painting his self-portraits, he is said to have painted from memory without using a mirror. The self-portraits are usually set against a landscape background or, in one instance, showing him seated at a piano, as he was also a musician and occasionally played the church organ on Sundays. Stark and uncompromising, they reveal a man who, unlike Van Gogh, always maintains his composure, casting a self-assured, scornful eye at the viewer. The greatest of all is virtually a ceremonial portrait. Ligabue is depicted full length, wearing leather boots, a hunting dog at his side, striding across his verdant fields. In the distant background can be seen a village with little houses over which he holds sway like some feudal lord.

The numerous wild beasts that feature in his paintings derive from childhood memories. Unlike Douanier Rousseau, who copied his animals from engravings in popular introductions to zoology, Ligabue had seen them alive in the circuses or zoos of his native Switzerland. When people professed amazement at their anatomical precision – another childhood legacy – he would reply: "I know them inside out"; he had seen their skeletons in some natural history museum and recalled every detail. In one of his most famous paintings, set in a fantastic jungle, a six-foot long leopard is shown leaping, while a giant spider and a

ANTONIO LIGABUE
LION
Before 1965, oil on blockboard,
35 × 34 cm (14·5 × 14 in).
Private Collection, Parma.

1. Marzio Dall'Acqua, *Ligabue*, Milan and Paris 1981, p. 130.

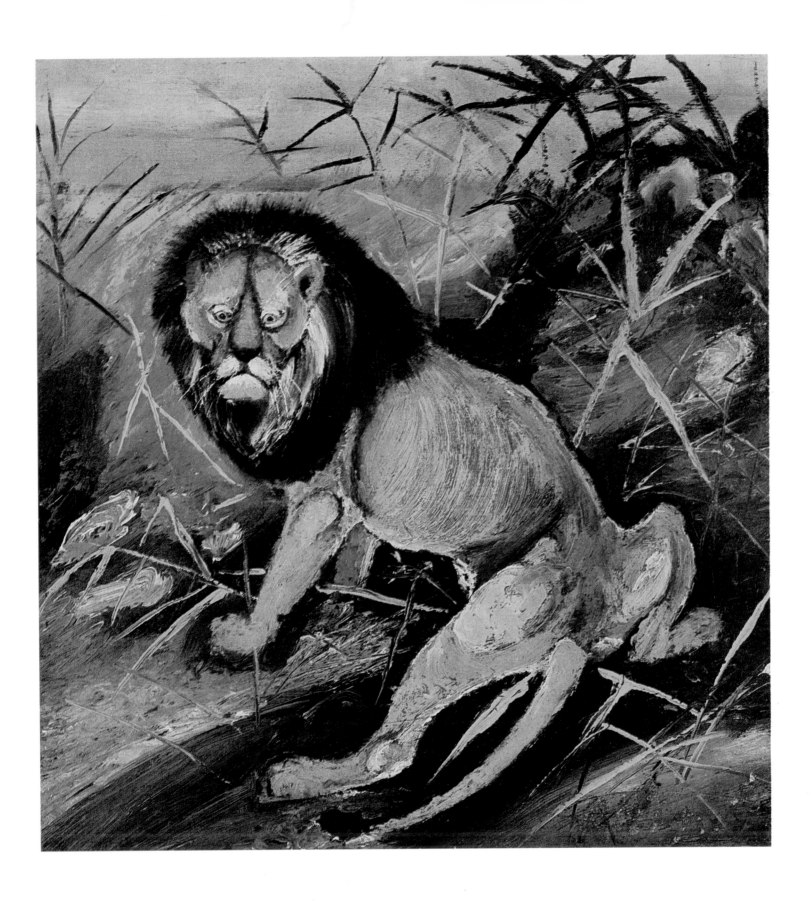

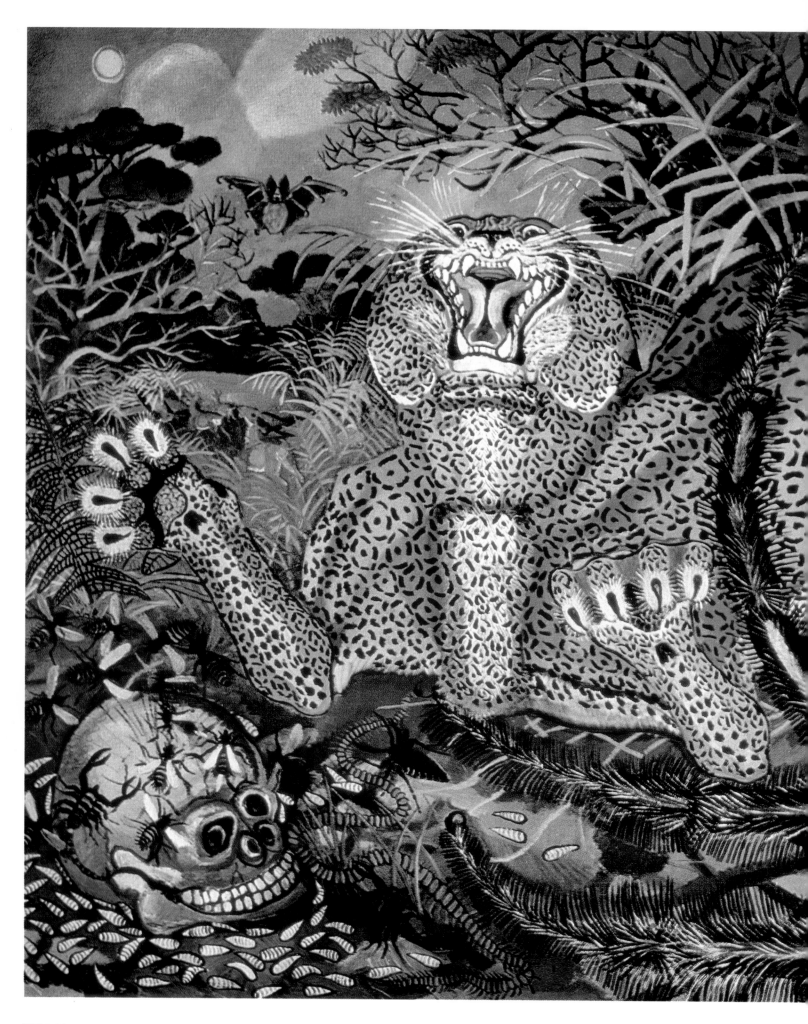

Antonio Ligabue

LEOPARD WITH BLACK WIDOW SPIDER

Before 1965,
oil on blockboard,
130×175 cm (52×70 in).
Private Collection, Guastalla.

pages 62 and 63
Antonio Ligabue
LEOPARD WITH BLACK WIDOW SPIDER
details.

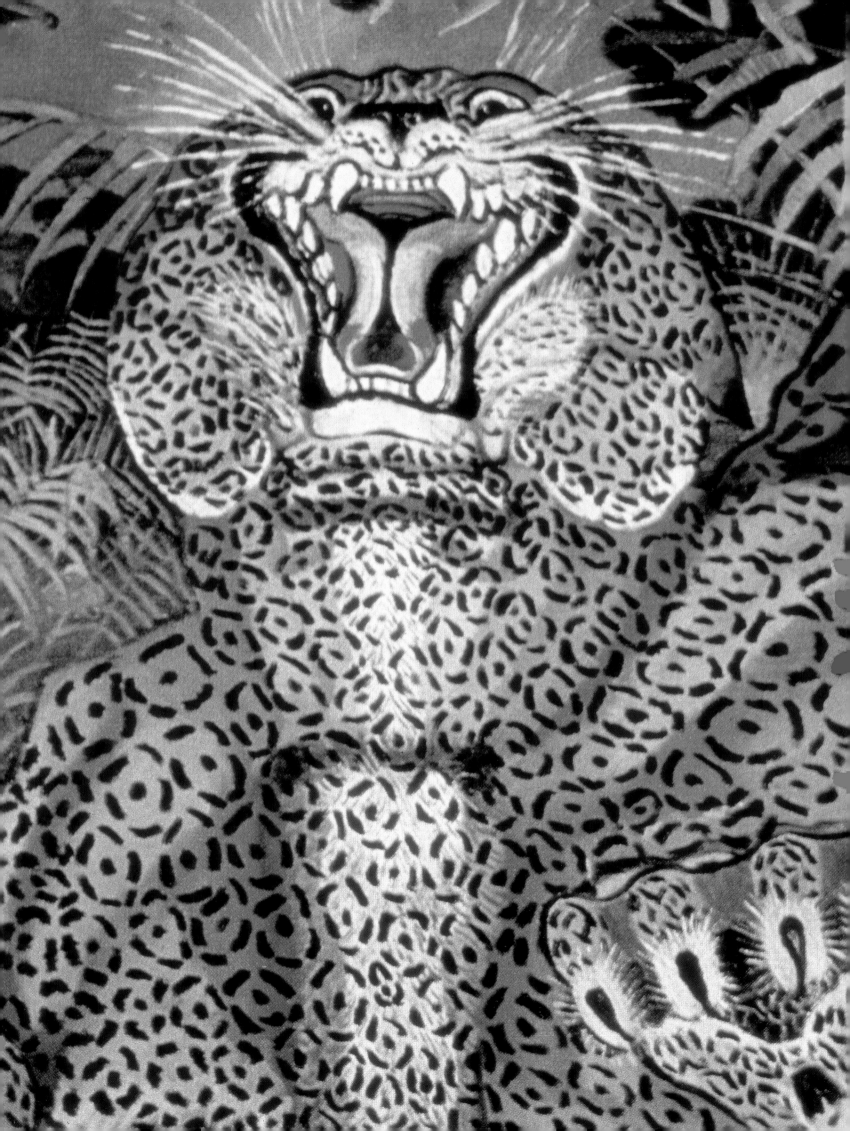

ANTONIO LIGABUE
SELF-PORTRAIT WITH DOG
Detail. Before 1965, oil on blockboard,
168 × 130 cm (67 × 52 in).
Private Collection, Brescia.

death's head stand symbolically in the foreground, and gazelles flee into the distance. The work was executed for a circus using a live, raging, caged wild beast as model. As he painted, Ligabue himself roared and bared his fangs, in total empathy with his subject. He also used to mimic the movements of the animals he painted, gesticulating wildly and daubing himself with paint before abandoning his canvas, utterly exhausted.

Again according to Dall'Acqua, Ligabue regarded these cries and gestures as a way of relating not only to animals, but to what he saw as the conflicting forces of reality itself. He spoke of evil humours, immanent energies endowed with positive or negative signs which waxed and waned. His works – in which a gorilla is shown dismembering an explorer, or a bird of prey ripping a pigeon apart with its claws – can be interpreted as a theatrical stage with all the actors permanently spying on and attacking each other, waging a ruthless struggle like that of life at its most primitive. At one point, Ligabue was given lessons by a friend, the painter and sculptor Marino Mazzacurati, who introduced him to oils, and he may have seen reproductions of works by modern artists at Mazzacurati's home. The crucial factor, however, lies elsewhere: Ligabue inhabited a world haunted by teeming presences and obsessions, a world where culture was submerged and it is this "submerged culture" which is embodied in the majority of his paintings. Indeed, not all of them attain the same degree of intensity. *Large Rabbit in a Swiss Landscape* shows a round-eyed rabbit hopping through tufts of grass, and there are paintings of other farmyard animals, like the pecking hens and haughty cocks with which he was so familiar from having shared their accommodation when he gave the carabinieri the slip on arriving at Gualtieri. Similarly, his depictions of horse-drawn stagecoaches, riders, haymaking scenes and castles with drawbridges are merely picturesque. With the exception of the portrait of little Elba which admirably captures original innocence, Ligabue's genius finds expression not in idylls but in a violent world teeming with wild beasts, reptiles and repellent insects which is truly his own; his forte is archetype rather than anecdote, and he is at his best when an inner earthquake erupts and terrifying but splendid fossils are thrown up from the depths of his mind.

When asked whether Ligabue was mad, his friends reply: "Sometimes yes, sometimes no!" As no clinical psychiatric records exist, their testimony is valuable. It would seem to indicate that, in contrast with the absolute majority of mentally disordered artists, he was paranoiac rather than schizophrenic; this would explain his "normality".

ANTONIO LIGABUE
PORTRAIT OF ELBA
Detail. Before 1965,
oil on wood,
40 × 41 cm (16 × 16 in).
Private Collection, Guastalla.

ANTONIO LIGABUE
PORTRAIT OF MME GNUTTI
Detail. Before 1965,
oil on blockboard,
69 × 49 cm (28 × 20 in).
Private Collection, Brescia.

Indeed, French psychoanalyst Jacques Lacan's first notable achievement was to establish, following on from German psychiatrist Emil Kraepelin, that paranoia, contrary to schizophrenia, does not involve degenerative symptoms and does not therefore entail the gradual destruction of the afflicted ego[1]. Lacan had studied the case of Aimée A., who claimed to be a "woman of Letters and Sciences". She had been arrested after smuggling herself into the wings of a Parisian theatre and slightly wounding an actress with scissors before being overpowered. Lacan made an unexpected discovery. Aimée A. maintained that the actress had been making fun of her each night on stage. She furthermore claimed to have received death threats from the "Kaypeeyou". The walls of her home were covered with newspaper photos of the Prince of Wales for whom she had composed love poems. She had also written two run-of-the-mill novels which were rejected by every publisher, one of whom she had apparently tried to beat up. An over-inflated ego, flawed judgement, persecution mania: everything pointed to mental instability.

Yet Aimée A. worked in the offices of a railroad company; she was a highly-rated employee and neither her superiors nor her colleagues had ever noticed the slightest oddity in her behaviour. It was thus possible to be "at the same time" mad *and* perfectly normal. When the Surrealists, with whom Lacan had close links, heard the story, they took it as validation of their own theory according to which madness was the very opposite of degeneration, a theory amply confirmed by the case of Ligabue. Confinement to an asylum is inadequate as a criterion for differentiating Art Brut and psychotic art but Jean Dubuffet may be right to state that madness is experienced by all artists in some degree; the essential question is whether it determines their social behaviour.

1. Jacques Lacan, *De la psychose paranoïaque dans ses rapports avec la personnalité*, Paris, 1932.

2. A hammer blow to philosophy

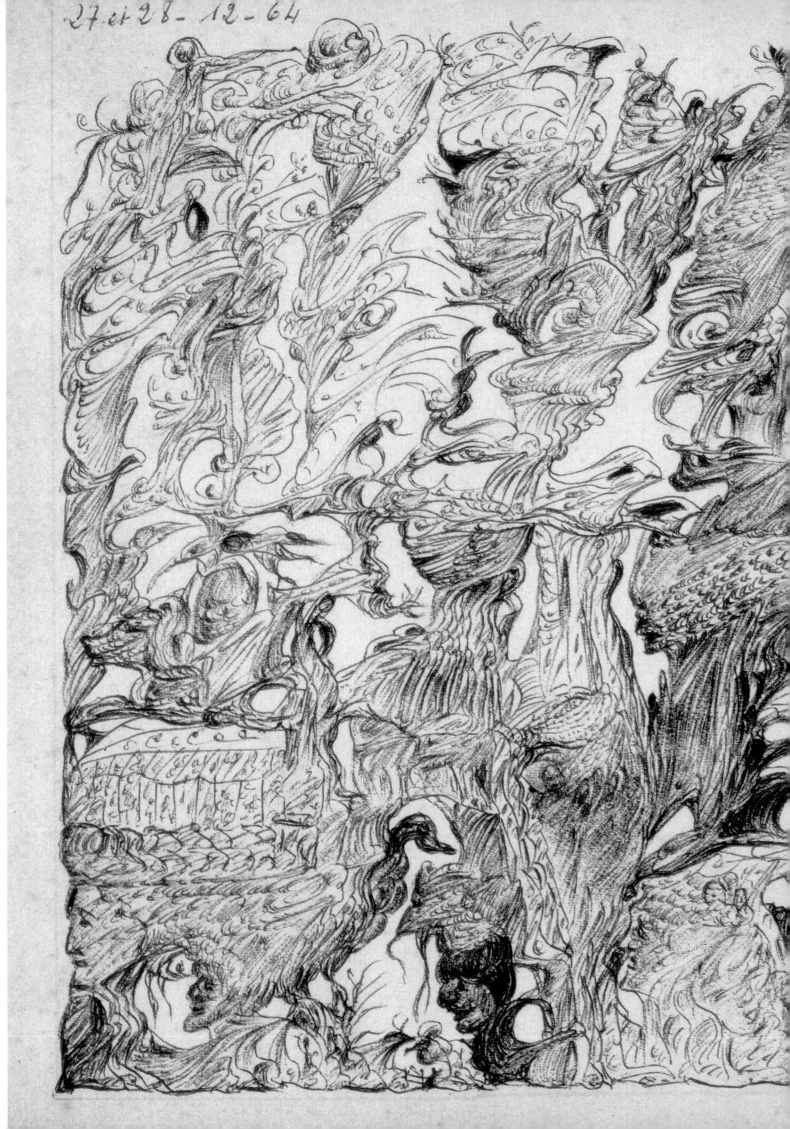
27 et 28 - 12 - 64

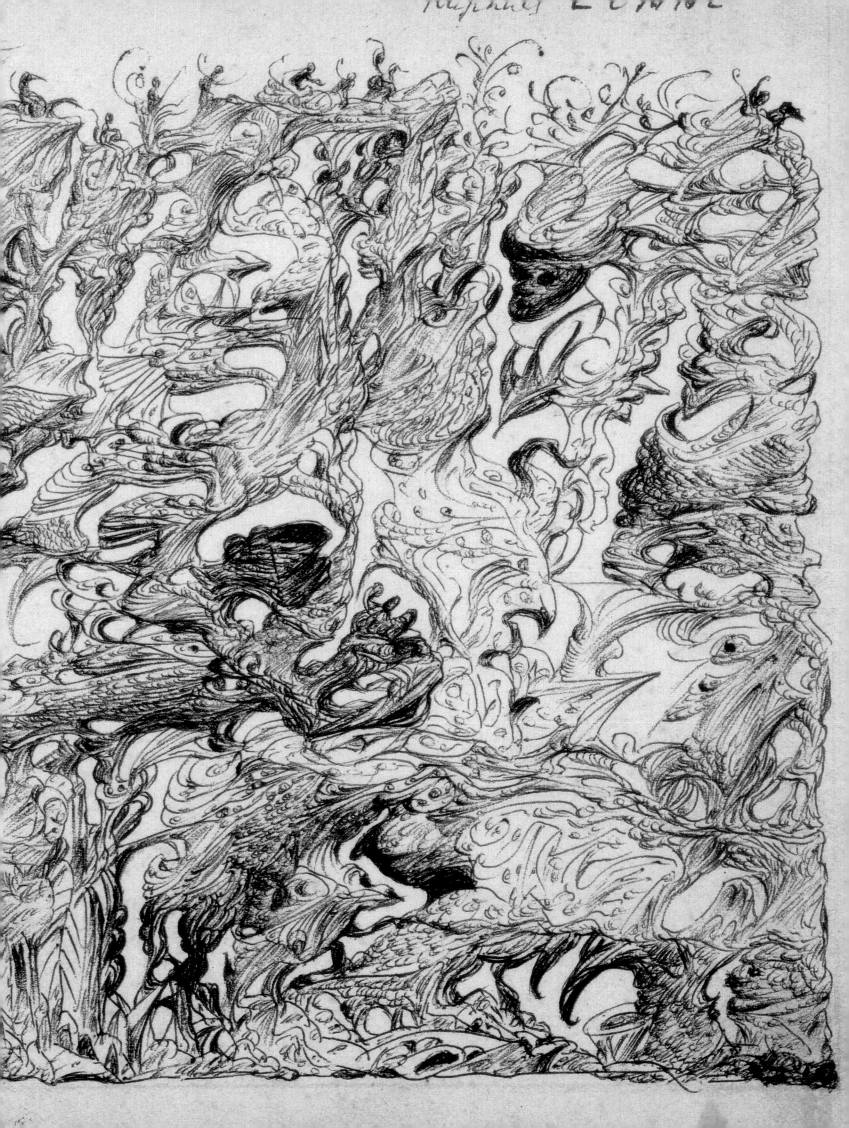

RAPHAËL LONNÉ

UNTITLED

27-28 December 1964, ink on paper,
17.8 × 25.2 cm (7 × 10 in).

*L'Aracine Collection, in deposit at the Musée
d'art moderne de la communauté urbaine de Lille,
Villeneuve-d'Ascq.*

RAPHAËL LONNÉ

UNTITLED

December 1951, ink on paper,
50 × 52 cm (20 × 21 in).

*L'Aracine Collection, in deposit at the Musée
d'art moderne de la communauté urbaine de Lille,
Villeneuve-d'Ascq.*

Art Brut and psychotic art both lead us back to fundamental philosophical concepts. Some artists are inspired by the fantastical or banal spiritual beliefs which figures like Jeanne Tripier, Laure Pigeon or Raphaël Lonné shared with Augustin Lesage, some construct all-encompassing systems which give their œuvre an inner rationale, as in the case of eminently creative artists like Adolf Wölfli or August Neter.

Little is known about Jeanne Tripier; she lived in a small flat in Montmartre, worked as a shop assistant in the Palais de la Nouveauté department store in Boulevard Barbès and later at the Grands Magasins Dufayel, and died at Maison-Blanche Hospital in 1944 at the age of seventy-five. She was a passionate believer in the occult and divination. Her intricately enmeshed embroideries using threads of various thicknesses, and her nebulous drawings – executed in a mixture of ink and water occasionally heightened with hair dye or nail varnish – were accompanied by *Messages* written in a small, fine hand. These usually ran to four pages, and mingled humdrum details of daily life with the sublime mysteries to which they were related. In a kind of theatre of the absurd, and in no apparent logical or chronological order, she introduces an endless stream of characters with fantastical names like Zed Zed Zibodandez, the Universal Dictator, Grand Master of the House and King of Ancient Miracles; Béglose, King of My Guy's Moon; Ox-Foot, Cistern and Morpheus of the Catacombs. Jeanne identified herself with Joan of Arc.

Her characters utter prophecies, launch wars and deploy supernatural means to free her. At times they communicate using a secret code or "spherical language" as she called it. Conveyed by official telepathy or divine carrier pigeons, the code consisted of a random association of consonants and vowels which would put to shame the most gifted composer of nonsense verse. As the following sample demonstrates, the perpetually changing consonances seem to defy interpretation:

> *"Xbdgxatuvwaytiviskitos, alsaqualificatifsogo bibiscoloyatel oniconilosis-kibitos; alleuiyabisloyosicos ürwisky yoyodelsicomatociscoyatismoyos; Jagocesisa Jgdcovryiscovoyaviscotismayomatissistos; vivivscos J. of Arc! pipisiscotoyomaticcosyovadismoloyadelmos is preparing great surprises for all the nomadic peoples…"*

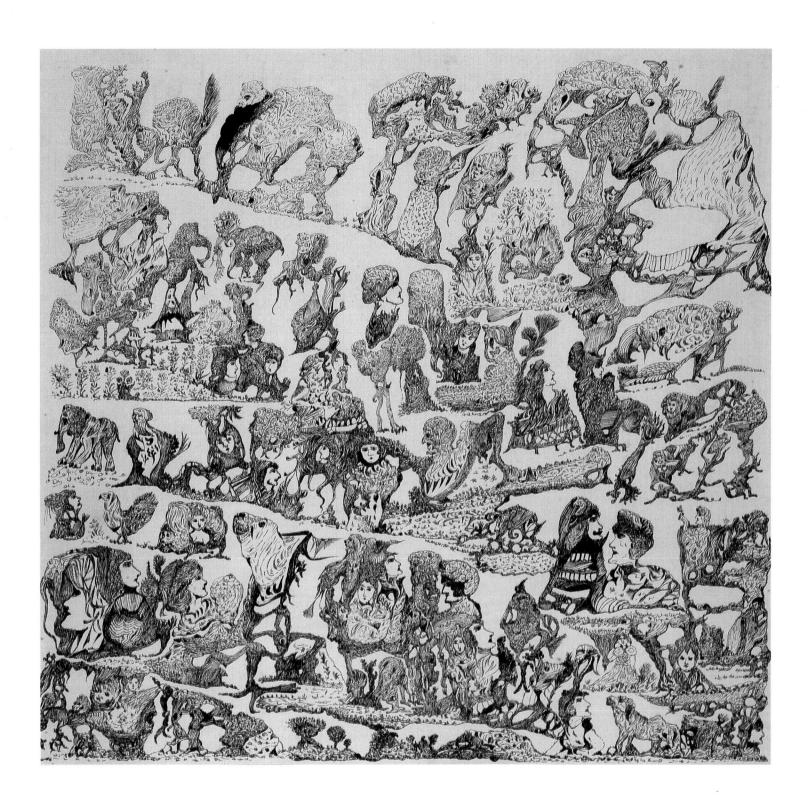

Raphaël Lonné
Untitled
9 March 1963, ink on paper,
11.5 × 24.5 cm (5 × 10 in).

*L'Aracine Collection, in deposit at the Musée
d'art moderne de la communauté urbaine de Lille,
Villeneuve-d'Ascq.*

Jeanne Tripier believed herself to be a key medium, a planetary dispenser of justice, and, in the presence of her doctors, expressed astonishment at having unintentionally produced such masterpieces.
Her certificate of commitment records chronic psychosis, psychic disturbance, logorrhoea and megalomania. As we know, however, not all Art Brut artists are psychotic nor have all been committed. Laure Pigeon, who died at Nogent-sur-Marne in 1965, was a sedate, dignified old lady, highly esteemed by her neighbours. At her home, following her death, five hundred carefully filed and dated blue or black ink drawings – extremely beautiful web or scroll-like compositions of a highly intellectual content – were discovered. She prized these for mediumistic rather than artistic reasons, and the convictions which motivated her are shared by many others who likewise believe that,

although disembodied, the dead retain their memories, feelings and consciousness, and that it is possible to communicate with them. Jean Dubuffet, who devoted a monograph to Laure, regarded her lengthy series of drawings as "an epic of death imbued with a poetic intensity seldom equalled even in the necrophilic fervour of ancient Egypt"[1]. Raphaël Lonné also experienced spiritualist visions. A country postman in the Landes department, he had never shown the slightest interest in the arts until, at the age of forty, he was introduced to spiritualism by a retired couple while making his round.

Guided by the spirits, he began producing automatic drawings for which he was completely unable to account. He was unwittingly engaging in

1. Jean Dubuffet, "Laure", in *Cahiers de l'art brut*, 6, Paris 1966, p. 72.

a form of psychic automatism similar to the experiments carried out by the Surrealists. Unconscious his drawings undoubtedly were, since he was not even aware of the existence of the unconscious.

Saint Adolf II, emperor of the gigantic

Adolf Wölfli – painter, writer, poet and musician – is deservedly one of the most famous psychotic artists. For over twenty years, besides prose writings, poems and musical scores which he alone could decipher, he produced a constant flow of imaginative coloured-pencil drawings accompanied by explanatory notes on the back. He also wrote his "autobiography" in a series of large notebooks which, when stacked up, formed a pile some six feet high.

Born on 29 February 1864, Wölfli lived with his parents for a few years in Bern. His father, a conscientious worker but inveterate drunkard, took to crime and was placed under house arrest in Schangnau, his native village in the Bernese Emmenthal region; there he died in a fit of *delirium tremens* in 1875. His mother, apparently a laundress, died shortly after. The orphaned Adolf, whose early childhood had been spent in what seemed to him a marvellous city, with its churches and brightly coloured houses, now found himself an outcast in a rural world the harshness of which it is nowadays difficult to imagine. Treated worse than a beast, beaten by his employers, he worked in local farms as a cowherd or general dogsbody. At the age of eighteen, by then a farmhand, he fell passionately in love with the daughter of a neighbouring farmer. In those days, the relationship was socially unthinkable and when the young woman's parents found out about it, they immediately put an end to the romance. Wölfli was utterly devastated. In his autobiography, he recalled the tragic experience: "I became sad, melancholic, I didn't know what to do. That very night, hopelessly lovesick, I rolled in the snow, in tears at the happiness that had been brutally snatched away from me".

The turbulent years which followed, marked by alternating spells of work, idleness, and disorderly behaviour, culminated in Wölfli's imprisonment on charges of indecency and the attempted rape of a fourteen-year-old adolescent girl. Diagnosed as mentally unsound, he was subsequently interned in Waldau Psychiatric Hospital near Bern. His confinement got off to a bad start. Because of his wilful brutality and coarseness, and his tendency to assault fellow patients both verbally and physically on the slightest pretext, he was locked up in solitary confinement. There too he flew into violent fits of rage, smashing the chairs and table and using the legs as battering rams to break down the cell door. He also experienced hallucinations, claimed to hear voices and spent long hours in fits of weeping. Otherwise, during the long spells when he was calm, he was put to work chopping firewood or picking lime blossom in the hospital garden – a job which didn't last long, as Wölfli reckoned it was easier to lop off the branches and gather the blossom on the ground. Meanwhile, he began the artistic activities which wholly absorbed him during the last twenty years of his life.

ADOLF WÖLFLI

standing beside the stack of his autobiographical notebooks.

Wölfli's perception of the world – or worlds – was hyperbolic, as his prose texts make clear. Everything is described in gigantic terms. He claims that during his travels he had seen cliffs over 350 leagues high, 25 million leagues long and 900,000 leagues wide, as well as the largest cave in the universe measuring 24 million leagues long, 500,000 leagues wide and 250,000 leagues high. He also speaks of trees with trunks 12,000 leagues in diameter and foliage full of several trillions of fruits so massive that on them stood "countless highly respectable plateaux and terraces, giant cellars, fortifications, giant valleys and canyons, as well as countless giant towns". The towns, no doubt, were

an echo of Wölfli's impressions of Bern, where he spent the first eight years of his life, before moving to a lonely and unhappy life in the little village of Schangnau. According to Wölfli's physician, Dr Morgenthaler, who wrote an invaluable study[1] of his patient, the buildings in the trees derived from his childhood vision of the Federal Palace, the seat of government of the Swiss Republic, which is built on a hillside terrace above a small wood. Wölfli may have glimpsed it from below, from the banks of the Aar, the river which winds round the federal capital. Other recurring features in his writings include fountains the size of seas spouting columns of water millions of leagues high, the saints, "God the Fader", and a pantheon of other gods and goddesses whom Wölfli alternately obeys or rules over. His universe also teems with gigantic animals like Giant Transport Bird, capable of carrying a load weighing several million tons, and huge snakes. Wölfli describes one occasion on which he and his travelling companions found their path blocked by the fourteen-league long, grey and white-spotted Giant Snow Serpent. It took them several hours to skirt round the massive body; when they finally reached the head, they struck up conversation with the monster before shooting it and selling off millions of quintals of flesh from its carcass. The figures he juggles with are equally colossal, dealing only in quadrillions and quadrilliards and, when these are not sufficient for his calculations, inventing new numbers such as the Reganive, the Surive, the Terative, the Unitive and the Oberon, each a thousand times greater than the preceding one,

1. Dr Walter Morgenthaler, *Madness and Art: The life and Works of Adolf Wölfli*, Lincoln, Nebraska, 1992.

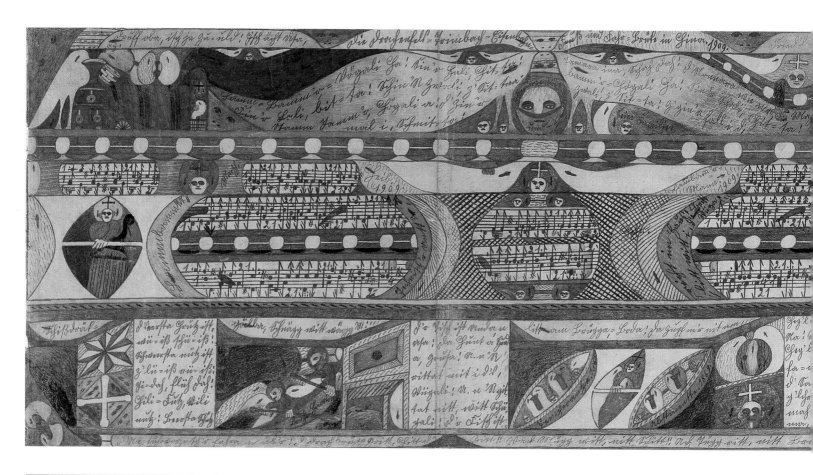

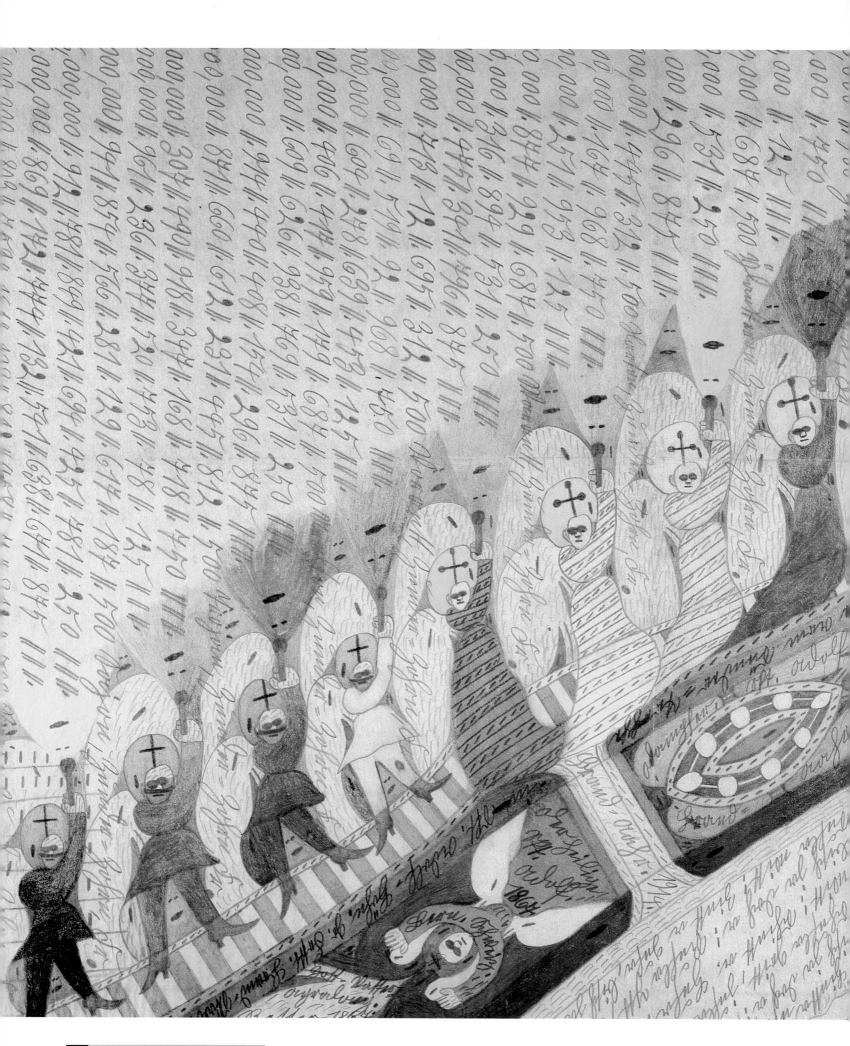

until reaching the ultimate number which he calls "Wrath", "Wraath" or "Wranth".

Although, for obvious reasons, it was impossible to encompass such vastness in his graphic work, it nevertheless forms a continuum within which each drawing provides, so to speak, a compact nucleus of visual energy. Nor does Wölfli employ perspective which, as we all know, can be used to create the visual illusion of width, establish spatial hierarchy and represent foreground, middle ground and distant scenes. This is not to imply that his drawings lack organization: they frequently include converging diagonals which run from the edge of the composition to the centre, or a succession of gradually expanding rings or webs. He frequently uses both procedures in the same composition, creating an effect of structural tension. Into this basic structural grid

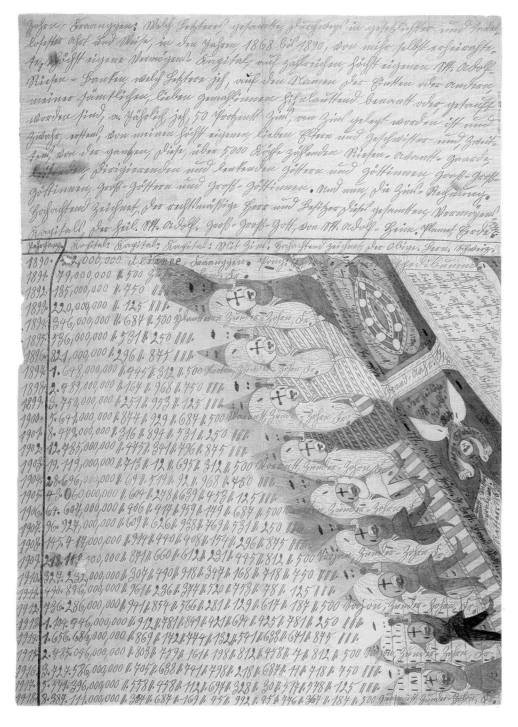

ADOLF WÖLFLI
RÄBLOCH
SKT. ADOLF-RING
RÄBLOCH
AT ST ADOLF-RING
1930, coloured
pencils on paper,
19.8 × 32.2 cm
(8 × 13 in).
Adolf Wölfli Foundation,
Fine Arts Museum, Bern.

ADOLF WÖLFLI
GROSS-GROSS-GÖTTINN REGENTTIA
GREAT GREAT GODDESS REGENTTIA
1915, coloured pencils on drawing paper,
27.6 × 21.4 cm (11 × 9 in).
Adolf Wölfli Foundation, Fine Arts Museum, Bern.

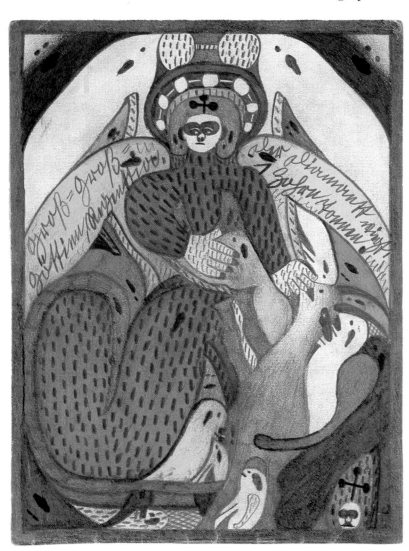

ADOLF WÖLFLI
YSAAR-THURM. SKT. ADOLF, ARESTANTT
YSAAR TOWER. ST ADOLF, PRISONER
1916, coloured pencils on drawing paper,
21.4 × 28.5 cm (9 × 12 in).
Adolf Wölfli Foundation, Fine Arts Museum, Bern.

he introduces an entire universe composed of figures enormous or minuscule, faces seen in close-up, towers, monuments, cities, palaces and, naturally, winged angels and saints – particularly St Adolf II, the incarnation of the artist himself. Indeed, Wölfli's works frequently display a pronounced mystical tendency, although God and the Devil are rarely present. However, unlike prose, drawing involves spatial representation and, faced with this unavoidable factor, the artist is forced to compress his universe while attempting to maintain its radiance. In his graphic work, as in his writings, Wölfli's favourite animal is the snake, followed by fish. He sometimes includes a cat, a beast of prey, a horse, a cow or a chamois, while the dozens of small birds which appear in many of his works are used to fill in empty space. Along with flowers and foliage, the dominant form of plant life is oval-shaped trees. The heavenly bodies – principally the stars, followed by the sun, moon and comets – are also much favoured. On various occasions he incorporates letters, numbers and musical notation which he also uses to fill in empty spaces or superimposes on the drawing. But Wölfli was by no means impervious to the modern world. His drawings include pipes, shoes, umbrellas, kitchen utensils, hotels, railway lines, factories, steamships, and bridges. Watches and clocks frequently recur; these probably echo childhood recollections of the wonderful Zytglocke in the Theaterplatz in Bern.

Modernism is expressed in many of his works, including *Grand Hotel Z* in which a colossal Z – a letter Wölfli adored – cleaves through the entire centre of the composition like a lightning bolt, or *Ship Propellors and Dynamo*, which is accompanied on the back by a scientific commentary worthy of Leonardo da Vinci. "Explanation: the present portrait (engraving) represents: on the left, the steamship propellor invented by myself in the year 1876 in the Blue Sea at Warrantt, Wrath: that is to say in the port of Giant Wrath City: and on the right, the dynamo, invented by myself the same year in Winterthur, Switzerland. The new rotary press used in printing works is another of my numerous former inventions; together with the Telephone, the Electric Light, Electric Clocks, the Rubber-Tyred Wheel, Lighthouses, the Submarine, the Torpedo Boat, the Destroyer, the Salt Plow, the Californian Harvester, the Funicular, the Cable-Car, Spiral Railways, the St Adolf Brake, Smokeless Gunpowder, the St Adolf Rifle, ditto the whippersnapper, the musket, the Flobert carbine, etzettera. Portrait executed for the Family of Doctor M., Waldau, Bern, by St Adolf II."

Many other sheets are covered with numbers and adorned with figurines or photos and illustrations cut out from contemporary newspapers.

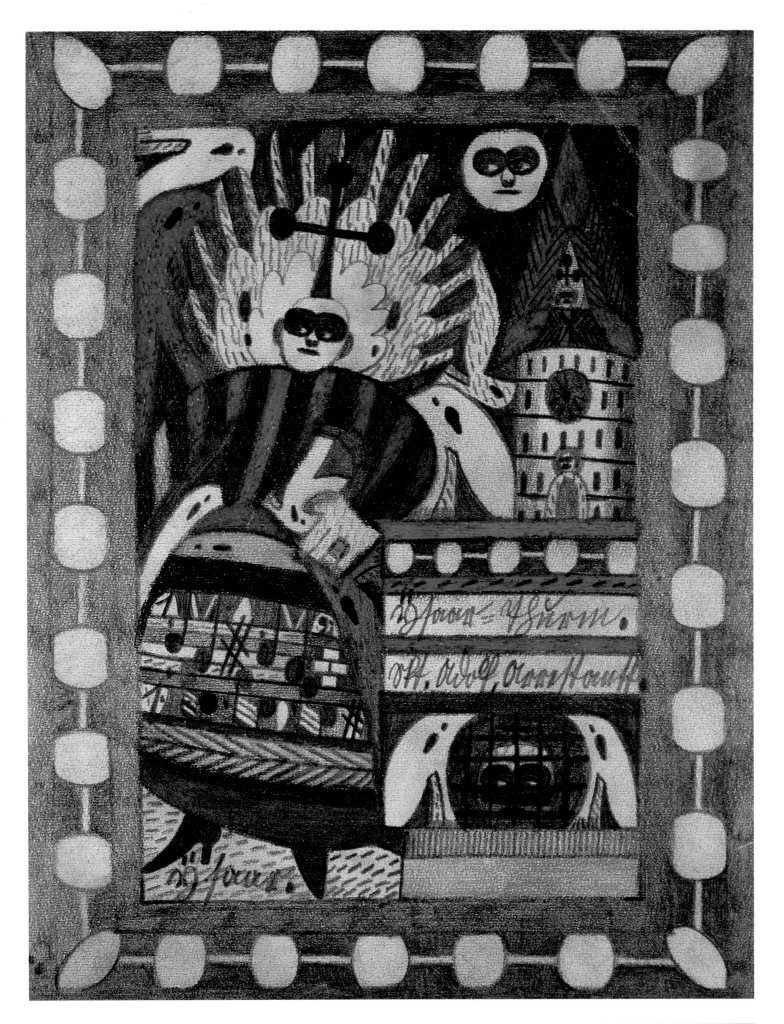

Pages 88 and 89

ADOLF WÖLFLI

SANTTA-MARIA-BURG-RIESEN-TRAUBE: UNITIF ZOHRN TONNEN SCHWER

SANTTA-MARIA GIANT GRAPE CASTLE: HEAVY UNITIVE WRATH OF TUNS

Detail. 1915, coloured pencils on paper, 72.8 × 105 cm (29 × 42 in).

Adolf Wölfli Foundation, Fine Arts Museum, Bern.

ADOLF WÖLFLI

FELSENAU, BERN

1907, coloured pencils on paper, 74.3 × 99.3 cm (30 × 40 in).

Adolf Wölfli Foundation, Fine Arts Museum, Bern.

Some drawings portray a solemn, celestial, central figure in a hieratic pose, usually wearing a crown and making a sweeping gesture. In one of these, *Great Great Goddess Regenttia*, the figure is apparently welcoming the beasts from earthly paradise who seek her protection. Here, the element of gigantic disproportion has been replaced by a sense of tranquility and a touching inventiveness, as if the work has come down across the centuries from some mysterious mediaeval bestiary. Often, he frames his drawings with rings of interlinking ovals which he christened "little bells", filled with little hatched sticks which he called "slugs". Wölfli's art involves a pictorial material which, although evolving through successive periods, constantly re-emerges in new combinations to form an immediately recognizable style, showing that he left nothing to chance.

At the same time, his themes and ideas are pervaded by an underlying symbolism. Each panel of *The Great Screen*, one of his largest works, illustrates the theme of original sin; the Fall is symbolized by four waterfalls, the artist having associated the German words *Sündenfall* ("original sin") and *Wasserfall* ("waterfall"). However, apart from the snake, whose sexual, biblical and cosmic symbolism is to be interpreted with circumspection, the crosses, circles, spirals and mandalas which appear in his drawings are all archetypal references springing from the collective unconscious. Asked about his art, Wölfli used to reply that it must derive from some higher authority, since it was quite impossible that he himself could have imagined the marvellous worlds he created. Like the majority of Art Brut or psychotic artists, he believed that his hand was guided by fate.

Because he spent some thirty years in an asylum, there is a tendency to portray Wölfli as the victim of psychiatric repression. At the outset, he did indeed find confinement intolerable, as testified by his fearsome fits of rage and the ensuing violence and destruction. But he also had a sense of humour which belies the image of a raving madman. This can be seen in his love of spoonerisms, at which he excelled – one of his proudest examples was: *Mit freundlichem Gruss, Bern, Schweiz* ("With friendly greetings, Bern, Switzerland"), which he turned into *Mit gründlichem Fuss, Schwern, Beiz* ("With a sturdy foot, Schwern, Beizerland")– and in some of the explanatory notes he wrote on the back of his drawings, solemnly noting, for instance, that his *Fish Platter*, the largest in the world, weighed 350 quintals. As the years went by, and he was absorbed ever more relentlessly and passionately by his creative work, he might well have been considered cured. A few years before his death, Dr Morgenthaler even insiduously suggested that he regain his freedom. Wölfli retorted that, although it might not seem to be the case, he was still actually insane and consequently had to remain interned in the hospital. His cell had become his studio; he was an acknowledged artist whose every need was catered for by his benefactor, the State. Why give all this up?

The witch who created the world

Born in 1868 in Ravensburg in Baden-Württemberg, August Neter was a capable, ambitious man who had served his apprenticeship as a mechanic then worked in Switzerland, France and the United States before returning to Germany, where he set up his own firm in 1897. For ten years his business was relatively prosperous; all that is recorded of his foreign travels is that he contracted syphilis. Brutality was apparently a necessary ingredient in his sexual relationships, and he frequented prostitutes in order to spare his beloved but frail wife. In 1907, he suddenly lost all appetite for work. Deeply depressed, he attempted suicide and was committed. The doctors diagnosed acute schizophrenia accompanied by hallucinations, in particular a celestial "apparition" which Neter claimed to have witnessed, one Monday at noon, in the capital of a principality, while in the vicinity of a barracks.

Neter was to remain permanently haunted by this apparition. At various points in his life, he gave an unvarying account of having seen, close by in the clouds, a white patch which then moved away, hovering in the sky like a plate or stage or screen. In the space of a half-hour, some ten thousand visions flashed across the screen at lightning speed. God the Father appeared in person, accompanied by the "witch who created the world", and their presence was interspersed by worldly scenes depicting wars, continents, monuments, magnificent supernatural castles at least sixty feet high and living, moving people. The entire experience was unsettling and left Neter deeply perturbed. He believed that they were visions of the impending Last Judgement, which God had revealed to him in order that he might save mankind. Neter simultaneously claimed to be Christ, a prince, a king and an emperor; he doggedly set out to prove that his grandmother was the

illegitimate child of Napoleon I and Isabelle of Parma and adopted the title of Août IV-Napoleon (*Août* being the French translation of his first name, August). He laid claim to the throne of various countries and believed that the First World War had been launched in order to free him from his humiliating internment. In his numerous writings, he elaborated the concept of a universal chronometer with anti-clockwise turning hands and a mechanism which he alone, the "Universal university mechanic", understood. He also struck up imaginary erotic relationships and used to treat the women around him, including the nuns who were his nurses, as his wives in disguise, showing them particular respect. Neter was a stocky, robust man, with swift, precise gestures; he had a sharp eye and spoke rapidly as if to quash any contradiction at the outset. His behaviour was perfectly normal when engaged in everyday practical activities and he was responsible for all

sorts of minor inventions and technical improvements at the asylum. His drawings and watercolours, which he began producing in 1911, are characterized by extreme precision. One of them, depicting a flower vase, displays a confidently tasteful exploration of chromatic harmony and might well have been painted by a gifted amateur. The lengthy series entitled *The Metamorphoses of the Skirt* is disturbing as much for its skilful graphic technique as for the veiled eroticism it exudes. The slowly unfolding sequence of inclined figures gradually reveals secret openings in the garment into which a suitor might slip his hand. Some drawings include a fashionable basque, a sloping figure eight, a snake or, finally, a shell resembling an upturned umbrella which envelops the hem of the skirt. This latter feature appears in the final drawing in the series, portraying a witch, who symbolizes the magic origin of creation, together with her emissaries, an eagle and a

August Neter |
Axis of the World and Hare
Before 1919, pencil
and watercolour on cardboard,
20.5 × 26.1 cm (8 × 10 in).
Prinzhorn Collection, Heidelberg University.

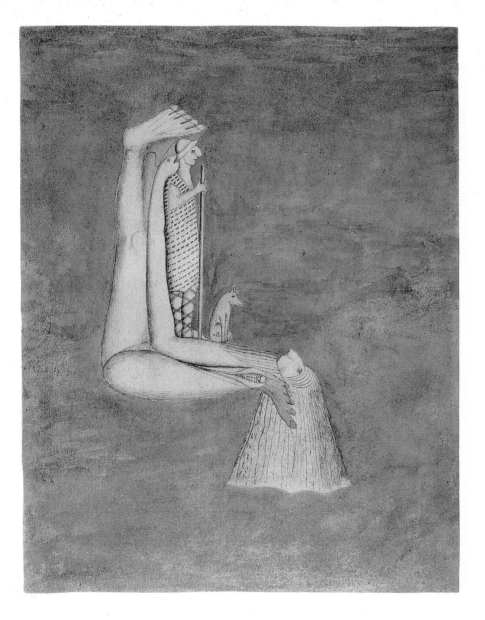

August Neter
Miraculous Shepherd
Before 1919, lead pencil,
24.5 × 19.5 cm (10 × 8 in).
Prinzhorn Collection, Heidelberg University.

August Neter
Miraculous Shepherd
Detail.

crocodile, as well as a cornucopia. Neter himself said of the witch: "The face appeared to me like a death's head, yet it was alive. The sutures on the skull formed a nightcap...The eye resembled a glass eye and sparkled; it was detached from its orbit..." Although this final drawing is, strangely enough, rather clumsily executed, it foreshadows two water-colours which unravel the creation myth contained in his haunting vision.

In these two watercolours, which function rather like Arcimboldo's illusionist paintings, only a close-up view of the head is retained. In the first, the nightcap is bordered by a row of tiny trees running along a path. The path circumscribes the witch's face which has become a lawn, separated by a wooden fence from the neck, itself another stretch of lawn. In the second watercolour, the planted area is more extensive. Trees delimit the base of the neck, the chin and the lower lip, while the cheek, dotted with acquatic flowers between which swim shoals of tiny fish, seems to be halfway between water and land, contrasting with the smooth, bony skull which is partially covered by vegetation. Both heads are surrounded by buildings, including a church, town hall, farms, houses with gardens, and a hunting lodge on the edge of a small

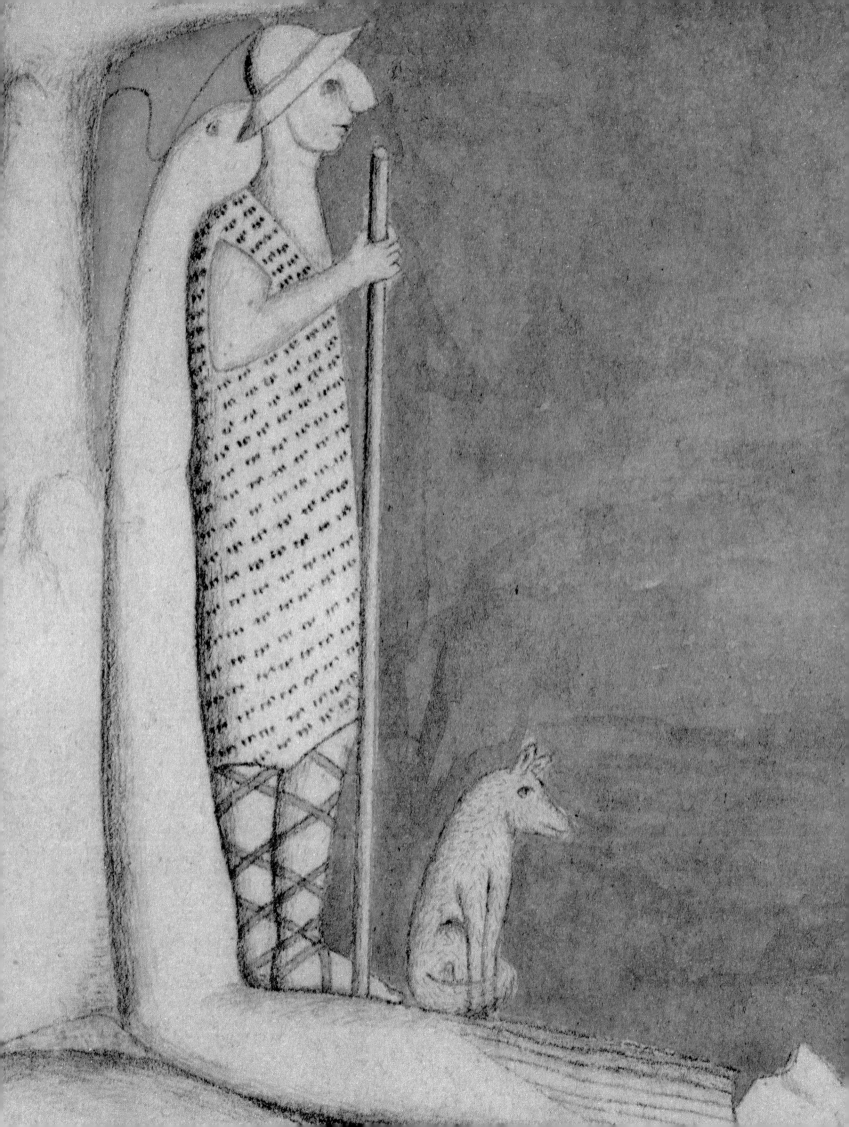

August Neter

Schiessbock

1915, coloured pencils

on drawing paper,

24.9 × 39.8 cm (10 × 16 in).

Prinzhorn Collection, Heidelberg University.

wood. The witch's detached eye has become a cosmic glass ball which, in the first watercolour, resembles the full moon and, in the second, a star ringed by a belt of satellites. In each case, the meaning is obvious: the artist has turned the head into an integral part of both landscape and town. The witch is the geographical and cosmogonic symbol of the Mother Goddess, and it is because we are blind to the world that she remains invisible.

Neter's elemental vision gave rise to two further astonishing works, *Axis of the World and Hare*, and *Miraculous Shepherd*, the meaning of which he explained in detail. Concerning *Axis of the World and Hare*, he wrote: "A cloud lowered, revealing the axis of the world. Then it was transformed into a plank… and this plank into a tree with seven branches, the seven-branched candelabra. Feet were added to the tree, goat hooves which changed into the hooves of a horse… the devil… My family tree appeared on the tree. The hands of God protected the tree, marvellous, extremely soft, feminine hands. The circles represent the annual cycles… But the tree wasn't to everyone's liking, and the pigs attacked it… setting themselves above God… scorning Him. The overall impression was of a live animal, a rodent!… Leaves grew on the tree… and the leaves turned golden. Then the storm gathered and blew away the leaves. The tree was spun round in the storm like a roller. The head of Jupiter, god of war, replaced the tree… Suddenly, a hare sprang out of the cloud and leapt onto the roller. It started to run along the

roller and the roller began to turn, that is to say the thing revolved around my family tree... The hare was then transformed into a zebra, then a glass donkey. The donkey had a towel tied round its neck and was shaved. Throughout the entire vision, a chalice appeared on the side".

Concerning *Miraculous Shepherd*, he went on: "At first there was a glistening, green and blue cobra, rearing its head. Then the foot was added. Then another foot. It was made from a turnip. On this second foot appeared the head of my father-in-law from M.: the marvel of the world. The forehead furrowed and became the seasons. Then it became a tree. The bark of the tree was split at the front and the crack formed the mouth of the face. The branches of the tree formed the hair. A female sex then emerged between the leg and the foot. This vulva shattered the man's foot, that is to say sin is transmitted by woman, bringing about the fall of man... One foot was raised against the sky, signifying the Fall to Hell. Then a Jew, a shepherd clad in a ewe-skin, appeared. The skin was covered in wool, nothing but Ws, auguring many evils... These Ws were transformed into wolves. The wolves were ferocious and were transformed into ewes: they became wolves in ewes' clothing. And then the ewes ran round the shepherd. I'm the shepherd... God himself!... The wolves are my enemies, the Germans..."

Hans Prinzhorn, who studied Neter's case, makes no attempt to interpret these two watercolours; he merely refers to their demented logic. He does, however, offer a lengthy interpretation for another drawing, entitled *Antichrist*, which depicts a colossal phallic figure, standing on a human-shaped cloud with arms outstretched, like a pope blessing an assembly of the faithful. But it is the two watercolours which show real artistic merit.

As may well be imagined, neither of them corresponds fully to the accounts given by Neter himself but only to one particular phase – a "freeze-frame image", so to speak. The first, *Axis of the World and Hare*, depicts the point at which the hare has just sprung from the cloud and leapt on the tree trunk lying on the ground; the trunk extends into two human legs culminating in horses' hooves, while inside can be seen an enormous leaf; the cloud itself and the chalice, symbols of Neter's sufferings, float high in the sky. In the second work, *Miraculous Shepherd*, the shepherd can be seen, clad in a ewe-skin and accompanied by a wolf, as he appears standing on a cobra at the juncture formed by the two legs springing from the tree. The tree, meanwhile, has sprouted a face with cascading female hair. What is striking about both works, apart from their surrealistic inspiration, is their absolute precision. As part of his mechanic's training, Neter had apparently studied industrial drawing, and the first watercolour features concentric circles similar to the ones normally used in those days to represent electro-magnetic fields. This precise draughtsmanship recurs in his diagrams of imaginary machines.

Neter died in 1933 at the Rottweil asylum near Rottermünster in Württemberg, thus escaping the fate – euthanasia, murder or deportation – which the Nazis reserved for the mentally ill. Comparing him to the Surrealists, and notably to Max Ernst, the psychiatrist Henri Ey later wrote: "I have never come across anything more fantastic than this work".[1]

1. Henri Ey, *La psychiatrie devant le surréalisme*, Paris, 1948, p. 27.

3. Eros in tears

Pages 104 and 105

E. Paul Kunze
Untitled
1913, pencil, ink and gouache on paper,
16.2 × 21 cm (7 × 8 in).
Prinzhorn Collection, Heidelberg University.

Heinrich Welz
Geometric Portrait
N.d., pencil on paper,
22.6 × 28.5 cm (9 × 11 in).
Prinzhorn Collection, Heidelberg University.

Heinrich Welz
"Willology" in the Sun
N.d., pencil on paper,
20.4 × 16.3 cm (8 × 7 in).
Prinzhorn Collection, Heidelberg University.

As in the case of Adolf Wölfli, disappointed love is often the critical trauma at which psychosis sets in. Because such an experience can prove damaging or even destructive to sexuality – identified by Freud as the basic drive in life – it is hardly surprising that it has been the root cause of insanity for many psychotic artists, in particular Heinrich Welz, another patient studied by Prinzhorn.

Welz lived in a private world of his own over which he exercised imaginary control. He would, for instance, regularly stand for hours in front of an open window with a spoon in his hand, gazing at the sky in order, so he claimed, to alter the position of the stars by sheer will-power. Born into an aristocratic family in 1883, he had become a lawyer before being interned as a schizophrenic following an abortive marriage project. Although the latter experience in itself does not explain his madness, its importance is revealed by his habit of turning somersaults, which he did at regular intervals, ostensibly to correct an imbalance in his physical make-up; the somersaults were made in the direction of Schweinfurt, the home of his beloved. He used also to spin his body, attempting to take off vertically in defiance of the laws of gravity. In Welz's strangest drawing, entitled *A Man's Thought Spheres Projected onto the Outside World*, the artist's own head, seemingly sculpted in stone, is shown bearing various elements including a castle, a lion and a group of women, as if to imply that he is the pillar of the universe. A larger work entitled *Geometric Portrait*, probably a self-portrait, depicts a male head in profile, encased in a mesh of radiating lines. Arguably, this could be taken to represent a kind of telepathic force field which, supplementing Welz's regenerative somersaults, was intended to intercept and tap the heart and mind of the loved one from whom he was separated.

He also drew pages full of little sketches which were meant to symbolize his ideas in graphic form. Significantly, among the recurring features

are the head of Venus, the word *Liebe* ("love") written in outsize letters, and, tucked in between enigmatic scrolls, interlacing and polyhedral motifs, a huge letter L (standing for *leben*, "to live").

The ancient natural world of times gone by

A traumatized libido seems to have had even more dramatic consequences in the case of Aloïse, whose work spanned a period of forty-five years and who, along with Wölfli, was the most prolific psychotic artist. Aloïse Corbaz, born on 28 June 1886 in Lausanne, had a fine voice and loved opera. She took singing lessons and dreamt of becoming a professional singer, but was forced to forsake her ambitions following a frustrated love affair. An elegant, attractive, twenty-five year old, she had a short-lived, passionate relationship with a young Frenchman who had come to Lausanne to study. Her elder sister Marguerite, who had been head of the family since the death of their mother, brutally nipped the romance in the bud. Aloïse shortly afterwards left for Germany where, having worked as a governess for a Leipzig family, she was taken on in a similar capacity by the chaplain to Kaiser Wilhelm II. Living in the luxurious atmosphere of the imperial court at Potsdam, occasionally singing for the Kaiser in his private chapel, she became hopelessly infatuated with him. In 1914, on the outbreak of war, she returned to Lausanne.

She had no sooner arrived home than her family grew concerned by her strange behaviour. She would lock herself away and write religious compositions. She believed that criminals and murderers sacrificed themselves for the good of mankind and regarded herself as an expiatory victim. She was convinced she was pregnant with Christ and would cry out in the street that she was being murdered, or that her fiancé and children were being abducted. On 21 February 1918, she was admitted to Cery University Psychiatric Hospital near Lausanne, diagnosed as suffering from *dementia praecox*, the term then used for schizophrenia. Two years later, her deteriorating condition offered no prospect of cure, and she was transferred to La Rosière asylum. A former thermal establishment converted into a clinic for the chronically insane, it stood in Gimel at the foot of the Jura mountains, in the canton of Vaud. Although initially rebellious – she would suddenly explode from a state of passive, uncommunicative apathy into violence, physically attacking other patients, taking up lewd attitudes and baring her breasts – she finally came to terms with her internment and started to paint, an activity she was to pursue until her death. At La Rosière, where she was employed mending and ironing bedlinen, she began hiding away in the toilets to draw hasty sketches on scraps of paper which she would carefully uncrumple, smooth out, and patch or sew into makeshift sheets. Later, when her activity came to light, she was given proper sketch books and coloured pencils and could spend her afternoons drawing on the very table on which she did the morning's ironing. Dr Jacqueline Porret-Forel, the physician who attended her and in whom she confided, has described in a

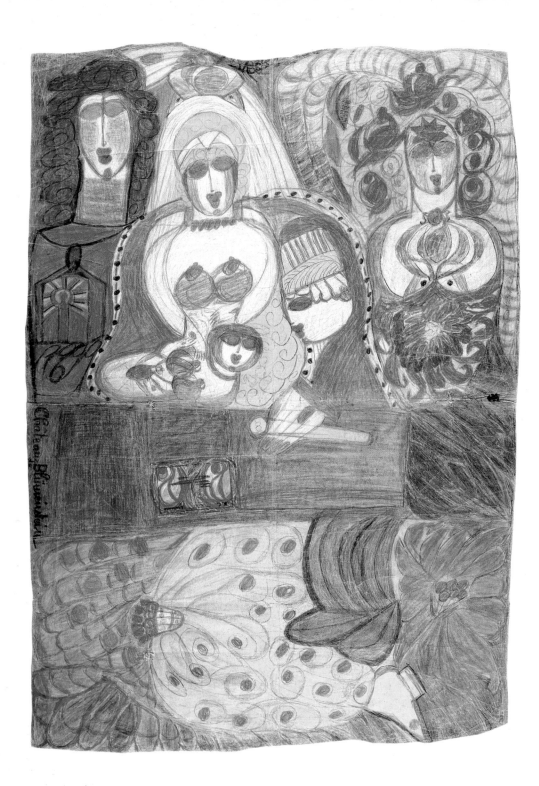

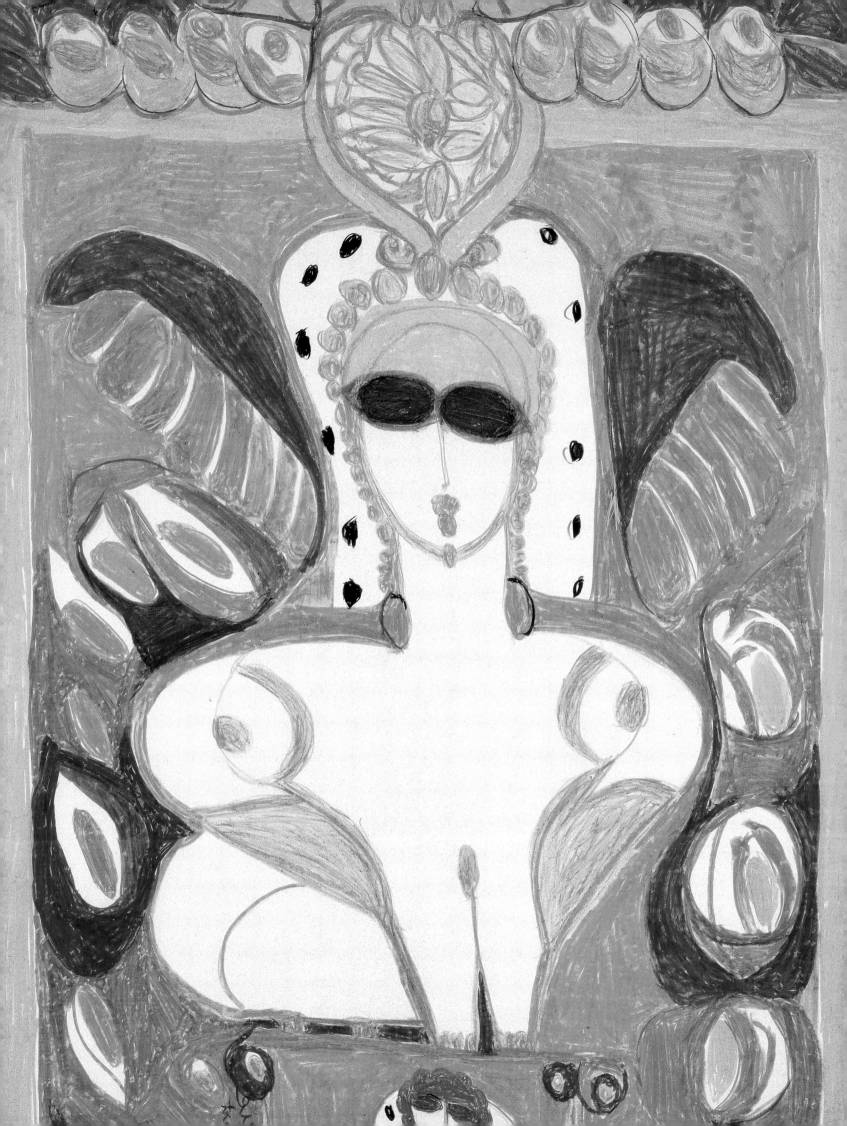

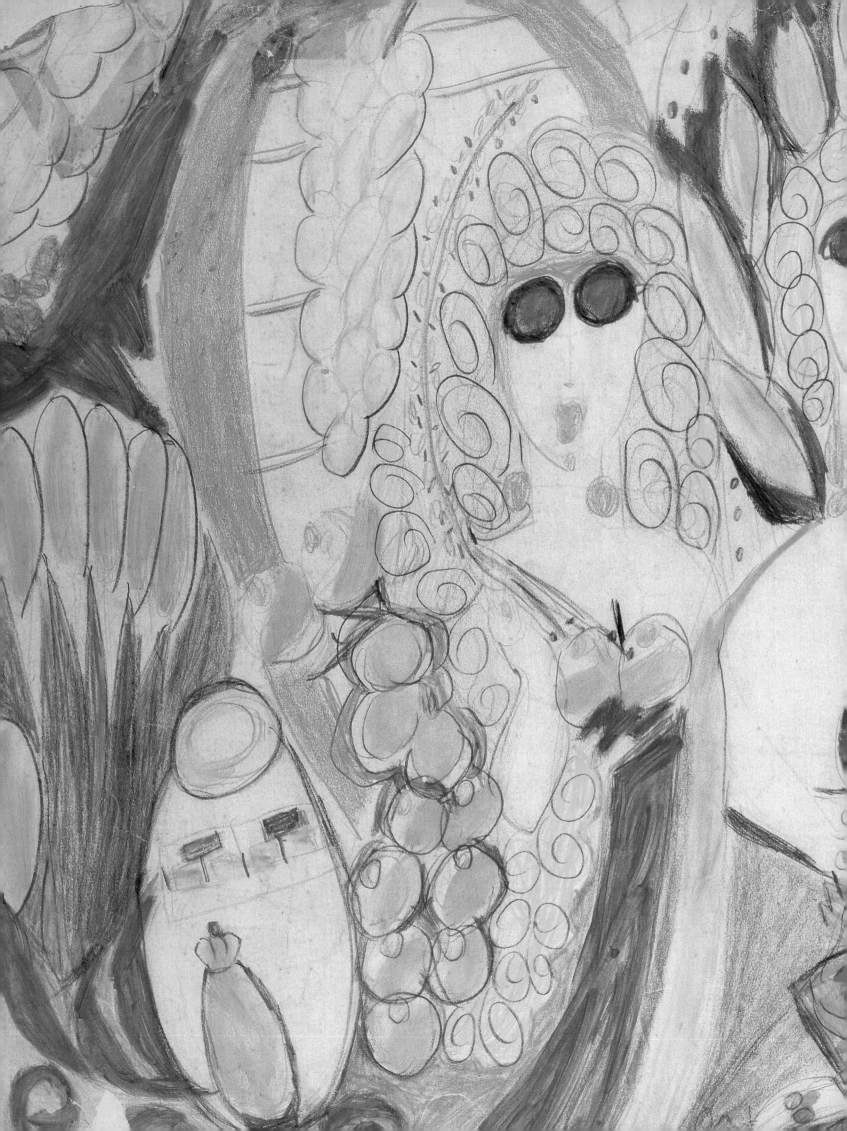

remarkable book[1] how Aloïse went about her artistic activity. She would work her pencils down to the stub and, when they were too short, break off the encasing wood, grind the lead into a coloured powder and spread it with her fingertips. She also used essence from petals and leaves found in the asylum gardens to obtain transparent effects. Occasionally, she worked with toothpaste or, in the latter part of her life, with soft chalks provided by Mme Porret-Forel. She experimented with gouache but abandoned the technique after a few attempts, finding it too opaque.

Her assessment of other people's painting revealed the eye of a connoisseur. Dubuffet's figures she described as "puppets"; fascinated by a cockerel in a Picasso reproduction she had been shown, she exclaimed, "Extraordinary – no one would dare do it that way", adding, "This is Cery painting", referring to the psychiatric hospital where she had first been interned.

Aloïse usually drew on both sides of the sheet of paper, constantly muttering unintelligibly through clenched teeth. Apart from a few portraits of crowned kings and queens, the opera and the theatre form the almost invariable theme – the bygone world of "the ancient natural world" she had frequented until, at the age of twenty-five, she perished existentially. Eroticism is ever present, expressed in her female figures – often naked – portrayed in suggestive poses or wearing dresses with plunging necklines. Although she used blue for the eyes of her figures – "in the theatre, eyes are always blue" – and green, brown and yellow for "the royal earth tossed into space", her favourite colour was red, the colour of love and power. Beginning a drawing, she would mutter to herself: "Red, I must obey", or "Red, you know, is beautiful for schizophrenics".[2] Her amorous royal damsels wear scarlet capes, their galants sport madder red, ermine-lined coats and even the pope swops his white robes for sumptuous purple. Above all, red is the colour used in a motif which is her unique pictorial hallmark: the winged phalluses which she depicts penetrating and flying off with vulvae, and which feature prominently in her largest work, *Cloisonné de théâtre (Compartmentalized Theatre)*[3].

The winged phallus is of course a recurrent theme in graffiti art, notably in the works which used to adorn the walls of Stains Fort to the north of Paris. Abandoned after the First World War, the fort lay derelict for almost fifty years before being demolished. During that time, it became the favourite haunt for graffitti artists from the Paris region, who would come to exercise their talents in the semidarkness of its rooms. In what was dubbed "the Sistine Chapel of graffitti", droves of large and small winged phalluses could be seen fluttering back and forth beneath female thighs. Inside some of the gaping vulvae appeared tiny children, indicating that the drawings were intended as fertility symbols rather than mere pornography. The winged phallus also commonly occurred in seventeenth-century erotic literature. In the

1. Jacqueline Porret-Forel, *Aloïse et le théâtre de l'univers*, Skira, Geneva, 1993.
2. *Ibid.*, p. 132.
3. Permission to illustrate this motif was not granted. See J. Porret-Forel's book at pages 132-133.

latter, one notorious character was Parapilla, a licentious monk whom God condemned to cultivate "the very unculinary stem", and who is portrayed in a charming illustration, basket in hand, picking neatly aligned rows of the aforesaid vegetable which sprout like carrots in a kitchen-garden plot. Aloïse brilliantly reinterprets the theme – or archetype. She portrays the sexual act in aerial progress, no doubt in reference to the passion she had experienced as a young woman and been so cruelly deprived of thereafter.

Although her themes were apparently inspired by hallucination – she used to say: "I copy what appears in my looking glass" – she also derived her raw material from newspaper advertisements and photos of festive events, notably the pageants at the Montreux *Fête des narcisses*, the Geneva *Fête des fleurs* and the Locarno *Fête des camélias*, with their ornamental floats decked out with huge animals, swans, butterflies and floral horses on which were perched beautiful young girls. She was also fascinated by press reports of princely ceremonies and advertisements for the Swiss release of new films. Her magnificent *Tsarina Bornot, Ballad of the Soldier in Bed*, once again featuring red as the dominant colour, was a free adaptation of three ads published in the Lausanne paper, *Feuille d'Avis*, one of which was for *The Devil's Teeth* starring Anthony Quinn. Famous paintings provided another source of inspiration. Jacqueline Porret-Forel was the first to discover the iconographical repertoire on which Aloïse relied, and notes that the kneeling Josephine in David's *Coronation of Napoleon* has been transmuted into a flower in a fashion typical of Aloïse's work.[1]

Most of her themes and characters, however, were taken from the opera and, at the beginning of her internment at La Rosière she used to sing operatic airs at her window. Donizetti's Mary Stuart, Gluck's Orpheus, Verdi's Aida, Lully's Armide and many other title roles appear in her writings long before they took shape in her art. Transferring her unfulfilled dreams onto the celebrated diva, La Malibran, she marvels: "(...) she toured Europe with a harp attached to her heart. In her chariot, bearing the organs of the seven wonders of the ancient world, she swept away the audiences in her arms".

Reference to sources raises a question: did Aloïse merely reproduce hallucinations and visions already present in her mind, or did she "actively" recreate them when drawing? Dr Alfred Bader observed her at work for many years and made a short film about her; he argues that her decisive gestures – she proceeded without ever correcting what she drew – mean that she was simply transferring a mental image onto paper. Michel Thévoz, on the other hand, argues that Aloïse's works assumed form as she was drawing. He cites the example of *Cleopatra*, an unfinished sketch, which the artist, despite her normal insistence on working alone, drew in the presence of Jacqueline Porret-Forel, who described the event thus: "Personally, I have only seen Aloïse at work on one occasion, in 1963. When I asked If she would like to draw an animal, she replied: 'I'm going to draw you a sweet little crocodile.'

1. *Ibid.*, p. 45 to 58.

Straight away, without the slightest hesitation or reflection, she drew at the top of the sheet a sort of little red shrimp with blue eyes, then a head with blonde hair and curls represented by a few red spiral strokes. On top of this, two or three red bulges formed a hat. Using a red pencil, she sketched a female face in profile, adding a second arthropod to the forehead and a third in the guise of a drop earring. Then, in a few swift red strokes, she added the breasts, bare shoulders and an arm supporting a black-haired male head kissing the naked breast. This sketch portrayed Cleopatra, with scorpions concealed in her hair, and Anthony or Caesar's head reclining on her breast".[1]

Aloïse may well have been a "handmaiden" to colour, as she said herself in connection with red. But Thévoz ventures farther and suggests that it was the colours which determined whether a figure was to be a king, queen, general, prima donna or someone else, and that this in turn dictated the scene to be represented. He bases his argument on Dr Bader's short film which shows Aloïse, feverishly at work, holding a set of different-coloured pencils in her left hand. As soon as the lead of one pencil broke or was used up, she hastily took up another, and this often entailed a change of colour. Aloïse did not merely accommodate these changes of colour; she made use of them. "We had the

1. *Ibid.*, p. 40.

feeling", concludes Thévoz, "that she used the assortment of colours in her left hand like a set of dice that favoured the unknown. Each colour possessed an intrinsic energy and, before coming to signify or represent anything, triggered an emotional response and accompanying image".[1] This is corroborated by the fact that, where she made a preparatory sketch (which she very rarely did), the outline never encloses the areas of plain colour; on the contrary, they spread out into other surfaces, eliciting new colours.

Aloïse's work is nonetheless based on her own cosmic vision. Put briefly, it could be said that, cut off by her internment from the "ancient natural world of times gone by", she found release in the universe that had become her family; impregnated by the light of the sun, whose rays refracted from her a multitude of images, she was transmuted into a creator from whom any being might arise. She saw no inconsistency in remaining herself and at the same time becoming a ubiquitous, eternal other, setting no bounds to her existence. She lived in a world turned upside down, propping up the heavens with her feet and simultaneously standing upright on the celestial carpet. She played with the stars, tossed the terrestrial globe into space and rejuvenated it. The mind-boggling conclusion is that she had left the annihilated terrestrial

ALOÏSE
ADORATION OF THE MAGI
Before 1964, coloured pencils on paper,
50 × 70 cm (20 × 28 in).
Musée cantonal des beaux-arts, Lausanne.

1. *Ibid.*, pp. 103-115.

world behind and never looked back. Her work is to be regarded as a cosmic theatre in which she saw herself as demiurge.

It is therefore hardly surprising that her largest work is *Cloisonné de théâtre*, a forty-five-foot long vertical scroll which includes the aforementioned scenes of aerial coitus. Comprising three acts and an interlude, it is a dramatic portrayal of Aloïse's love story from the lover's meeting to their separation and the ultimate union of Psyche and Love. The multiple episodes feature women naked or in long dresses with plunging necklines, men in boots and ceremonial uniform, garlands of camelias and a series of little faces which fill the empty spaces and are as if carved into the composition; they are both vertiginous and highly decorative. Apart from the coital scenes, the graphic technique is striking, as is its powerful symbolism, notably in the "panel" depicting macabre, brown and bottle-green birds whose presence signifies death. Aloïse almost certainly attached particular importance to the *Cloisonné*; contrary to her normal practice, the work is signed. It transforms the confusion of the early drawings secretly dashed off in the toilets into a methodical style which places her squarely in the leading rank of psychotic artists.

A born colourist, capable of juxtaposing bold colours and creating subtle harmonies, Aloïse shows certain affinities with the Fauves. Her works depict orange and lemon-yellow faces, mauve wigs and pink elephants with blue or green paws. Unfortunately, during the final months of her life, an ergotherapist made her work with a felt marker pen on glossy Bristol board. It was an absurd request since the board absorbed the synthetic ink, removing all trace of her line-drawing. According to her biographers, the few insignicant works she produced expressed little more than vague formal reminiscences. In 1964, shortly after this pitiful experience, Aloïse died at the age of seventy-eight.

The sadistic magnum opus

With the exception of Welz, whose regenerative somersaults for the benefit of his beloved would seem to indicate a tender-hearted disposition, the sexuality expressed in the work of male psychotics – unlike Aloïse's idealized eroticism – involves amorous relationships in which the man is simultaneously portrayed as both victim and executioner. This is clearly illustrated in two drawings by Oscar Deitmeyer, of whom little is known other than that he was a patient in a Munich institution in 1894. These depict a voluptuous, provocative woman enticing a visibly anxious young man. In the first drawing, the woman is wearing a dress which reveals her ample breasts; in the second, she is wearing only her boots. This is a sado-masochistic striptease: the man here is a victim, shrinking back from the voracious charms of the conquering female. Equally frightening is the drawing by Karl Gustav Sievers, a patient in Göttingen, of an enormous woman riding a bicycle. His model was apparently a certain Anna, a farmer's daughter capable of doing the work of several men. According to Sievers, she was so large and fat that she had to sit at the back of the church during Sunday

service to avoid blocking the view of the congregation. Fear of the opposite sex appears in a whole range of works, from Paul Kunze's suggestive portrait of a running woman wearing a split skirt, similar to those worn by Spartan maidens, which opens to show from her thighs up to her armpits, to the impressive phallic crotch drawn by the virtually unknown Kalz – or Kalt. It reaches its climax in Joseph Sell's *Sadistic Magnum Opus*, a thick notebook of minutely detailed drawings, the secret of which is tucked away behind two cardboard covers bound with black and white thread.

Joseph Sell, born in 1878, was a sickly child, so sensitive that the mere sight of Father Christmas sent him into convulsions. One of his brothers has stated that Joseph would tremble at the sight of one of his class mates at school being punished. After apprenticeship as a carpenter, he trained to become a railway-company draughtsman. Very soon, however, he began to display a mistrustful attitude – principally towards his senior colleagues – which developed into persecution mania. He imagined that people were denigrating him, that they wanted to kill him and were firing shots at his windows. One day in 1907, he refused to get out of bed, lit candles, and behaved in such a bizarre manner that he had to be taken into mental care. At the asylum,

Karl Gustav Sievers
Untitled
N.d., pencil and watercolour on tracing paper,
17.4 × 25.5 cm (7 × 10 in).
Prinzhorn Collection, Heidelberg University.

he complained that the doctors conjured up irritating voices to prevent him from sleeping. According to Prinzhorn, who studied his case, he was also convinced that he had a role to play in promoting political stability between Germany and Austria. In his voluminous correspondence addressed to public authorities and princes, he would sign himself off as Level, Prince Level, Level of the Marble Crown, or Level, World Director of Nature. In his letters he explained how, at the asylum, having refused instructions to take in hand a crowd of married women, who were expecting satisfaction, he was being harassed into submission by means of what he called a "comprimis apparatus". And how, during the night, he was tormented by the stink of corpses and subjected to the most humiliating tortures. He claimed that his constant sufferings were transmitted by "electronic radio waves" and were accompanied by painful sensations including intense itching of the optic nerves, tingling in the hands and feet, crackling of the skull bones, cervical vertebrae and back, and tickling in the eyelids, nostrils, pharynx, larynx and genitals. He also complained of electrically-transmitted smells of vomit and female genitalia, and spoke of being continuously pumped full of intestinal winds which infected him with rectal cancer and made walking practically impossible. Prinzhorn offers

a penetrating analysis of Sell's terrifying perception of his own body, noting that, amidst this preposterous catalogue of physical titillation, emotional reactions and delirious images, two conspicuous factors form the basis of his apprehension of the world: firstly, the electrical circuit produced by a dynamo located in his home town or in the asylum, to whose airborne waves he has been rendered receptive by the baths and, secondly, the effects produced by this circuit which lead him to organize his bodily sensations and sexual fantasms into a system corresponding to his sado-masochistic needs. "The crucial factor is that he is required to suffer in order that others may achieve sexual pleasure whereas, in actual fact, he himself derives pleasure from his own suffering. This masochistic element and its associated perverted tendencies are matched by the sadistic element which he satisfies in his drawings and their accompanying commentaries."[1]

Regarding the events which led to his being committed, Sell claims to have had himself whipped in a brothel and that this had come to the knowledge of his superiors. He also adds that, from the age of sixteen, he thought that it was impossible to have sexual relationships because of the defilement involved. At the same time, he regretted never having spent a single night with a woman, since peace of mind was unattainable without one. A highly intelligent person, he managed to diagnose his own "fear of the opposite sex", in his opinion the most dreadful of all afflictions and one which also affected doctors, rendering them incapable of helping others. *The Sadistic Magnum Opus*, on which he worked from 1910 until 1914, was thus, by his own confession, a kind of substitute for sexual activity.

The notebook containing *The Magnum Opus* is divided into twenty sections of ten to fifty pages placed in paper folders bearing solemn inscriptions in curious block capitals. Each section is composed of a series of drawings and a lengthy text written in pencil in a small, regular, but somewhat illegible hand. Most of the drawings depict erotic scenes of punishment and "titillating ordeals", set in boarding schools or reformatories and involving female characters. The bathrooms, gymnasia and toilets in which the scenes take place are equipped with an array of intricate devices and apparatuses which Sell's unflagging imagination dreamt up for all sorts of unspeakable purposes. The women wear high-laced boots and are dressed either in wardress' uniforms or transparent robes. Their rigid poses and slow movements seem to convey a sense of sacred intensity. Sell, as we know, had trained as a draughtsman before being interned. Madness did not impair his technical skill and in his work there is no clumsiness or distorsion. *The Sadistics Magnum Opus* is the work of an accomplished hand.

The same approach and technique recur in three 1916 drawings enigmatically entitled *"CNL" Project, "Canal" Project*, and *"Hyperdrome"* and all bearing the signature "Level". The first depicts a young, red-haired woman wearing high-heeled boots and a green skirt. Her torso is enveloped in a leather-covered bodice attached by straps; around

1. Hans Prinzhorn, *op. cit.*, p. 284.

Page 124, top

JOSEPH SELL

"CANAL" PROJECT LEVEL

1916, miscellaneous techniques on cardboard,
36 × 13.4 cm (14 × 5 in).

Prinzhorn Collection, Heidelberg University.

Page 124, bottom

JOSEPH SELL

"CANAL" PROJECT LEVEL

1916, miscellaneous techniques on cardboard,
38.5 × 13.4 cm (15 × 5 in).

Prinzhorn Collection, Heidelberg University.

Page 125

JOSEPH SELL

"CNL" PROJECT LEVEL

Detail.

Pages 126 and 127

JOSEPH SELL

HYPERDROME

N.d., pencil on drawing paper and parchment,
16.4 × 25.3 cm (7 × 10 in).

Prinzhorn Collection, Heidelberg University.

JOSEPH SELL
THE UNIVERSE INSIDE OUT
Detail. N.d., coloured pencils,
22 × 15 cm (9 × 6 in).
Prinzhorn Collection, Heidelberg University.

her neck is a tight, high collar resembling a surgical collar. The three-quarter profile shows her standing, holding in her gloved hands an unidentified leather accessory from which hang straps – perhaps intended to bite into the flesh of the wearer – and which she is seemingly offering to a partner in some sado-masochistic game. Behind her, a white dress and slip are hung above a riding crop and a lace-fringed umbrella. In the left and right foreground, completing the composition, stand two instruments – a stool with a hooked appendage on top, and a weird gymnastic apparatus resembling an enormous vagina. The second shows a rear view of a woman clad entirely in leather, with an exaggeratedly narrow, tightly-laced waist. Thrusting her pubis against the end of an apparatus composed of a trunk placed horizontally on a four-legged trestle like a market stall, she seems to be deriving intense pleasure from the contact. The scene is set outdoors and the woman is portrayed against the background of a burning town and a smoke-filled sky.

The third drawing, *Hyperdrome*, is executed in black pencil – while the two other compositions are in coloured pencil – and depicts a group of nine figures. It brings to mind the illustrations of piles of intertwined bodies typically found in editions of Sade's works, yet here only women are portrayed and, moreover, no sexual ill-treatment is involved. Judging from the gestures and attitudes, the scene no doubt represents the ceremonial dressing of the central figure around whom the others busy themselves. Yet this is no run-of-the-mill ceremony.

It is well-known that bathing used to form an essential part of the treatment of the insane. Cold baths were prescribed as a sedative for hysterical patients, hot baths as a stimulant for the apathetic. Sell was so irritable, gruff and incommunicative that he was kept almost constantly in bed in solitary confinement and must have had more experience of such baths than any other inmate. As we have seen, sanitary appliances play a central role in *The Sadistic Magnum Opus*. But the bath features even more prominently in *The Universe Inside Out*, a colour drawing of wonderfully free expression, which portrays the artist's suffering. "I'm there in the bath at the bottom left. It's dreadful what can happen to one in the bath: real torture! (...) You're left to stew in the bath for five days with the rotting remains of a half-eaten meal floating on the surface: the acidity from the salad enters your pores and if bits of orange-peel cling to your head you sustain even more acidity ; if you splash water on a fly it spins around a couple of times buzzing then instantly dies. The world turns inside out and the entire exterior surface becomes a stomach lining. When you've gone through that, the reverse of the universe is worse than Christ's sufferings on the Cross."[1] The bath in which Sell is immersed is placed inside a urinal-shaped cave and behind it lies a huge snake. Other features include a polar bear, Pope Leo XIII flying through the clouds shadowed by Sell's *alter ego* brandishing a flail to administer "theological

1. Hans Prinzhorn, *op. cit.*, p. 291.

chastisement", and a number of small, blue figures symbolizing monarchs. Since "the sun is the prince of sexuality", the entire scene is bathed in the light from twin suns and the world is represented by a ball. Whereas Sell's sadistic drawings are clinically precise, this one displays greater *brio*; it is somewhat reminiscent of André Masson's *Dawn at Monserrat*, painted in 1935. Masson had lost his way and been forced to spend the night lying on a boulder; the painting represents his impressions of the star-spangled sky he saw swaying over his head and beneath his precarious perch.

4. Human, all too human

Prinzhorn's book includes a reproduction of a pencil drawing entitled *Apparition of Air* depicting a hallucinatory face. Although little is known of the artist, identified as Otto St, clinical records mention that this is one of his "air drawings". These were transmitted to him over the centuries by "air currents" and occasionally included recognizable portraits of his forebears. The artist believed that his drawings vanished as soon as they were on paper and this explains their characteristic fleeting, ghostly effect. The portrait selected by Prinzhorn is a composite web of suggestive lines in which the mouth, nose, ears and eyes are given a particular emphasis. Recalling the convolutions of the human brain, the head – minus skull, flesh and skin – is turned inside out like a glove and the cortex oozes on to the paper; this is a depiction of man reduced to a puff of air, a mere breath, his soul a pitiful discharge.

The nineteenth-century French socialist Proudhon wrote: "Art always revolves around the human face". He meant that the essence of any school and of any stylistic evolution is the treatment given to the human figure. His friend Courbet's realism was thus, in his view, distinct from all previous schools of painting. But his dictum is even more relevant as an explanation of the fundamentally different nature of Art Brut and psychotic art.

In the latter, the human figure is often transformed to such an extent that it becomes barely recognizable. The Lausanne *Collection de l'art brut* includes, for instance, a drawing entitled *Human Body*, produced around 1910 by a mysterious Katharina. The least that can be said is that it is far removed from the anatomical sketches by Leonardo or Andreas Vesalius. The crayon drawing depicts jumbled organs linked together by a strange network of flexible tubes. Their various functions are designated by a bizarre combination of anatomical and chemical terms – betraying the artist's faulty grasp of human anatomy. Indeed, the American psychiatrist Paul Schilder has shown that psychotics can display a highly confused notion of bodily structure, mentioning one patient who was forced to hide in a doorway to reassemble his body whenever a passer-by stared at her too closely, and another who anxiously spent his nights searching the bedclothes for his own limbs, convinced he had mislaid them[1]. In a similar vein, Katharina's drawing reduces anatomy to a incoherent apparatus.

Works by other psychotics depict the body as a veritable machine, the plan and functions of which are provided by the artist. This was the

1. Paul Schilder, *L'image du corps*, Paris, 1980.

case of Robert Gie, a carpenter who suffered from persecution mania accompanied by bodily hallucinations and sense-data illusions. His drawings portray little figures linked together by networks of fluid. The human being is transformed into a hollowed-out automaton, stripped of all power and individuality by the very process which supplies nervous stimulation. The branches of the ramified nerve system spread out in various directions across the foreheads, mouths, hearts and bellies of the little figures. One of his drawings depicts a centrally-located machine with a gigantic human head seen in profile; the mechanical atmosphere is heightened by cogged wheels which speed the flow of nervous energy. A very similar case is that of Joey, the autistic child described by Bruno Bettelheim, who was unable to walk, eat, digest, defecate, play or sleep in real life unless plugged into an imaginary electrical system.[1]

With other psychotics, like Karl Brendel, the depiction of the human body resembles the tadpole-figures drawn by children who, in their first attempts at symbolization, begin with small, truncated men whose limbs are attached directly to their heads, before moving on to a fuller representation. They are still more reminiscent of head-and-foot figures in some mediaeval works, where the trunk is eliminated or abridged. In the drawings of Carlo Zinelli, interned in San Giacomo Hospital in Verona in 1947 after having fought in the last war, the human body is subjected to violent assault. The entire pictorial space is crammed with homunculi whose faces are swallowed up by huge solar eyes and whose bodies are riddled with holes – wandering souls with neither hearth nor home, abandoned in an absurd world.

Heinrich Anton Müller is, however, the artist who has produced the most striking depictions of human dereliction and has most brutally distorted the human image. Müller was the inventor of a revolutionary vine-pruning machine but his idea was pirated and utilized by unscrupulous manufacturers. He subsequently developed mental troubles which led to psychiatric internment for the rest of his life. In hospital, he set about building large perpetual-motion machines; he also constructed a gigantic telescope and would spend days peering through it at an object he had made, and which his doctors interpreted as a symbol of the female genitalia. Unfortunately, his machines and telescope have been destroyed and all that remains are a few poor-quality photographs. He would also occasionally draw and although his multi-angled portraits are somewhat reminiscent of Picasso they convey a seething rage which is far removed from comparable works by the Spanish master. Can this be a man? Or that a human head? The entire morphology is distorted; teeth and noses are reduced to mere claws and hooks, cheeks to hollow pockets of flesh and chins to bony protuberances. In Müller's portraits, mankind, guilty of stealing his invention, has literally *lost face*.

Nevertheless, in the work of psychotic artists – which, as we have seen, can range from the bewitchingly theatrical vision of Aloïse to Joseph

1. Bruno Bettelheim, *The Empty Fortress*, New York, 1969.

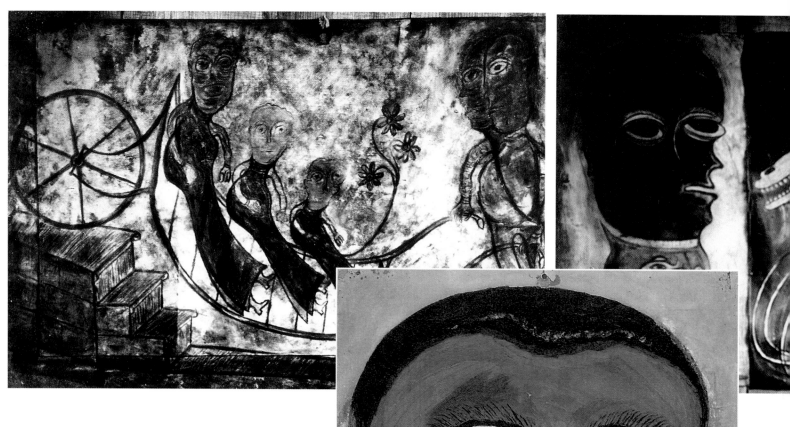

Top, left to right

HEINRICH ANTON MÜLLER

LOST WORKS

Prinzhorn Collection, Heidelberg University.

HEINRICH ANTON MÜLLER

HEAD OF A MAN

Between 1917 and 1922,
gouache, chalk, indian ink
and pencil on cardboard,
79.5 × 44.5 cm (32 × 18 in).

Kunstmuseum, Bern.

Sell's sado-masochistic compositions – the human figure is not invariably represented in mutilated form. Nor is it disfigured in the work of August Klotz, an artist who offers a serene, essentially playful image of man, despite the fact that he was an acute depressive who stabbed himself in the belly and identified his suffering with that of Christ on the Cross. Klotz generally portrays fashionably-attired dandies sporting moustaches. The portraits are shown in profile, assembled, mixed, occasionally grouped together against the background of an imaginary landscape, and are characterized by unrestrained freedom of execution. Klotz painted for his own enjoyment and was an excellent colourist. A gentle magic emanates from his works, many of which make play with free association.

Creative insanity

Franz Pohl offers the most fascinating example of creative talent exalted by madness. Born in 1864 in the Baden region, Pohl was a wrought-iron craftsman who studied at both Munich and Karlsruhe Decorative Arts Schools and became a teacher in a technical college, a post which he lost after a few years due to his arrogant demeanour. He indulged in an expensive lifestyle of theatre and brothel-going. During the winter of 1897-1898, while living in Hamburg, he developed a persecution mania which quickly attained considerable proportions. He became obsessed by his experiences at the theatre where he believed he was surrounded by insulting voices. He was convinced that he was being spied upon through his keyhole and was forced to move house. Whenever Pohl returned home by tram, at the end of the line, the conductor would call out "Terminus!". Pohl would misinterpret this as "He's nuts" and would have a go at him. On a visit back to his native

Pages 138 and 139
CARLO ZINELLI
UNTITLED
3 September 1967,
recto-verso,
gouache on paper,
70 × 50 cm (28 × 20 in).
L'Aracine Collection, in deposit at the Musée d'art moderne de la communauté urbaine de Lille, Villeneuve-d'Ascq.

FRANZ POHL
SELF-PORTRAIT
N.d., coloured pencils,
28 × 19 cm (11 × 8 in).
Prinzhorn Collection, Heidelberg University.

FRANZ POHL
FABULOUS ANIMALS
N.d., coloured pencils,
40 × 29 cm (16 × 12 in).
Prinzhorn Collection, Heidelberg University.

Baden, he stuck out his tongue at the train guard who, so Pohl claimed, had done the same to him. His senses of taste and hearing were also subject to hallucinations. From 1898 he was confined in a variety of institutions and was murdered by the Nazis in 1940.

Pohl was a diminutive, mild-mannered, highly affected person. He had a somewhat large head, black hair and beard, and sharp, mouse-like eyes. His clinical record mentions only rare outbreaks of anger or violence directed at other patients. During his years of internment, he spent most of his time quietly drawing, writing or composing music, replying gruffly to any questions put to him. He would greet visitors with suspicion and very cunningly steer them away from his pictures, constantly inventing fresh pretexts to avoid untying the bundle in which they were tucked away. In a detailed description of one of his visits to Pohl, Prinzhorn portrays this man of genius: "One moment he would be muttering about unfinished things, twisting and turning his bundle, the next he would be running to the window and signalling to someone outside. Catching sight of a doctor, he uttered a cry of warning to the visitor, took refuge in a corner and anxiously watched, ceaselessly mumbling and gesturing with his hand to ward off the doctor's presence. Then he painstakingly checked the doors, listened intently in all directions and began turning his bundle this way and that, all the while shrugging his shoulders thoughtfully and timorously glancing to either side, paying not the slightest heed to what was being said to him. When he had at last undone the string and taken out a drawing, he suddenly tapped his forehead as if struck by a flash of inspiration, carefully tied up the bundle again and began fumbling in his jacket pockets, brushing aside each question with a little wave of his hand. Finally, he dug out a little newspaper packet and took from it a short cigar stub which he then contemplated, lovingly sniffed, and cautiously lit. He walked back and forth in short, solemn paces, still imposing silence upon the prying visitor by slight gestures and artful glances. Having smoked half an inch or so of his cigar, he carefully extinguished it and wrapped it up again, stuffed it in his pocket and came back to the table with a friendly smile. However, even when we managed to overcome his quirky behaviour and actually see some of his drawings, no conversation was forthcoming. His silence was only broken if we professed to admire his colours or the curve of a particular line. Then he would reply in a painterly fashion, 'Yes, that's very good... More red is required', etc."[1]

Before turning his back on the world, Pohl had received a thorough artistic training. Shortly after his internment, he began drawing scenes of asylum life. These drawings – a shaving session in a cell in front of a wire-netted window showing a rear view of the patient sitting on a chair along with a nurse holding a razor in his hand; studies of various attitudes of other patients who would pose for him; an interior view of a convalescent room with its furniture and a few slumped or distraught inmates – are accompanied by abstruse commentaries which shed light

1. Hans Prinzhorn, *op. cit.*, p. 298.

on his psychotic state. But otherwise, despite a certain sophistication, notably in the rendering of depth, they remain mere sketches of no aesthetic value. There is something astonishing about a mental patient producing such hackneyed work in the bland, descriptive style typical of college textbooks of the day. Pohl was still influenced by the teaching he had received and had himself transmitted: the upheaval in his mind had not yet unearthed its unsuspected treasures and his artistic training, far from stimulating his imagination, was still acting as a brake on it. Pohl became a great artist several years later when his schizophrenic condition had considerably deteriorated. The beginning of his mature period is signalled by his baroque *Decorative Sketch*, featuring a pair of demonic faces, one above the other, surrounded by flowing curves which fill the pictorial space like wrought-iron flames, creating an effect of extreme rhythmic tension. This was followed by drawings in which faces are simultaneously deconstructed and reconstructed as if cut up into fine slices or are shown suspended in the air within a frame seemingly detached from the wall. One of these, entitled *Penne*, is nightmarish. In the foreground is a witch or warlock with several eyes. The creature is surrounded by freshly-formed or gestating goblins spawned by the malignant vapour emanating from a pot, the mysterious contents of which are bubbling away on a stove. In the background, the obsessional atmosphere is heightened by a field enclosed by a wall and a house lashed by rain. The work is living proof that psychosis, rather than diminishing what was, at the outset, a somewhat limited artistic talent, can actually enhance it.

Pohl's psychosis led to several masterpieces, including *Fabulous Animals*, an almost unbearable coloured-pencil drawing which carries the hallucinatory powers of metamorphosis to fever pitch. Set in a room in which wide-open French windows look out onto a garden, it shows a monster – half-boar, half-stag and with its nose and eyes taken directly from one of the artist's self-portraits – with, on its left, a little dog with blurred eyes and a large, round head. Both dog and beast seem to be approaching the viewer, and the proximity of three butterflies – one large and two small – which flutter down from the top edge of the composition is equally disturbing. The cruel effect is completed by a harsh, sustained red. Human, all too human: in the crude, oppressive figure of the monster, Pohl's physical identity dissolves into bestiality.

Another important work is *Exterminating Angel*, referred to in the introduction, and which Prinzhorn unhesitatingly ranked in the tradition of Grünewald and Dürer. "Everything that we have perceived in the schizophrenic attitude, in terms of impulses of great value rising to every greater intensity, finds its culmination in this work", he writes. "The angel, crowned with glittering beams, sweeps in from the top of the picture, his left arm and crooked hand reaching forward; in his right hand he holds a sword slanted in front of his face, in almost pensive fashion. Visible between his arms, the angel's left foot is stamping on the throat of a man whose own right hand reaches to his neck as

| FRANZ POHL
DECORATIVE SKETCH
| 1904, lead pencil,
| 39 × 25 cm (16 × 10 in).
Prinzhorn Collection, Heidelberg University.

| FRANZ POHL
PENNE
Detail. 1901,
pencil on drawing paper,
39.3 × 25 cm (18 × 10 in).
Prinzhorn Collection, Heidelberg University.

he tries to ward off his assailant with his left. The victim's twisted legs are seen from behind writhing along the right-hand edge of the drawing. Despite the brutal horror, the tangled limbs form a masterly composition. The way in which the dynamic of each movement described is restrained just sufficiently to allow an overall view without loss of tension can only be described as grandiose. And the use of colour matches the composition in quality. The entire palette is brought into play: bold reds, greens and blues give full force to the scene while yellow half-tones verging on green and darkening towards the edges provide transition between the sharp contrasts, echoing the formal tension and displaying a similar consummate mastery. It is no insult to evoke the names of Grünewald and Dürer."[1]

Schizophrenically-transformed vision can no longer be dismissed as mere pathological degeneration. Pohl's work places psychotic art on an equal footing with museum art. Both derive from the same, unique, creative force and, consequently, all argument as to the cultural or non-cultural nature of artistic production becomes irrelevant.

The case of Louis Soutter is analogous. The "young, well-loved and celebrated" Soutter started out drawing and painting works in an academic style before emerging as a notable artist following a mental breakdown. Born into a well-to-do family in Morges in Switzerland on 7 June 1871, Soutter was both an accomplished violinist and a brilliant painter and draughtsman when he met an extremely wealthy young American woman whom he married, and with whom he opened an art school in Colorado Springs. The romance, however, soon turned sour; the couple divorced and Soutter returned to Europe. A gloomy, reserved, unsociable figure, his career plummeted from virtuoso violinist to dance-hall musician and, notably, cinema-theatre accompanist in the days of silent movies. Although impoverished, Soutter kept up the luxurious lifestyle he had led in America. He frequented the smartest tailors, wore made-to-measure silk shirts, and offered his friends magnificent presents, leaving his family to pay the bill. The family, fed up with his lavish behaviour, placed him under financial supervision before packing him off to an old people's home in Ballaigues in the Jura in 1923. He entered the home at the age of fifty-two and spent the remaining nineteen years of his life there.

Although he produced few paintings, his thousands of drawings fall into two distinct periods. Those from the first period chart his mental torment in seismographic form, revealing his nervous impulses rather like Michaux's drawings under mescaline. The rare people who witnessed him at work – like Michel Thévoz, the leading connoisseur of his life and oeuvre[2] – were impressed by the virtually automatic way Soutter would spread his hatching across the sheet. Author Jean Giono, a close friend, records that the movement of his hand was more a vibration than a gesture. Although, from a stylistic point of view, bodies appear in these drawings disfigured in Expressionist fashion, the overall physical structure remains intact. The principal themes are

1. Hans Prinzhorn, *op. cit.*, pp. 308-311.
2. Michel Thévoz, *Louis Soutter*, Lausanne, 1989, p. 76.

FRANZ POHL
THE EXTERMINATING ANGEL
Detail. N.d., coloured pencils,
40 × 29 cm (16 × 12 in).
Prinzhorn Collection, Heidelberg University.

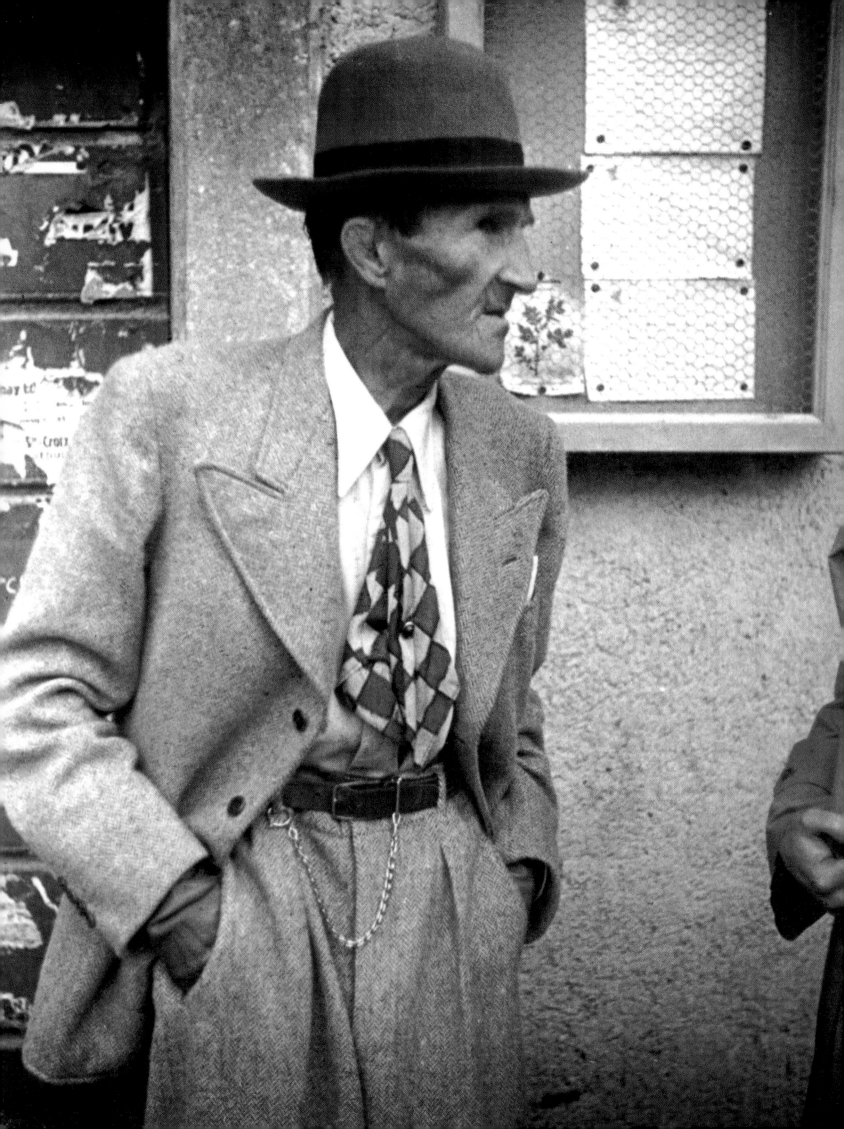

LOUIS SOUTTER

Forcibly interned in an old people's home
at the age of 52, he devoted
the final years of his life
to creative work.

voracious women or ambiguous religious scenes in which a latent sense of guilt is felt – unlike Soutter's occasional nature drawings, which depict ripe, innocent fruit. The break with his early academicism is complete and, here again, insanity proves creative. Indeed, Soutter apparently displayed all the symptoms of what Freud called melancholy, and the family decision to send him to an old people's home rather than a psychiatric institution was no doubt a face-saving move. Thévoz rightly stresses the importance of a 1924 drawing which reveals the artist's approach. Entitled *New York* and featuring a row of strange buildings, when turned upside down the drawing can be seen to have started out as an Egyptian temple, the columns and statues of which are clearly distinguishable. Turning the picture round once more, the original ground becomes the sky in the final version. This is very close to Surrealism and its bizarre, incongruous juxtapositions. Moreover, Thévoz notes that "in leaving the initiative to form, Soutter allows himself to be guided by a graphic logic which escapes rational control (...) Unintended forms emerge (...) The lines are magnetized by an unforeseen result (...) The final image, clinched by the caption, bestows a retrospective inevitability on every stroke".[1] It is a dream-like process with all the uncertainty and latent metamorphoses this involves.

Soutter's major creative work, however, lies in his second period, during which he produced finger drawings. Afflicted with failing eyesight and sclerosis of the fingers, he began dipping his fingertips in an inkwell and using them like a brush. These black and white drawings, in which lanky, emaciated, barely human figures are seen walking and gesticulating in empty space, evoke his mental ordeal. The themes include peasants, spade in hand and rake on shoulder, setting off to work in the fields, children playing football, and Christ on the Cross. The drawings abound in archetypes such as juxtaposed circles, spirals, scrolls and mandalas; they flow from sheet to sheet like a sort of mediaeval *danse macabre*, that apotropaic ritual in which death, the daily concomitant of life, was mimed in the streets of town and village, and even in churches dragging the living in her wake. Here, convulsive, distorted figures dance on the brink of oblivion.

1. Michel Thévoz, *op. cit.*, p. 78.

Louis Soutter
**Saloons américains
du tragique New York**
American Saloons
in Tragic New York
N.d.,
oil on paper,
50 × 65 cm (20 × 26 in).
Musée cantonal des beaux-arts, Lausanne.

Left

Louis Soutter

SEULS

ALONE

Detail. 1937-1942,

finger painting on paper,

65×50 cm (26×20 in).

Musée cantonal des beaux-arts, Lausanne.

Centre

Louis Soutter

LE SUPRÊME SYMBOLE

THE SUPREME SYMBOL

Detail. 1937-1942,

finger painting on paper,

58×44 cm (23×18 in).

Musée cantonal des beaux-arts, Lausanne.

Right

Louis Soutter

SAUT À LA CROIX

LEAP ON THE CROSS

Detail. 1937-1942,

finger painting on paper,

58×44 cm (23×18 in).

Musée cantonal des beaux-arts, Lausanne.

LOUIS SOUTTER
JEUX
GAMES
Detail. N.d.,
finger painting on paper,
44.4 × 57.7 cm (18 × 23 in).
Musée cantonal des beaux-arts, Lausanne.

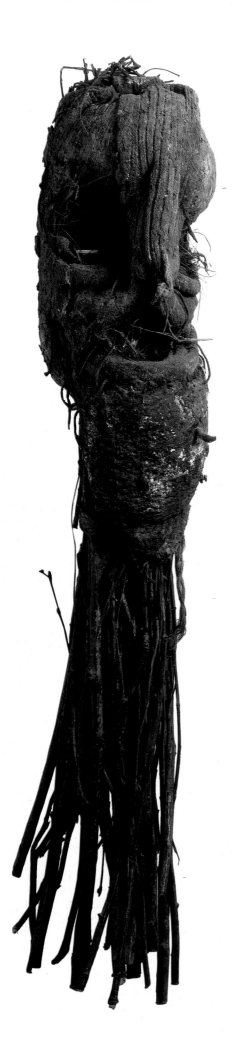

Night and Fog

The work of Michel Nedjar focuses, not on mediaeval death, but on its modern counterpart, the clinically administered death of the concentration camps. Born on 12 October 1947 in Soisy-sur-Montmorency in the Val-d'Oise department, Nedjar intended to follow in his father's footsteps and become a tailor. One evening, aged thirteen, he saw on television Alain Resnais' film *Night and Fog*, which tells the story of the Nazi camps and genocide. A Jew himself, Nedjar knew that many of his own relatives had been deported. He was obsessed by the shocking images, which suddenly brought home to him a reality of which he had hitherto been only vaguely aware. He was particularly distressed by a scene in the film showing a family being led to the gas chambers: "I felt I was watching my aunts, cousins, both my grandfathers... Whenever I experienced a moment of happiness or peace, I would instantly shatter it by summoning up this image".[1]

He had been no stranger to happiness. At home, he had his own sewing machine; he loved its purring noise and the smell of materials and even as a child he used to cobble together clothes and dolls for his sisters. Instead of the brand-new materials his father worked with, he much preferred those his grandmother sold in her shop on Boulevard de la Chapelle, a heady assortment of secondhand rags, old jackets, and crumpled, outmoded dress which still breathed the life of their former owners. He turned the family cellar into a little dream world, where he would play with dolls purloined from his sisters, or make new ones from sticks and roots wrapped in offcuts given to him by his grandmother or gleaned from his father's workshop. Sometimes he would bury them, in an unconscious rite of inhumation. But after he had seen Resnais' film his dreams turned into nightmares. "From then on, I knew I was racially condemned." Fascinated by this horrific revelation, he turned to art to exorcise it.

There is indeed something deathlike about the mute, immobile, human-featured doll. Rilke contrasted it with the noble-minded rocking-horse "which rocks little boys' hearts and brightens up the playroom", regarding the doll as a bumpkin Danae whose limbs move woodenly in response to the golden shower of our imagination. He considered dolls indifferent to human tenderness and confessed that he subconsciously hated them; he preferred the rudimentary kind, stuffed with sawdust, which could be treated like an "object" to be played with, carted around anywhere and finally tossed away. What was Nedjar's relationship to this "object"? It seems to have been identical to Rilke's, in any case quite unlike that of Bellmer whose famous *Doll* – with a body and limbs which can be taken apart and reassembled at will – is a pure object of desire. The doll's soul – or "flesh of the soul" as Nedjar later described it (an expression which in French puns on "dear lady") – is all the more fascinating for its elusiveness, and it was the doll's soul that, even as a child, he was unconsciously attempting

1. Quoted by Roger Cardinal, *Publications de la Compagnie de l'art brut*, n° 16, Lausanne, 1990, p. 75.

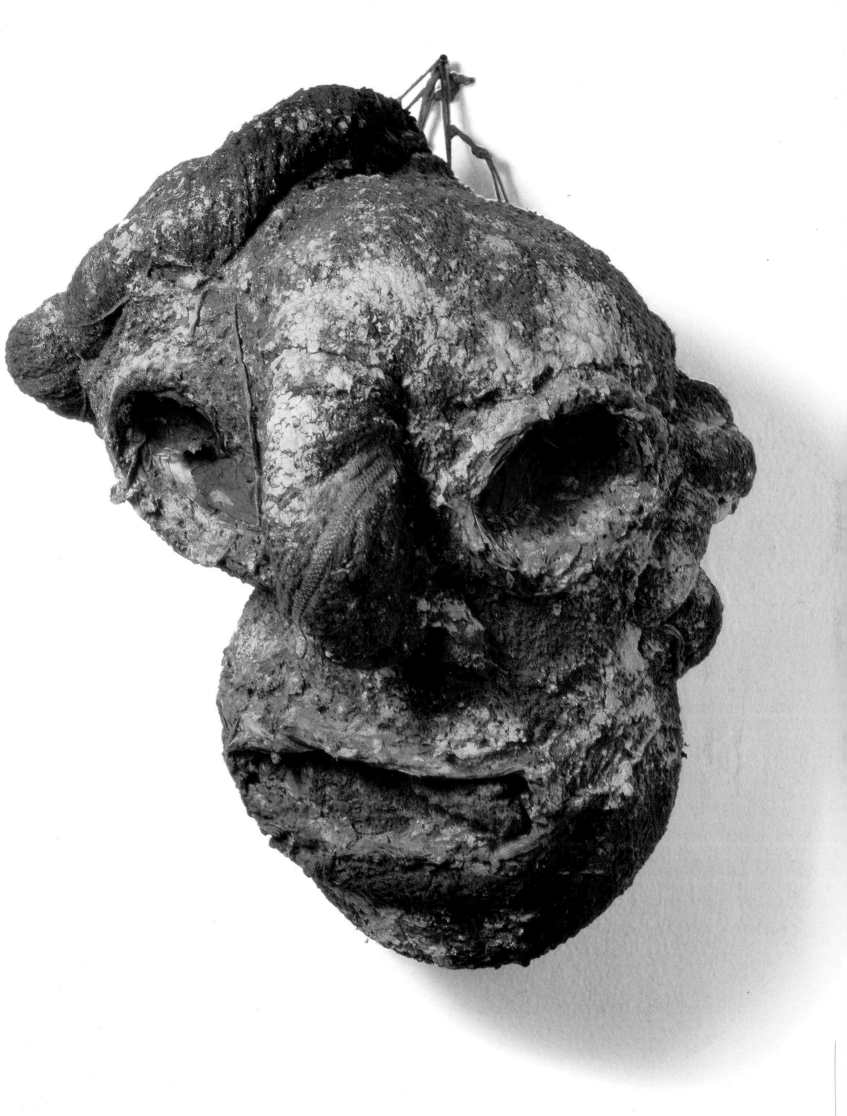

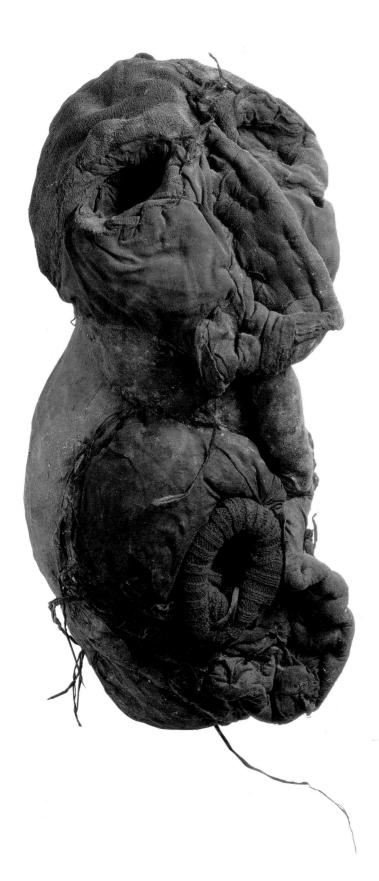

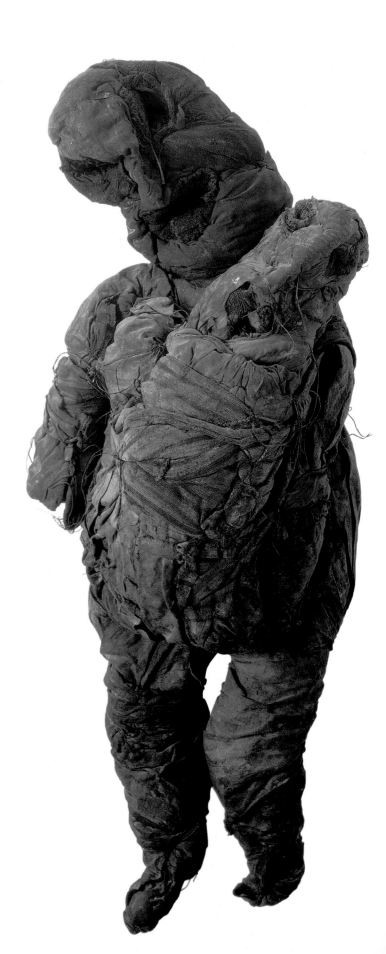

Page 154

Michel Nedjar

Untitled

Before 1986, materials, wool, string, pigments and branches, $57 \times 10 \times 16$ cm ($23 \times 4 \times 6$ in).

L'Aracine Collection, in deposit at the Musée d'art moderne de la communauté urbaine de Lille, Villeneuve-d'Ascq.

Page 155

Michel Nedjar

Untitled

Before 1986, materials, wool, string, earth and pigments, $38 \times 28 \times 27$ cm ($15 \times 11 \times 11$ in).

L'Aracine Collection, in deposit at the Musée d'art moderne de la communauté urbaine de Lille, Villeneuve-d'Ascq.

From left to right

Michel Nedjar

Untitled

Before 1986, materials, wool,
string, earth and pigments,
$38 \times 15 \times 29$ cm ($15 \times 6 \times 12$ in).

L'Aracine Collection, in deposit at the Musée
d'art moderne de la communauté urbaine
de Lille, Villeneuve-d'Ascq.

Michel Nedjar

Untitled

Before 1986, materials, wool,
string, earth and pigments,
$63 \times 22 \times 20$ cm ($25 \times 9 \times 8$ in).

L'Aracine Collection, in deposit at the Musée
d'art moderne de la communauté urbaine
de Lille, Villeneuve-d'Ascq.

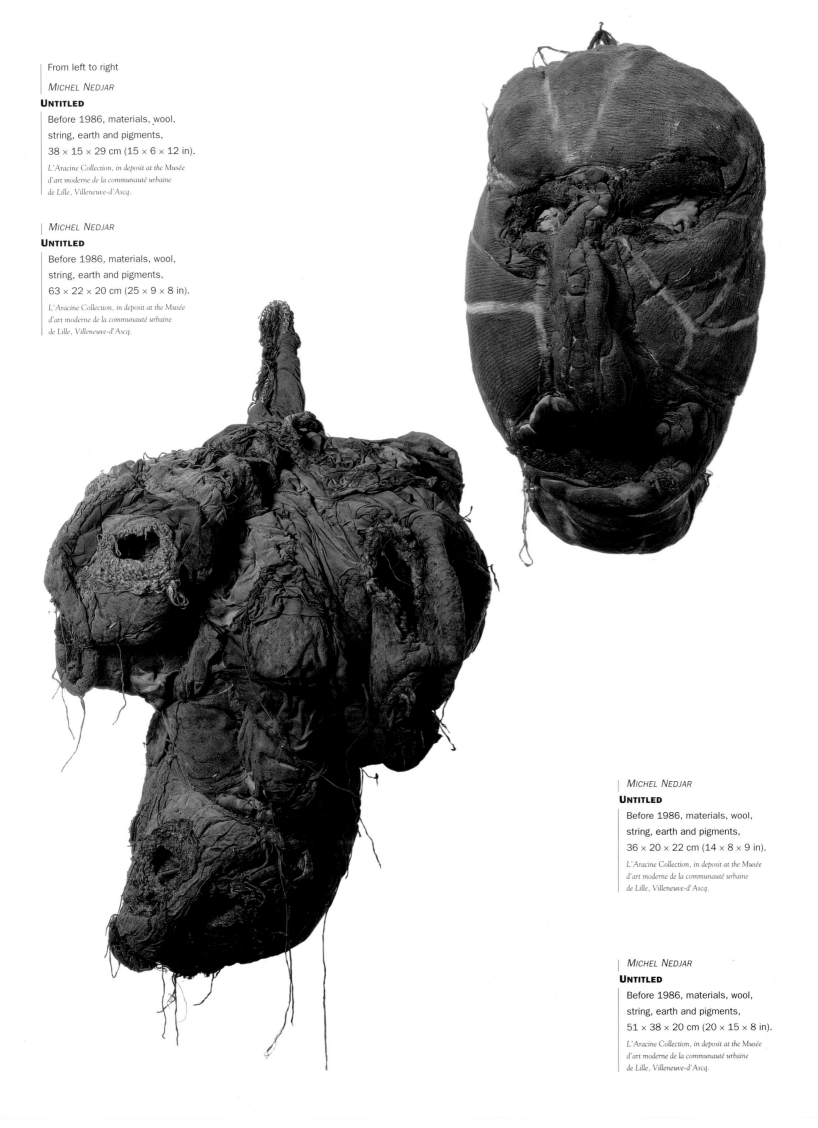

Michel Nedjar

Untitled

Before 1986, materials, wool,
string, earth and pigments,
$36 \times 20 \times 22$ cm ($14 \times 8 \times 9$ in).

L'Aracine Collection, in deposit at the Musée
d'art moderne de la communauté urbaine
de Lille, Villeneuve-d'Ascq.

Michel Nedjar

Untitled

Before 1986, materials, wool,
string, earth and pigments,
$51 \times 38 \times 20$ cm ($20 \times 15 \times 8$ in).

L'Aracine Collection, in deposit at the Musée
d'art moderne de la communauté urbaine
de Lille, Villeneuve-d'Ascq.

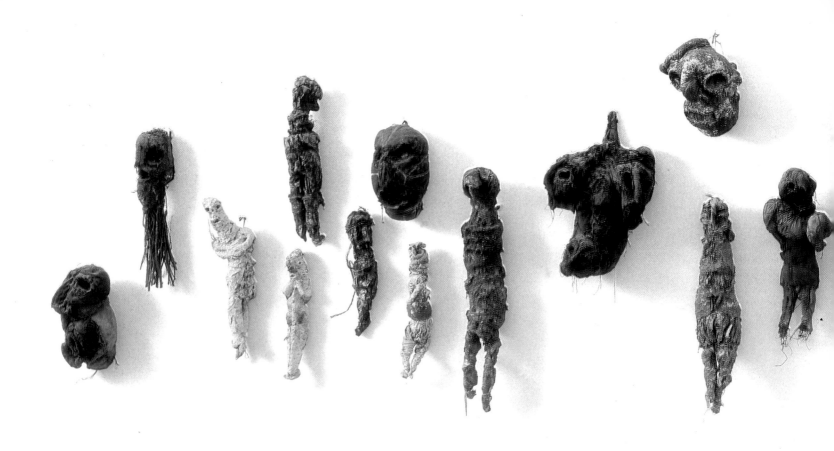

to grasp. It is therefore no surprise that he turned to dolls as his first form of artistic expression on reaching adulthood.

Nedjar's dolls, as one might expect, have little in common with the wax or china faced dolls beloved of collectors. Made out of remnants of rags or sackcloth, woven, stitched or bound, then kneeded and imbrued with earth stains, any human resemblance – other than to mummies or corpses – is remote. Despite the absence of any skeletal or muscle structure, they are striking and terrifying. Some retain a recognizable, albeit much distorted, human form; others are shapeless agglomerates beyond the capacity of language to name. Children pamper, caress and lavish attention on dolls but also mistreat them. "It's true I tie my dolls up very tightly", says Nedjar, adding: "energy emerges when I work with the rags. Piecing together the remnants is like amassing energy". Are these disinterred bodies? What cataclysmic fate has befallen them? How long have they lain buried? How far has decomposition advanced? The notion of creation yields to that of *tortion*. Nedjar's dolls have indeed been subjected to physical and spiritual torment; like the *kapo* in the death camp, Nedjar is a torturer. Modern history is dominated by conflict rather than peaceful coexistence and these dolls also conjure up the image of a species wiped out by some biological catastrophe. At the dawn of Western civilization, Empedocles imagined a drifting flotsam and jetsam of neckless heads, free-floating eyes, severed shoulderless arms, twin-faced, twin-chested creatures and unattached limbs searching for a body with which to unite and slowly, tentatively, assume human shape once more. There

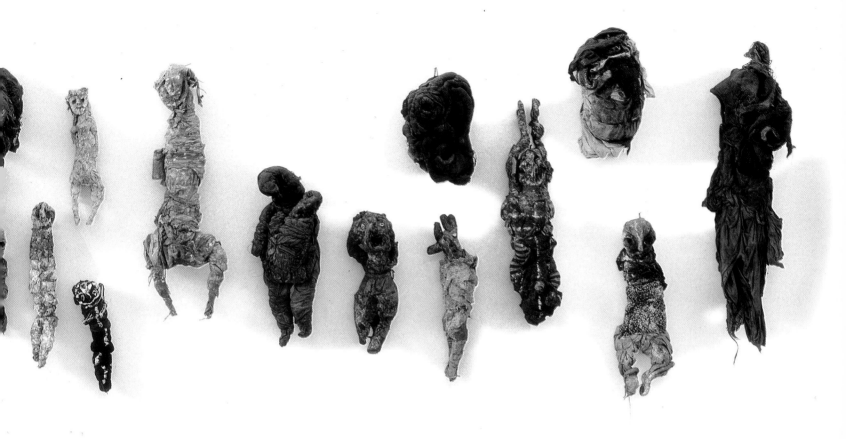

is something in Nedjar's work reminiscent of Empedocles, but located at the opposite end of the evolutionary chain, as if the time had come for mankind to dissolve back into the primeval slime. In this, it shows affinities with the work of the Philadelphia Wireman, an anonymous American artist whose sculptures, in a range of sizes, were found in dustbins, and consist of fragments of metal, plastic, packaging and rubbish bound together by wire. Like Nedjar's dolls, they too portray an inhuman decomposition of bodily features.

After the dolls came the masks, resembling monstruous gargoyles detached from some grotesque cathedral. To describe the humanity that they represent as misshapen would be understatement. Despite the presence of a nose, an occasional mouth, a forehead and empty eye sockets, man is no longer recognizable. Here he is, in a word, *eliminated*. The dolls have been compared to Baroque art; but the aim of the Baroque was to give material, tangible expression to other-wordly spiritual forces by displaying them on a wordly stage. If we imagine that Nedjar's masks represent figures from a world beyond, they can only have been spawned in some demoniacal universe which the artist has wrenched from the depths of his psyche. What has our century done that could explain such distortion of the human face? Nedjar touches upon the metaphysics of evil. His masks occupy a special place in Art Brut, turning human spirit into a futile passion and abolishing all hope. In 1923, in *The Ego and the Id*, Freud provided a re-interpretation of psychoanalysis based around a concept he had partially glimpsed yet long rejected: the death instinct, which he believed lay embedded in

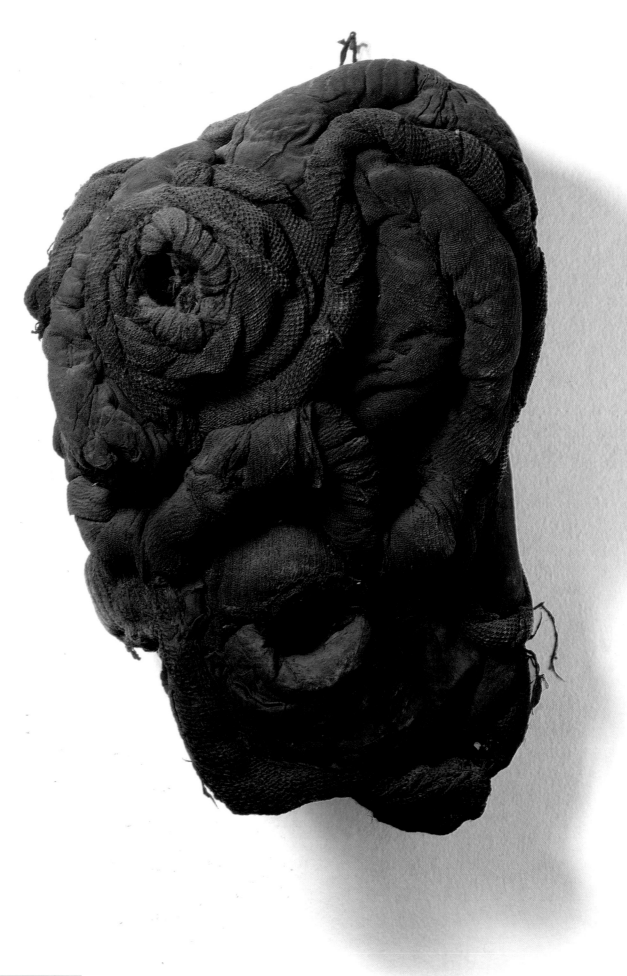

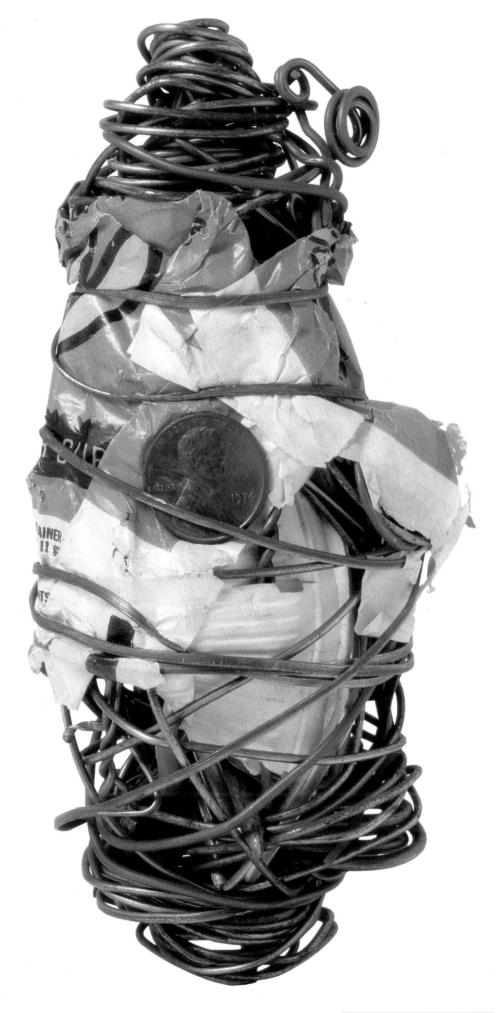

Michel Nedjar
Untitled
Before 1986,
materials, wool, string,
earth and pigments,
42 × 21 × 30 cm
(17 × 8 × 12 in).

*L'Aracine Collection,
in deposit at the Musée
d'art moderne
de la communauté
urbaine de Lille,
Villeneuve-d'Ascq.*

*Anonymous
(The Philadelphia
Wireman)*
Untitled
1970s,
assemblage of wire,
coins and paper,
17.5 × 7 cm (7 × 3 in).

*L'Aracine Collection,
in deposit at the Musée
d'art moderne
de la communauté
urbaine de Lille,
Villeneuve-d'Ascq.*

the heart of man. Traditional moral teachings maintain that man is basically good, wise and kind, and that bloodthirsty actions must therefore be ascribed to personality disorders or to the vagaries of political and social history. Freud, on the other hand, argued that the truth pointed to aggressive impulses present in each and everyone of us. His early works had explored contrasts between the conscious and the unconscious mind. Phenomena such as dreams, slips of the tongue or subconsciously deliberate mistakes were seen as momentary abberations containing latent significance which pyschoanalysis set out to exorcize. The discovery of the Id now revealed that the psyche was ultimately constructed on a much deeper set of basic drives over which the conscious will exercised little control. The earlier Freudian concept of Eros – which, with its emphasis on sexuality, had caused such a stir in Viennese *salons* – was replaced by Thanatos. Reason bowed to forces beyond its control.

Adolf Hitler's deranged mind was already haunted by the conviction that the Jewish people constituted a social virus which had to be eradicated. When he took power, preoccupied by his compatriots' health and obsessed by the dangers of tuberculosis, he not only built sanatoria but also manufactured mobile anti-TB units which made X-ray treatment available to all Germans, even those living in the remotest areas. But this was not enough. The *other* disease – the Jew – remained to be dealt with. The death camps were designed as a prophylactic rather than a racial "solution". In the work of Nedjar, both psychotic art and Art Brut, long regarded as peripheral phenomena, match the twentieth-century in all its horror. His art gives visual expression to the absolute evil of the "final solution".

5. Builders of dreams

Pages 164 and 165
Chomo
staging a presentation
of his sculptures.

nlike the art of the mentally ill, which is cut off from the outside world by the the walls of the asylum, Art Brut has given rise to monumental creations including two internationally famous works – the *Watts Towers*, erected in a sprawling industrial suburb of Los Angeles by Simon Rodilla, a.k.a. Sam Rodia, an immigrant Italian mason, and the *Palais idéal* built at Hauterives in the Drôme department in France by country postman Ferdinand Cheval – "Facteur Cheval".

The seven *Watts Towers* soar to a height of some 100 feet, interlinked by a network of arches. The three tallest are named after Christopher Columbus's caravels, the *Niña, Pinta* and *Santa Maria*; their amazing structures loom up against a background of derelict slums. The ensemble consists of a variety of features, notably a main wall covered with a wealth of motifs and an entrance with raised porch. Inside, apart from the three large towers, there are ponds, a dome-shaped arbour, fountains, stalagmites, and a ship intended to represent the galleon in which Marco Polo sailed. The structures are decked out in a gleaming, multi-coloured mosaic composed of stones, remnants of tiles and crockery, broken bottles and crushed glass; the overall effect is reminiscent of Gaudí's Parque Güell in Barcelona. Rodia, whose goal was to transmute urban garbage into a work of art, would shoulder his sack and set out to gather his raw material at nightfall. Primitive structures, gigantic cages, Towers of Babel, Gothic spires or skyward-pointing rockets, the *Watts Towers* are all of these things and, probably, an impressive tomb – the artist is said to have buried his wife under the main tower, erected in her honour. This is a work of genuine creation, far removed from those pitiful attempts at originality, the blue or green concrete giraffes and gazelles that stand in front of the suburban bungalows of retired people, and which all too often pass for works of art.

Simon Rodia
The Watts Towers
erected in Watts
in suburban Los Angeles.

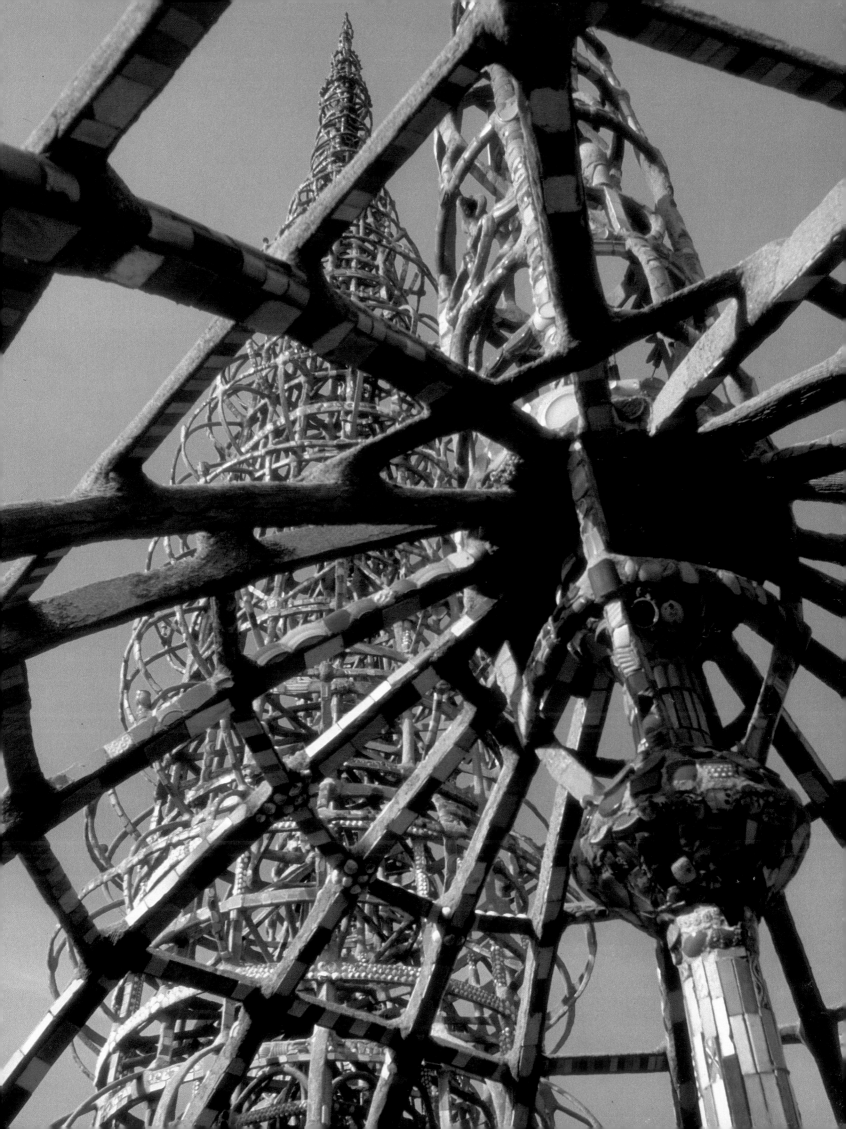

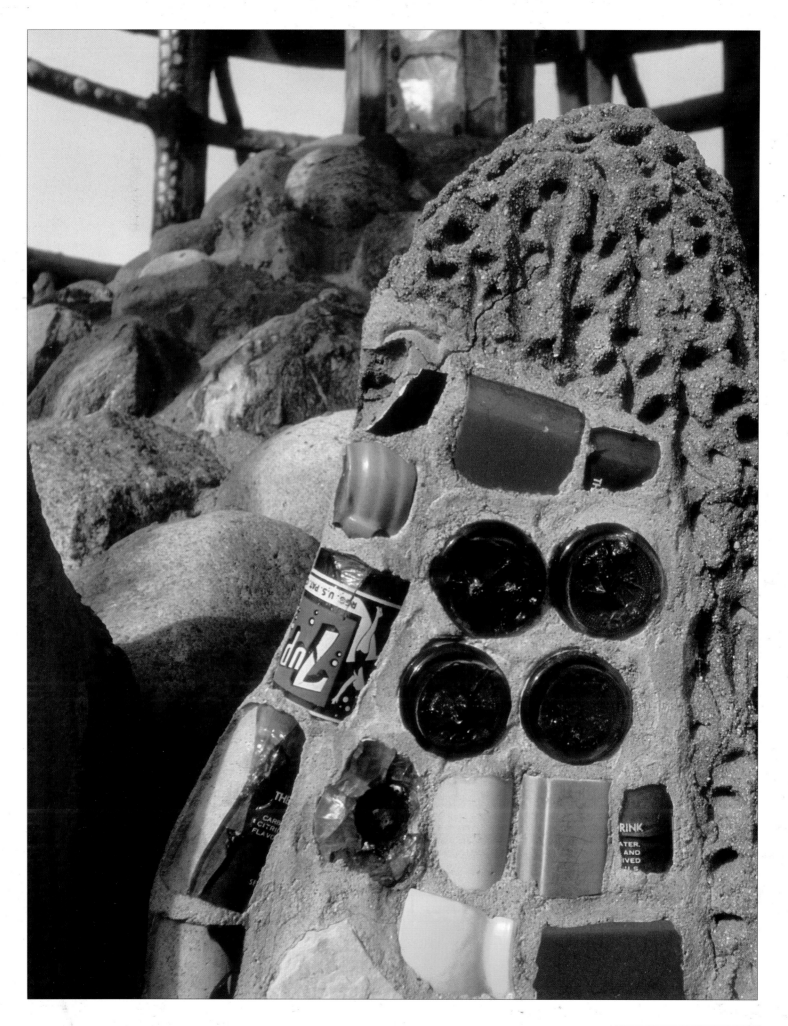

Pages 168, 169, 170 and 171
Simon Rodia
THE WATTS TOWERS
Close-up views.

A miraculous stumble

The most spectacular work by a visionary builder is certainly Facteur Cheval's *Palais idéal*, which he single-handedly constructed between 1879 and 1912. In 1969, André Malraux, then French Minister of Culture, had it listed as a historic monument, against the advice of his own departmental officials who regarded it as "hideous", pathetic, "the brainchild of a country bumpkin". Malraux retorted: "It was a perfectly normal decision, based on the fact that architecture by ordinary people is extremely rare and that it was a question of safeguarding a work which is exceptional in many respects", adding that France was fortunate to possess it, and that steps should be taken to ensure its survival. At the time, the monument was threatened with ruin: the stonework was eaten away by moss and lichen and frost had cracked the sculptures. It was in pressing need of restoration and, a few years later, work began. The successive stages involved delicate measures such as sealing the cracks in the masonry by the injection of lime mortar and replacing the rusted wire microstructures. The *Palais* was thus scrupulously restored to its original state. Charles-Ferdinand Cheval, who was born in Charmes-sur-l'Herbasse in 1836 and died in Hauterives in 1924, was the son of subsistence farmers. At the time of his birth, dire poverty reigned in the Drôme department. Villages consisted of a few straggling cottages clustered along unpaved streets and the animals were often better housed than the inhabitants. Food was scarce; clothes, along with the few pathetic wooden spoons that did duty as kitchen utensils and the odd bench or rickety table that made up the furniture, were handed on from generation to generation. Most villagers slept on beds of dead leaves and went barefoot. The only drink was water; meat, and even white bread, were extreme rarities. After his father's death, Cheval initially took over the family smallholding, then worked as a baker and a day labourer before doing various jobs for the Postal services. In 1867, he was formally sworn in as a country

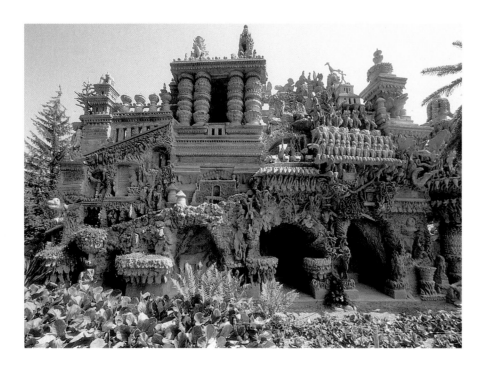

postman and transferred to a permanent position at Hauterives Post Office where he was put in charge of the Tersanne round.

Every day, winter and summer, right up until his retirement, he trod his twenty-mile round through an arid landscape – an ancient seabed with a subsoil full of sedimentary layers of pebbles, multiform segments of tufa, beds of sand and small deposits of shells exposed by violent storms – which offered ideal opportunities for geological meditation. Over the years, as he observed the surrounding countryside on his daily round and reflected on man and nature, Cheval dreamt of building a fantastic palace with grottoes, towers and sculptures, a dream he initially believed impossible as he had never touched a mason's trowel and was totally ignorant of the laws of architecture. Then, one day, he accidently stumbled on a stone and what can only be described as a miracle occurred. "One day in the month of April 1879", he writes in his diary, "in the course of my country postman's round, about a quarter of a league from Tersanne, I was striding along when my foot struck something which sent me flying. I wanted to see what had caused the fall." He noticed, lying in the middle of the path, a stone covered with markings that recalled his *dream*. He was now three years past "the age of forty, called the autumn of life". In other words he had already lived out half of his allotted span.

The stone was so curiously shaped that he picked it up and took it home. The following day, back at the same spot, he discovered others

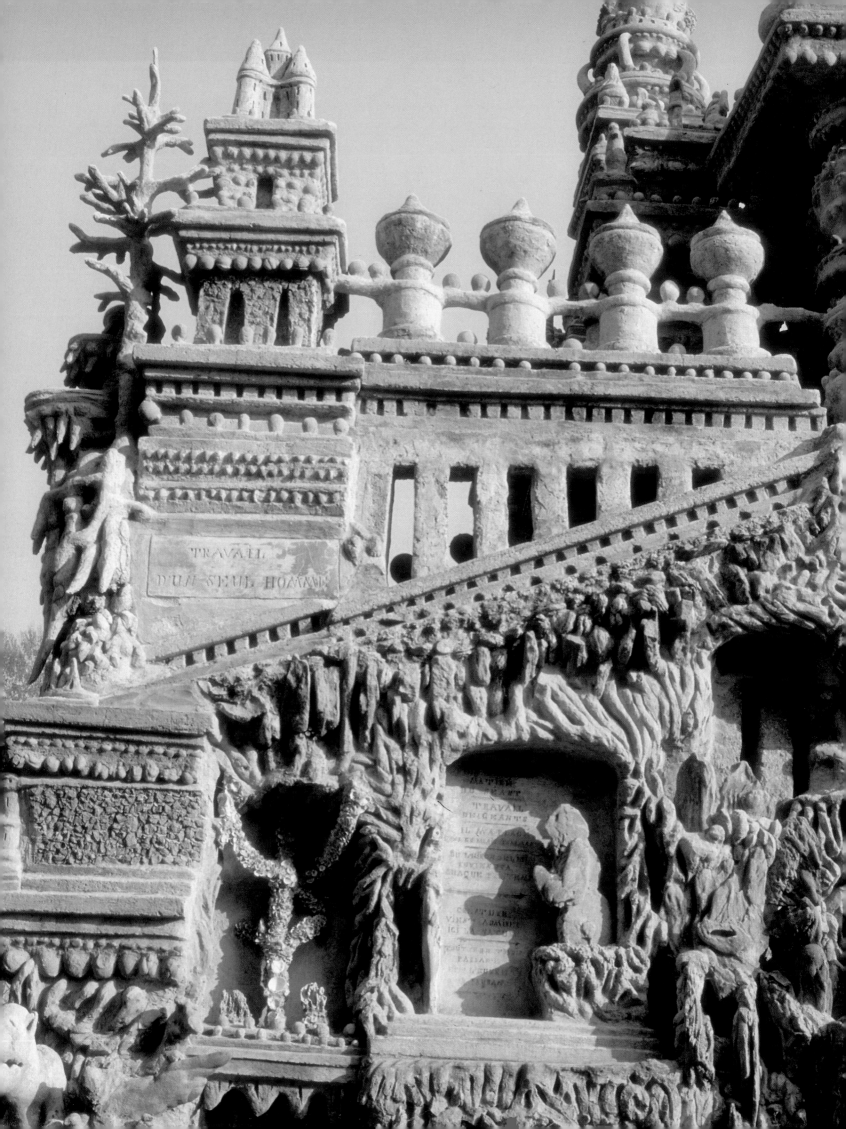

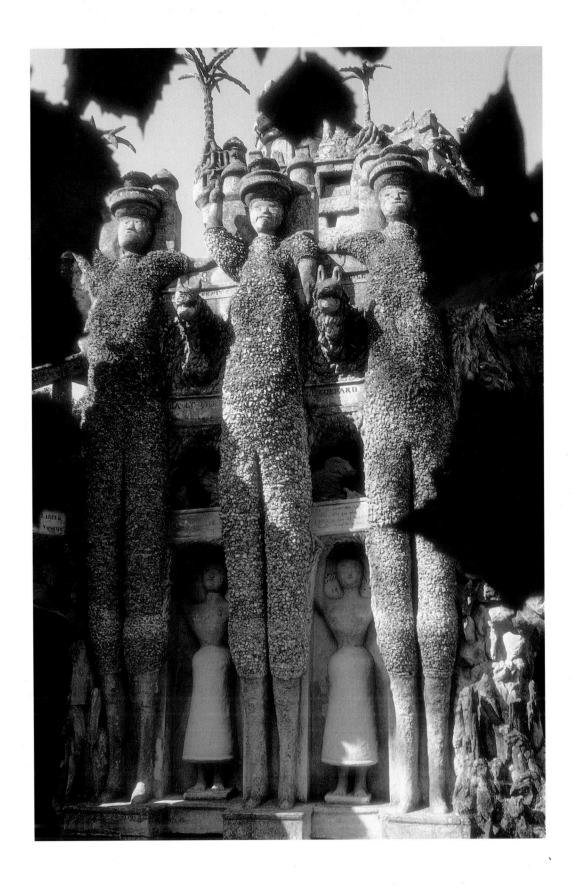

| THE FACTEUR CHEVAL
THE PALAIS IDÉAL

| North façade, east corner.

Hauterives, Drôme department.

| THE FACTEUR CHEVAL
THE THREE GIANTS

| Caesar, Vercingétorix and Archimedes
sheltering two Egyptian mummies
between their legs.
East façade of the Palais idéal.

Hauterives, Drôme department.

like it. Thus began twenty-seven years of epic toil during which Facteur Cheval gathered the agglomerates, fossils and segments of tufa which he chanced upon during his daily round and brought them back home, either in his pockets or in a basket or, in the latter days, by wheelbarrow, prompting the locals to refer to him as "a poor crackpot who fills up his garden with stones".

He regarded the multiform stones as veritable sculptures and his *Palais* is essentially an assemblage of natural elements, even if his own role involved much more than the mere choice of materials. He created the bas-reliefs of flora and fauna with which he decorated his Palace, and where he did not carve the stone, he would supplement it with mortar, shaping components for the figures that he envisioned. Restoration work has revealed the composite nature of the rows of figures along the arches at the apex of the palace. Their legs are composed of long slanting stones joined at the crotch, their bodies are sculpted and the heads are made of a lump of sandstone.

Like most self-taught artists, the Facteur Cheval shows a variety of cultural influences in his work. It has been suggested that, given his keen interest in Islam, he might have worked as an army baker for the Imperial expeditionary force in Algeria, but there is no evidence to support this claim, any more than the similar suggestion that Douanier Rousseau visited Mexico. On the other hand, like everyone else, he was influenced by what his French contemporaries dubbed "the event of the century": the 1878 Paris Universal Exhibition held between the Trocadéro and the Champs-Élysées. The teeming throngs of Turks, Egyptians, Moroccans, Chinese and Cossacks to be seen there fired his cosmopolitan imagination. At the time, Cheval was employed loading the mail at Lyon-Perrache railway station and, although he did not actually visit Paris, the Exhibition constantly featured on the postcards and in the newpapers which he handled there. He also owned a complete collection of the *Magasin pittoresque*, a popular encyclopaedia sold in instalments, a forerunner of modern news magazines, and its articles and illustrations offered him a sedentary world tour. Equally significant as influences, and much closer to home, were the magnificent cream and sugar-candy cakes which confectioners displayed in their shop-windows and which so closely resemble his own creation. The *Palais* is of considerable size. The east and west façades are each 85 foot long, the north 45 feet, and the south 40 feet, and the height varies from 26 to 33 feet. "Between the east and west façades runs a 65-foot long, 7-foot wide gallery which leads at either end into a maze

THE FACTEUR CHEVAL
THE PALAIS IDÉAL
South façade.
Hauterives, Drôme department.

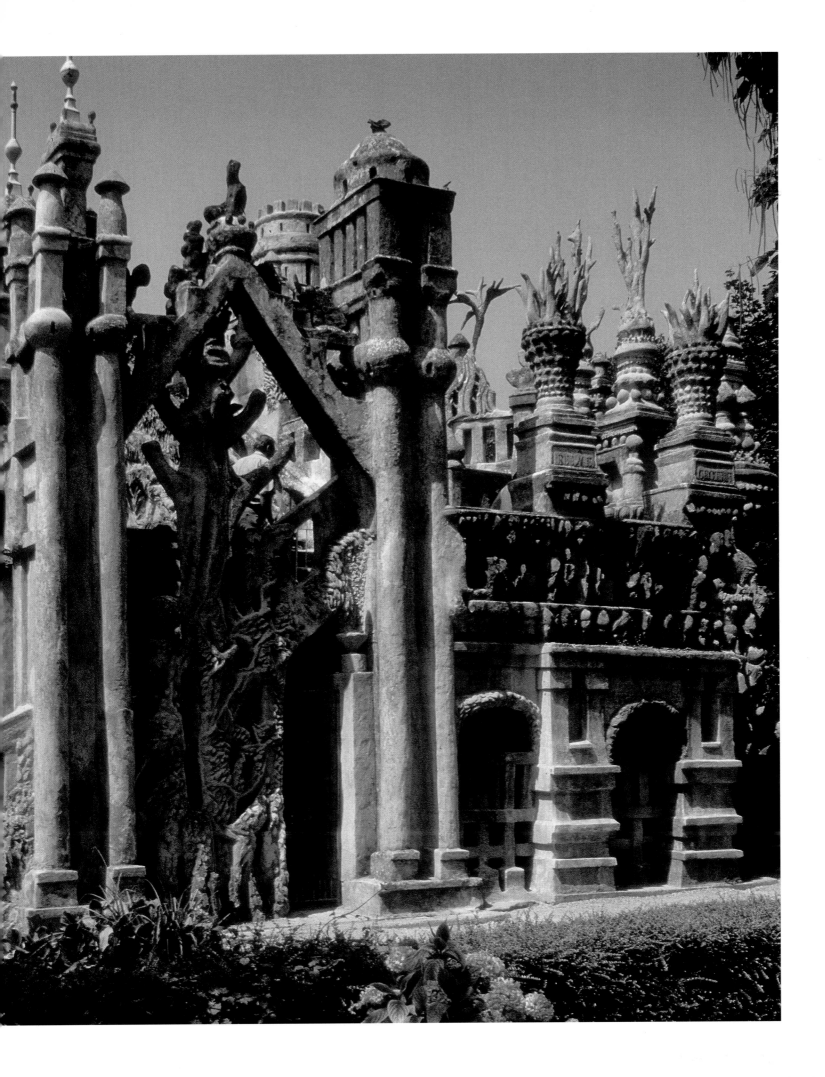

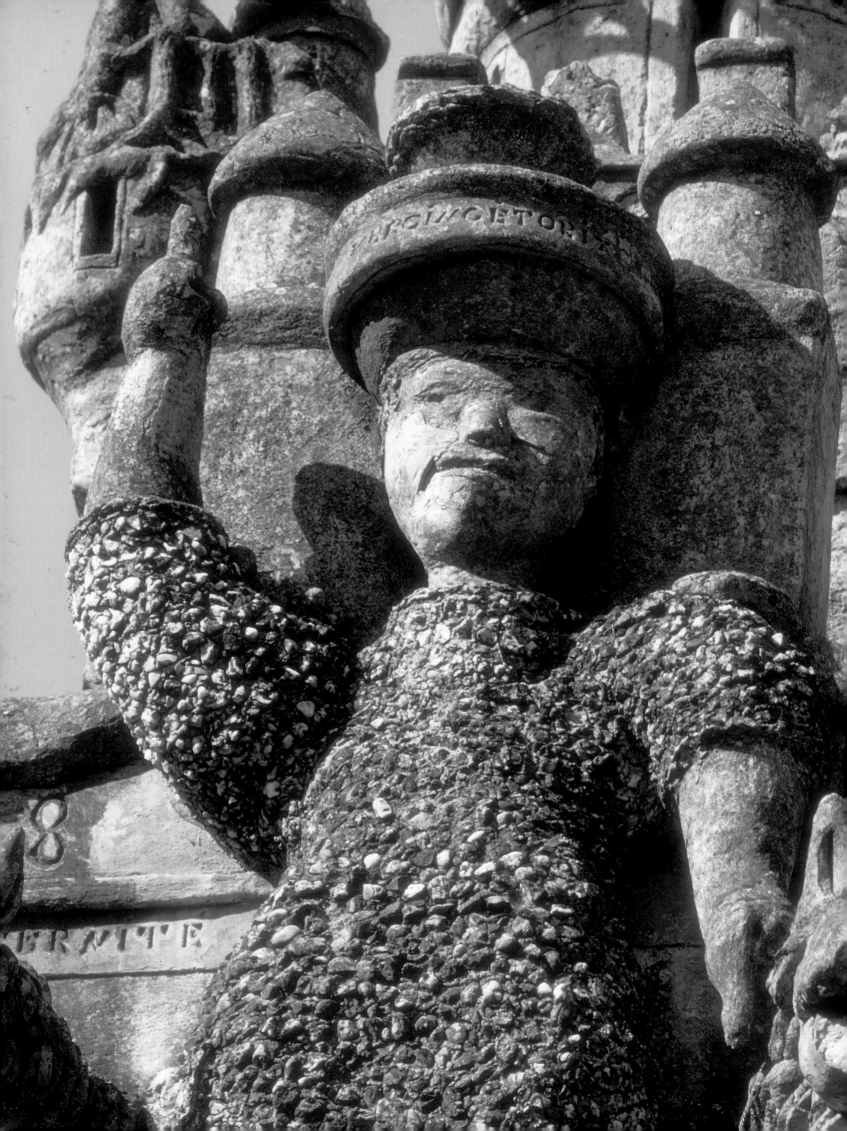

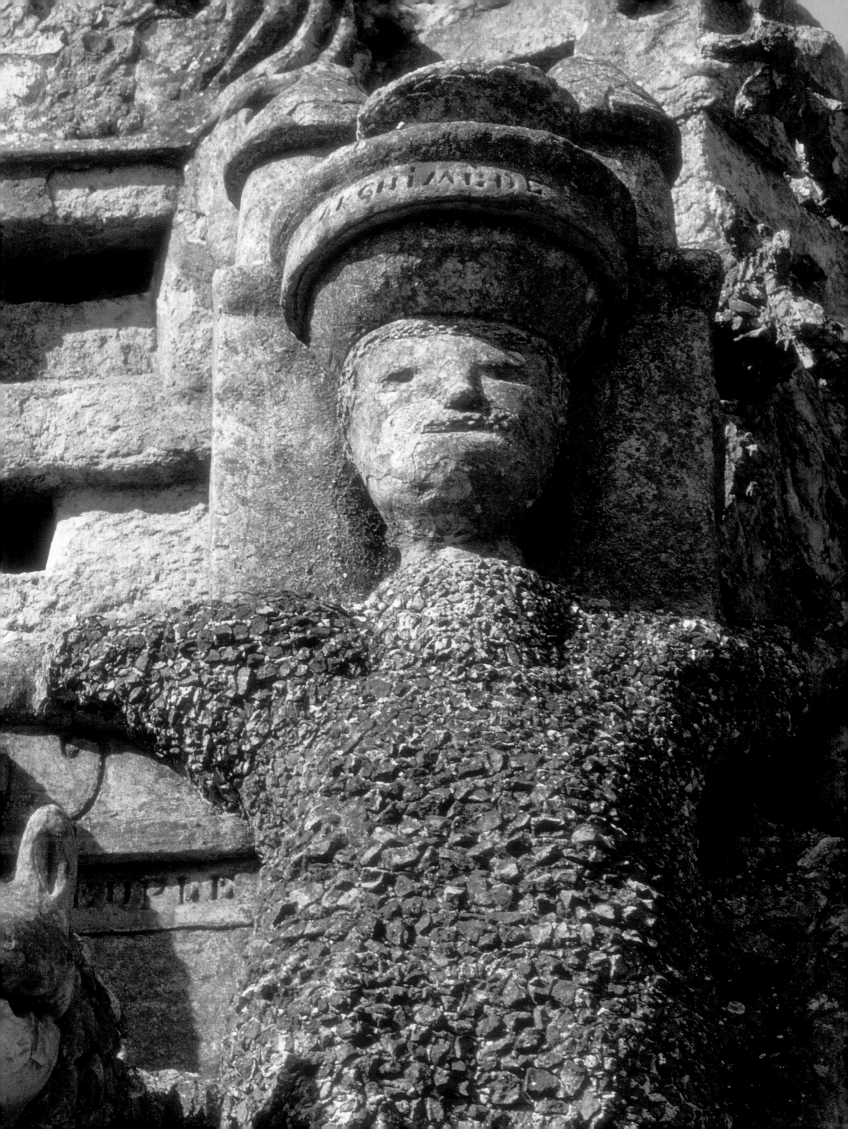

Pages 180 and 181

THE FACTEUR CHEVAL

THE GIANTS

Detail. East façade
of the Palais idéal.

Hauterives, Drôme department.

THE FACTEUR CHEVAL

CHIMERICAL ANIMAL

Detail. North façade,
east corner of the Palais idéal.

Hauterives, Drôme department.

Page 184

THE FACTEUR CHEVAL

WOMAN'S FACE

Palais idéal, Hauterives, Drôme department.

Page 185

THE FACTEUR CHEVAL

MOTHERHOOD

Detail. The woman,
wearing a crown, carried
an infant in her arms.

Palais idéal, Hauterives, Drôme department.

of curious sculptures. At one end, the sacrificial array includes a host of different features reminiscent of former times which I personally sculpted or modelled: cedars, bears, elephants, traditional Landes shepherds, and waterfalls. At the other end, seven figures from Antiquity stand above ostriches, flamingos, geese, and eagles. The visitor wonders whether he has been transported into a fantastic, chimerical dream that stretches beyond the confines of the imagination. Is he in India, the Orient, China or Switzerland? It is impossible to tell, as the styles of all lands and all ages are mingled and blended together."

As the above shows, Facteur Cheval was adept at publicizing his monument for the benefit of journalists who came to interview him towards the end of his life. His descriptions are precious testimony of his intentions. In another of these interviews, he explained, for instance: "There's an Egyptian touch to the grotto with the three giants; below, you can see three mummies which I modelled and sculpted, the three giants are supporting the Tower of Barbary where fig trees, cacti, palm trees, aloes and olive trees grow in an oasis watched over by the otter and the leopard. The three Giants are the guardians of my Monument". These figures, to which Cheval oddly enough gave the names of Caesar, Vercingétorix and Archimedes, are in fact three phallic columns or totems, with gravelly bodies that are part organic, part inorganic; they form an impressive trinity in marked contrast with the numerous small-scale motifs, such as the discreet washerwomen or the picturesque Swiss chalet. The gigantic and the miniature constitute the two basic principles underpinning the rhythmic structures of the façade.

Marc Fenoli, who has written one of the most perceptive analyses of the *Palais idéal*, mentions that Cheval's original ambition had been restricted to erecting a monumental fountain which was intended to become the fountain of life and abundance from which, metaphorically, the flow of mortar would gush forth to give form to the edifice.[1] From then on, its living waters continued to spout, irrigating Cheval's imagination. The ever-increasing flow of figures was spatially organized to create a myriad of organic, mythical and even alchemical modulations, nurturing and pervading the stone like welling sap. This well or stream explains the peculiar layout of the monument. Contrary to traditional architecture, in which the interior is contained within the enclosing walls, here interior and exterior open onto each other. The Grotto of the Hind and Fawn, the Antediluvian Museum, the Wheelbarrow Shrine and the Druid Tomb have no clearly defined limits, but give onto and combine with each other, while remaining open to the outside world through gaps in the building's fragmentary façade. To the visitor contemplating it and moving through it, this creates the impression of a ceaseless flow, a vital force injecting life into each part of the massive stone structure.

His *Palais* seems to have sprung from the earth like some unknown species of surreal plant; Cheval displayed a no less pronounced taste for

1. Marc Fenoli, *Le Palais du Facteur Cheval*, Grenoble, 1990.

182 BUILDERS OF DREAMS

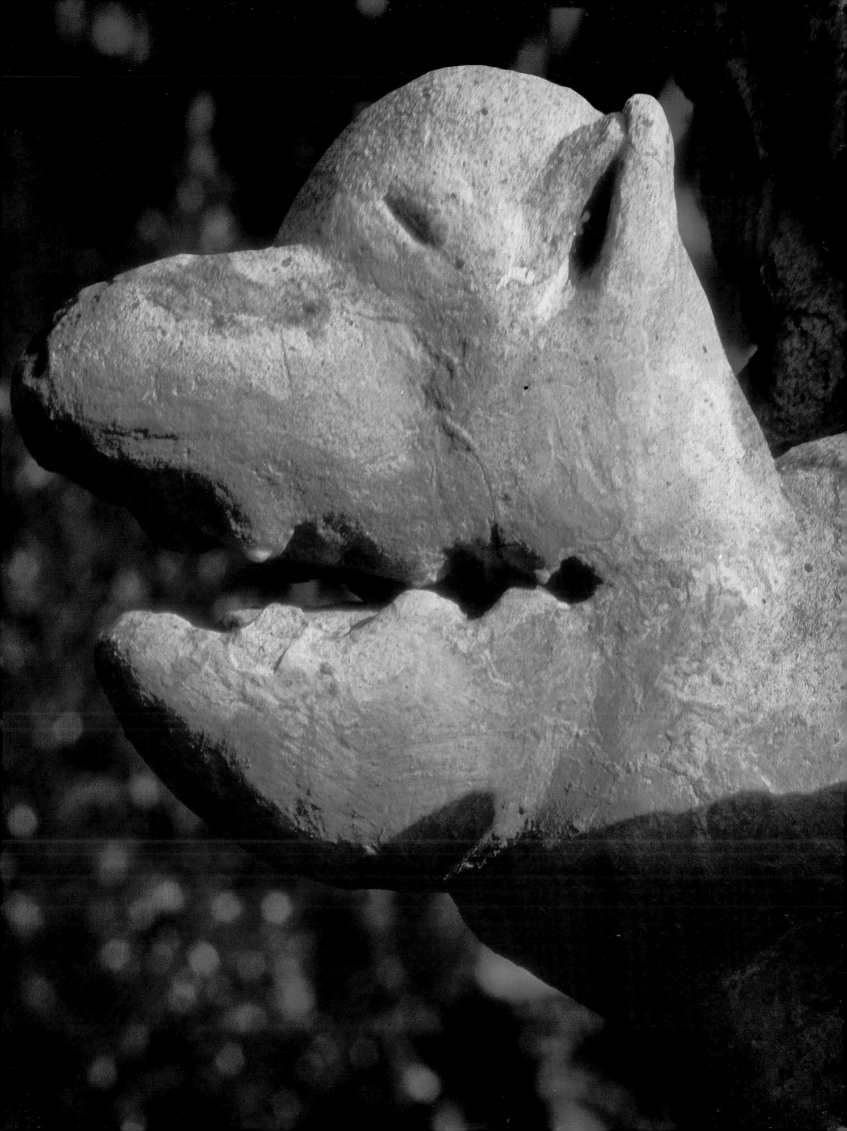

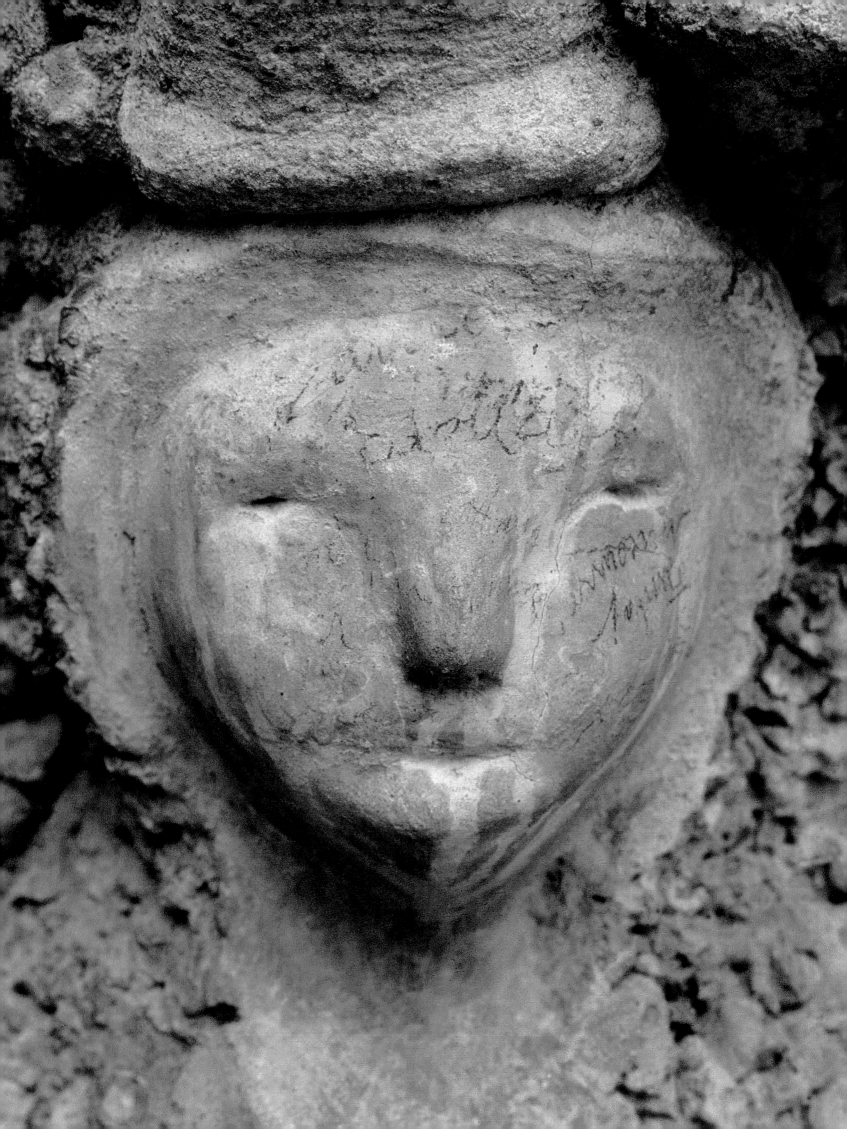

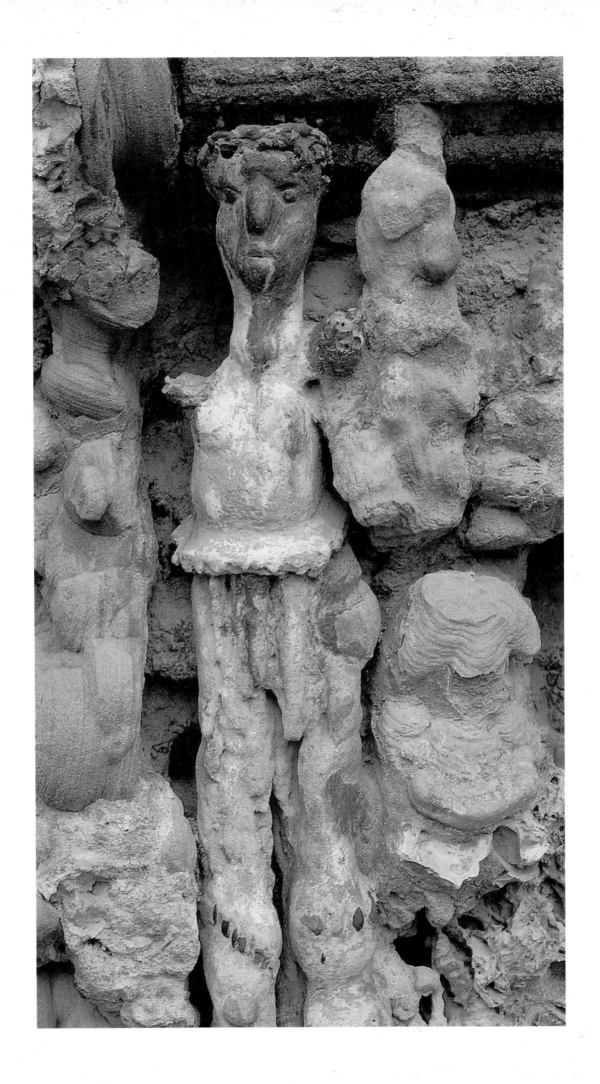

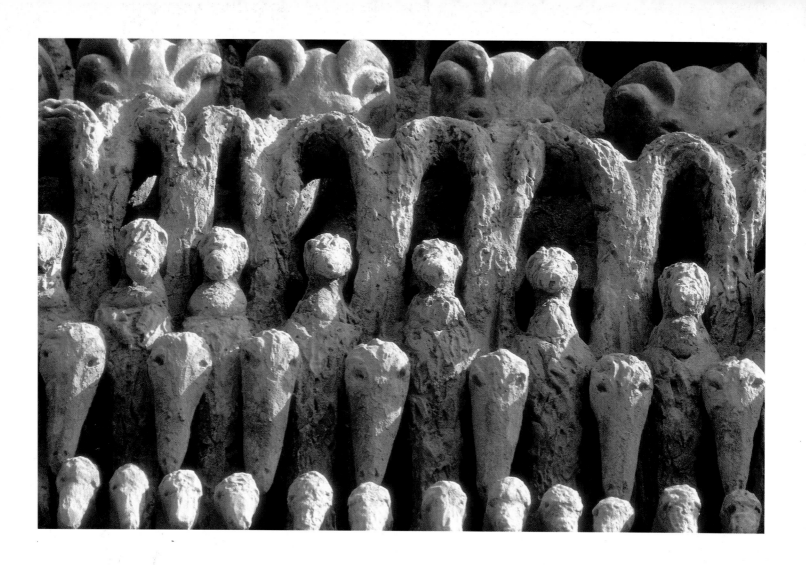

THE FACTEUR CHEVAL
CONCRETIONS
Detail.
North façade.
Palais idéal, Hauterives, Drôme department.

THE FACTEUR CHEVAL
BIRD
Detail. Summit
of the north façade.
Palais idéal, Hauterives, Drôme department.

the fantastic and the grotesque in the burgeoning features with which he embellished it. The wily snakes, tangled like rambling creepers on the north façade, and the twin-horned, goat-headed octopus with its flabby, pincered tentacles outspread are among the many figures straight from some mediaeval bestiary. "Above, perched on a tentacle as if it were a branch", writes Fenoli, "are a pair of billing and cooing birds. Tentacles swaying in the current, the octopus awaits its prey like some ambiguous species of marine anemone. Perhaps the monstrous composite body of this chimera is deliberately intended to surprise, feeding off the striking effect it produces."[2]

Cheval's brimming psyche – since this is what lies behind his metaphors – also led to more enchanting incarnations. Monsters like the leopard's head emerging from between the giants or the Picasso-like woman on the façade, formed out of concretions, are legion. But there is also a whole range of sculpted animals, baby elephants, birds, bears and hares, which conjure up an image of pristine innocence. In those days, few people had heard of the unconscious mind and Facteur Cheval, like that other postman, Raphaël Lonné, probably delved all the deeper into his inner self for the fact that he remained blissfully

1. *Ibid.*, p. 54.

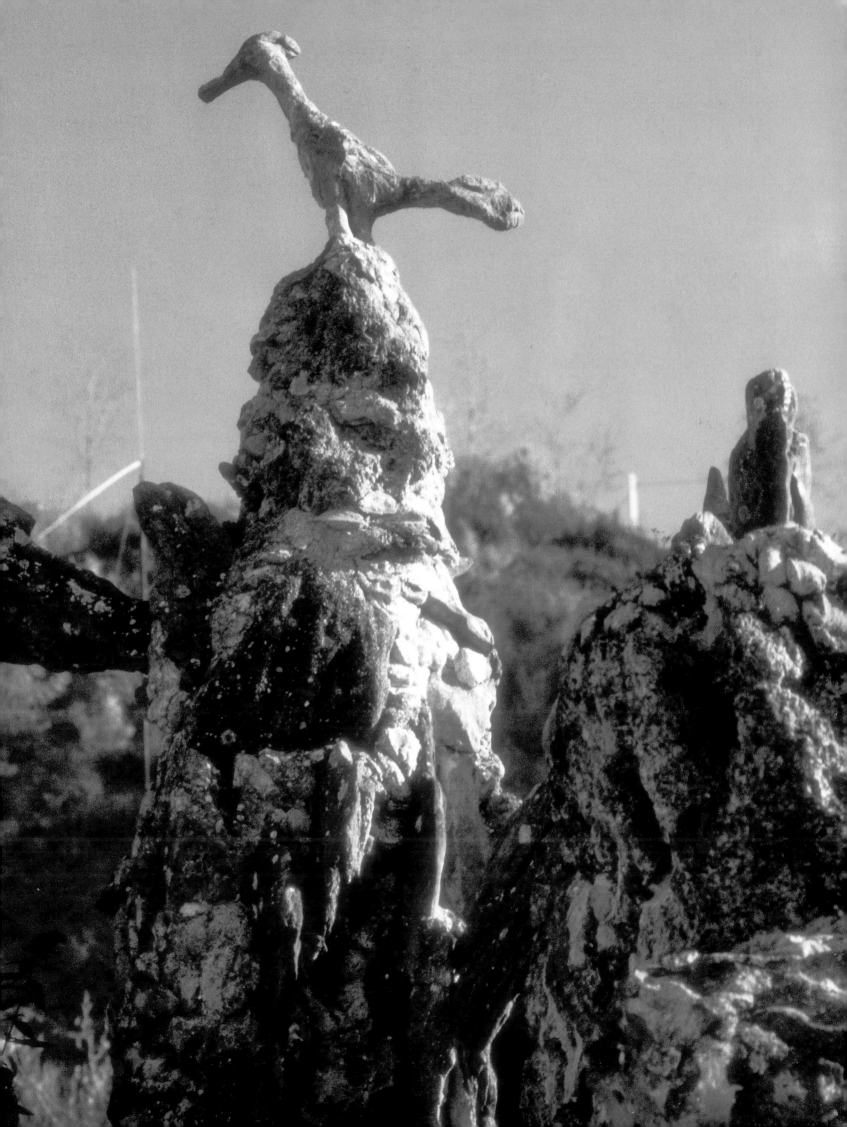

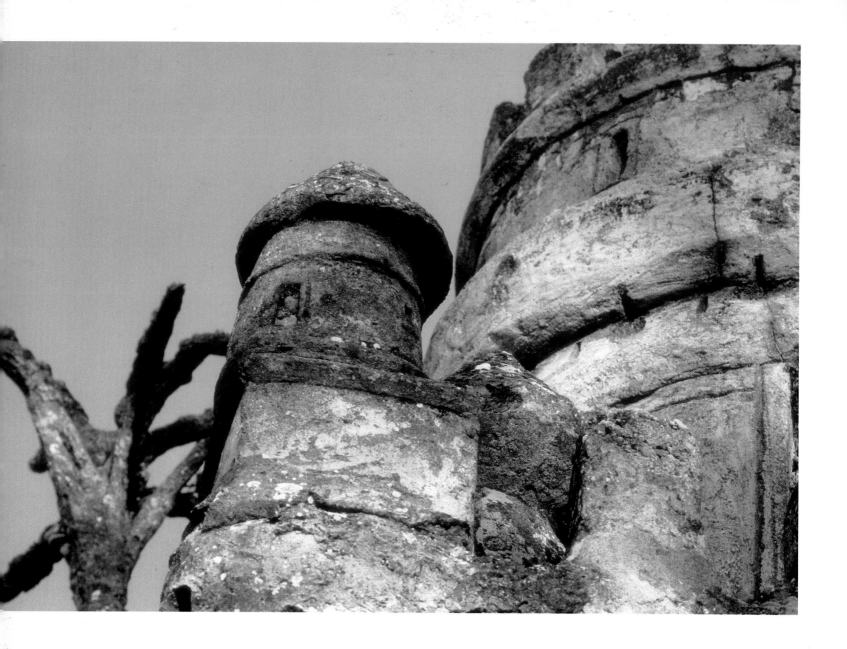

ignorant of its very existence. But Hauterives is not simply reducible to the expression of one individual's subconscious. Freud is known to have detected in his patients an autonomous faculty of resistance which he labelled "archaic residues". Jung developed from this the concept of the collective unconscious, which posited that deep down in each individual psyche lie primordial life forces of which we are barely aware. He extended the universally accepted doctrine of physical evolution to encompass the evolution of the mind.

Jung believed that the unconscious mind, far from being a mere cesspit, formed a thoroughly coherent substratum of archetypal images which manifested themselves in our dreams and provided permanent inspiration for artists. The theory is amply confirmed by the *Palais idéal*, which, with its features drawn from ancient civilizations, its interrelated meanings and its metamorphoses, ultimately creates a mysterious coherence more convincing even than the analogous case of the paintings of Lesage.

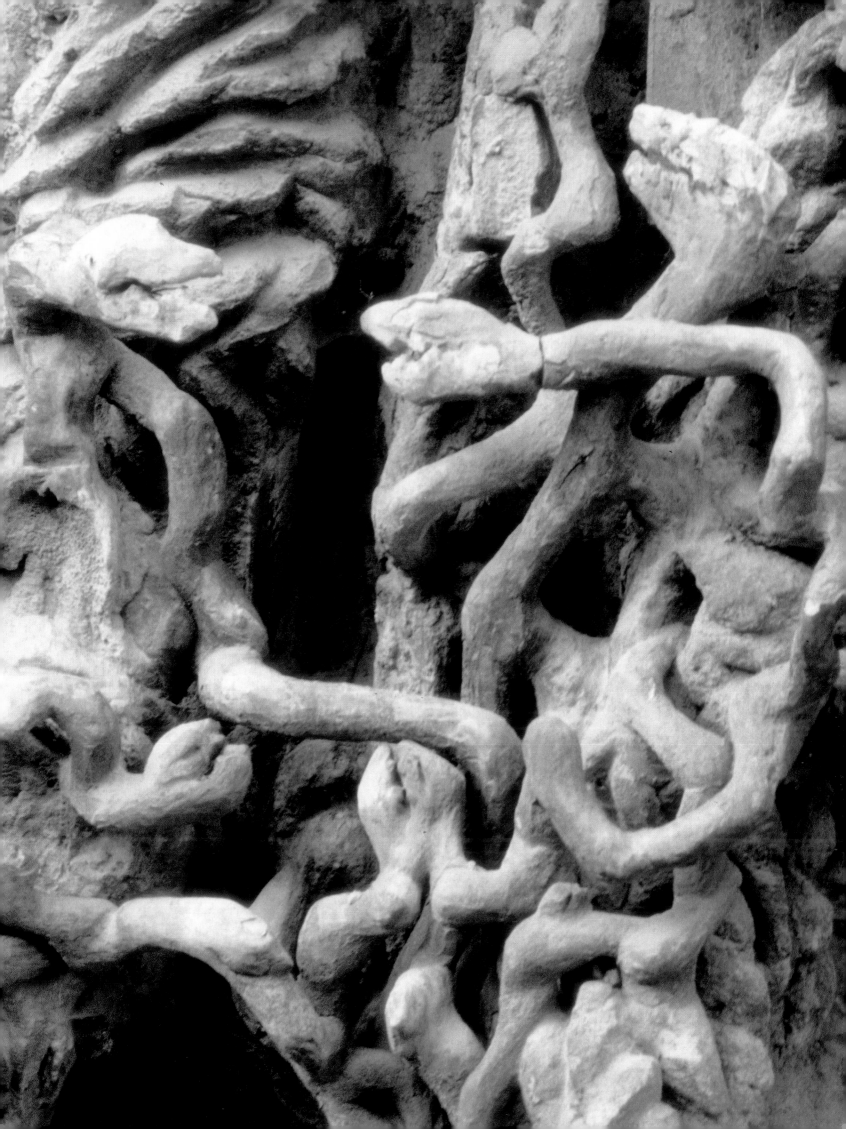

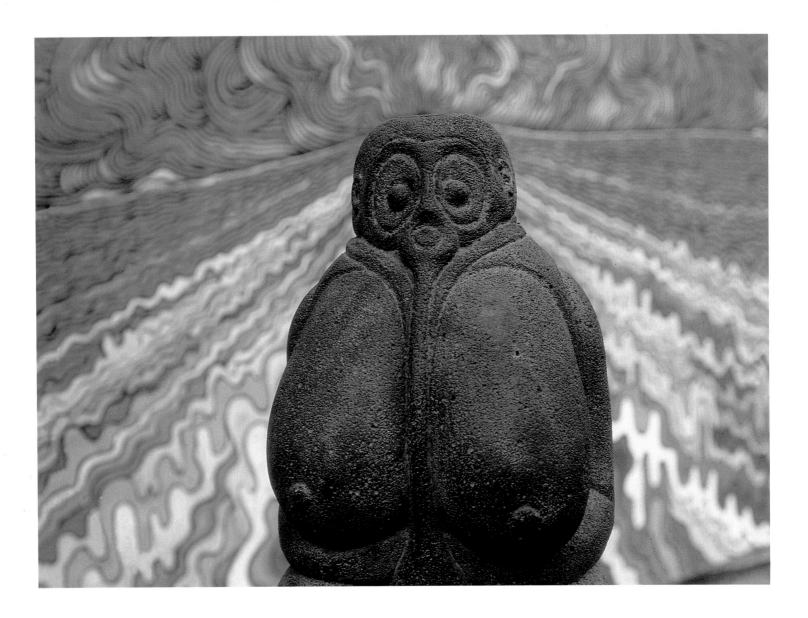

The man of twenty-three reincarnations

The painter Jean Revol, who, for a number of years, ran a painting workshop for mentally-handicapped youngsters, has written about a visit made with his young protégés in 1980 to Chomo's Village of Preludial Art, not far from Achères in the Fontainebleau Forest.[1] Having shown them around his enchanted domain, Chomo spoke to them in his refined, poetic manner about his twenty-three reincarnations. He then evoked the mystery of their own former lives, the sole explanation of their present condition, telling them they should only suffer if they could convert this suffering into joyful creation. It was a memorable day in their bleak lives, one upon which they often looked back. Chomo's words had brought them a ray of hope.

At the time, Chomo was seventy-three and had been living as a recluse in his Village for some twenty years. His earthly reincarnation took place on 28 January 1907 at Berlaimont in the Nord department. Born

1. Jean Revol, *Art des débiles, débiles de l'art*, Paris 1986.

CHOMO

PERSONNAGE

C. 1985, polished painted stone,
height 80 cm (32 in).

Achères-La-Forêt, Seine-et-Marne.

CHOMO

GODDESS

C. 1985, polished painted stone,
height 80 cm (32 in).

Achères-La-Forêt, Seine-et-Marne.

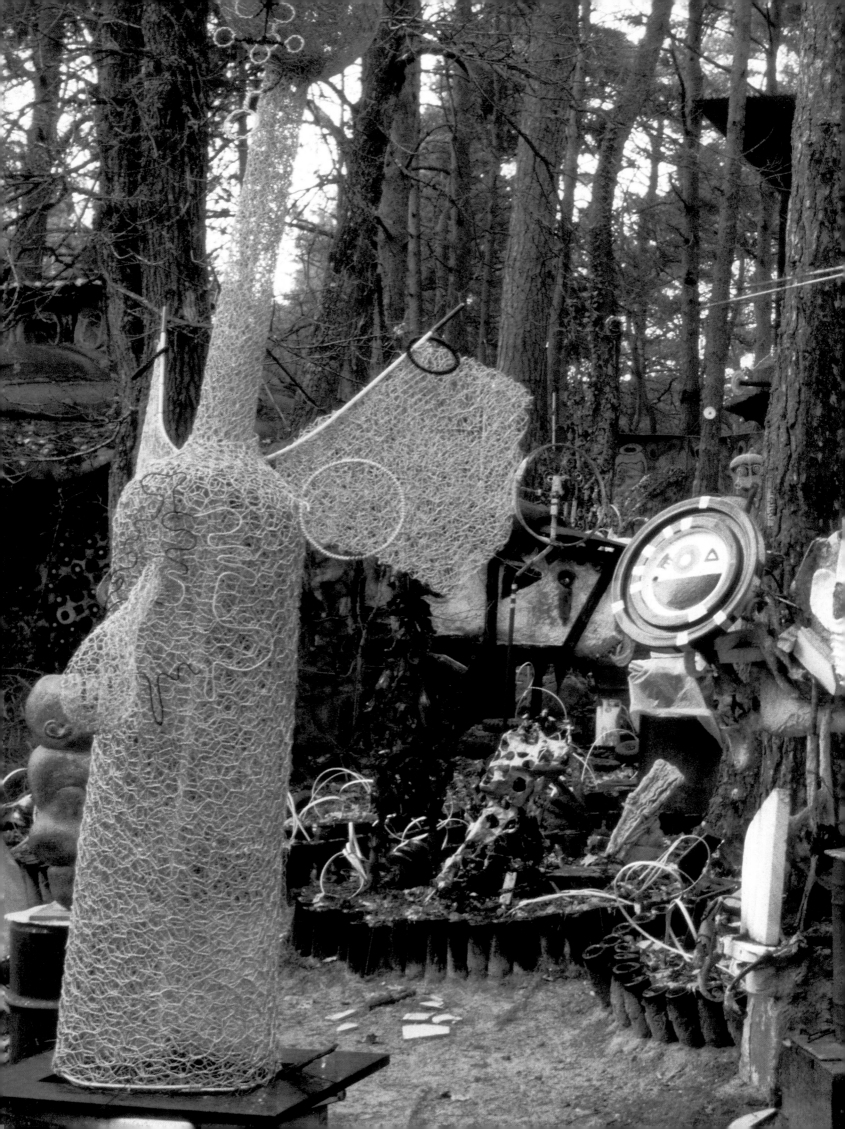

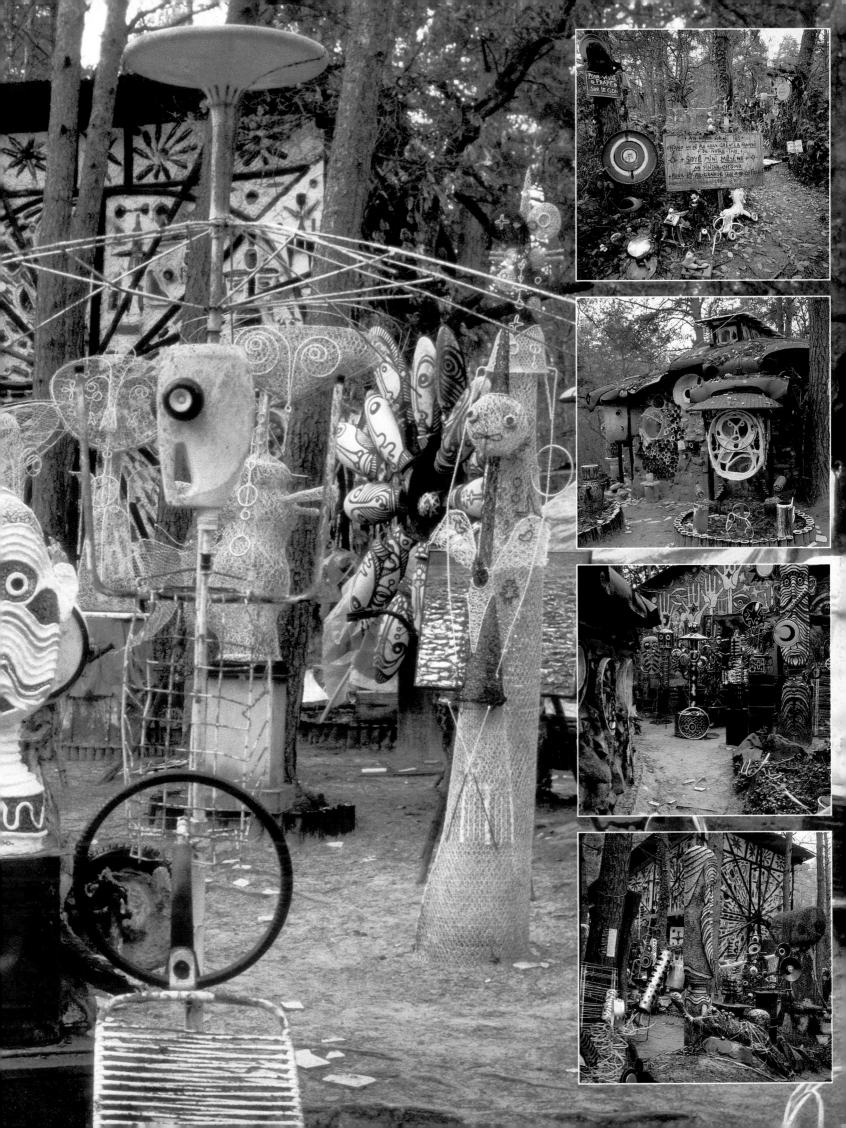

Pages 194 and 195

CHOMO

VILLAGE OF PRELUDIAL ART

built by Chomo
in the 1960s
out of scrap material
at Achères-la-Forêt,
Seine-et-Marne.

Roger Chomeaux, he simplified his name when he became an artist. Although he claimed to have been an indifferent scholar, he had nevertheless studied painting and sculpture at the Arts Schools of Valenciennes, then Paris. In other words, unlike typical Art Brut artists, he started out with an academic training which he subsequently made wholehearted efforts to reject. One anecdote gives a brief idea of the kind of art he practised in his early days. Taken prisoner in 1940, he was interned in a POW camp. The German officers at the camp admired his drawings and a sculpture of Christ so much that they asked him to replicate a bust of Hitler. Had he not been repatriated to France shortly after, he would probably have had to comply with the request. His work was thus the opposite of what the Nazis labelled "degenerate art", a term which, as I mentioned at the outset, applied to all artists, including Picasso, Nolde and Kokoschka, who participated in the modernist revolution in the opening decades of the twentieth century. His Village of Preludial Art was laid out on a forest plot acquired by his wife during the Second World War; there she had had built a little timber-frame house intended to serve as a weekend family retreat. In 1960, Chomo, whose work had by then considerably evolved, exhibited his "scorched wood compositions" – completely black canvases – at the Camion Gallery in Rue des Beaux-Arts in Paris. In his own words, "it caused a great kerfuffle", but did not attract any buyers. It was at that point that he withdrew from society and began building his Village, using scrap material garnered from municipal garbage dumps. He lived off forest plants, crusts of bread gleaned from dust-bins, and rabbits which he poached.

Today, the Village of Preludial Art is said to contain some thirty thousand works – a figure perhaps exaggerated by Chomo – along with several buildings, including the Sanctuary of Scorched Wood, the Church of the Poor, and a construction christened the Refuge, which has a roof made from the bonnets of wrecked cars and windows made out of stacked bottles, necks pointing outwards, glued together by hessian steeped in plaster. The Village is open to the public on Saturdays and Sundays for a modest entrance fee and Chomo ritually baptizes visitors in the Refuge with his "Vin Sauvage", a home-brewed concoction of crushed berries, brambles, elderberry and white dead-nettles fermented in a mixture of water and honey. At the entrance to the Village stands a signpost, written in the phonetic language dear to Chomo's heart, inviting visitors to "FÈTE UN RÊVE AVÈQ CHOMO" ("JOYN IN A DREAM WITH CHOMO"). Among the bushes and dangling from trees are more of his characteristic, oracular messages such as, "Man needs mystery more than bread", "Broadcast love cells", and "God smashes and destroys when the Spirit's gone out of it".

For Chomo sees himself as a mystic and a prophet as much as a builder. He not only believes in the cosmic reincarnation of man, he thinks we are ruled over and commanded by the Invisible and that free will is mere illusion. In his opinion, the unconscious mind acts as a crucial

link to this Invisible power. It is striking to note that his conception closely matches that of the German Romantics. Indeed, Carus, Goethe's friend and a distant forerunner of Freud, wrote: "The unconscious is merely the subjective term for what we objectively call Nature". Similarly, Chomo shares the Romantics' fascination with darkness, the creative fount of all things. When he speaks of the moonlit night sky one is reminded of Schelling, who saw in the night a vast energy begging to be set free: "If the night itself could only rise, if only we could be bathed in nocturnal day and diurnal night, this would be the ultimate goal of all desire". Moreover, for Chomo, reason and reasoning lead to the destruction of vital forces and man's material strength. He gives the example of how he managed to carry a twenty-five-foot long tree trunk single-handedly without further ado, having initially considered the task impossible. Death is another central preoccupation. He believes there is no such thing, that the body is merely a vessel for the soul and when it is worn out and returns to the soil the soul will be reincarnated on other planets. To his neighbours, Chomo is the "mad man of the woods", constantly in trouble with the gendarmes or the land registration authorities who have attempted to have his strange Village demolished. But he shrugs all this off, convinced as he is that madness is the creative source from which works of art and even the planets spring. Effectively, his own works – his ocular rings,

CHOMO
in front of a bas-relief
representing
a "super-consciousness".

Page 198
CHOMO
TOTEM HEADS
C. 1984, miscellaneous materials,
heights 70 to 160 cm (28 to 64 in).
Achères-La-Forêt, Seine-et-Marne.

Page 199
CHOMO
HEAD
Detail. C. 1985,
polished painted stone,
height 80 cm (32 in).
Achères-La-Forêt, Seine-et-Marne.

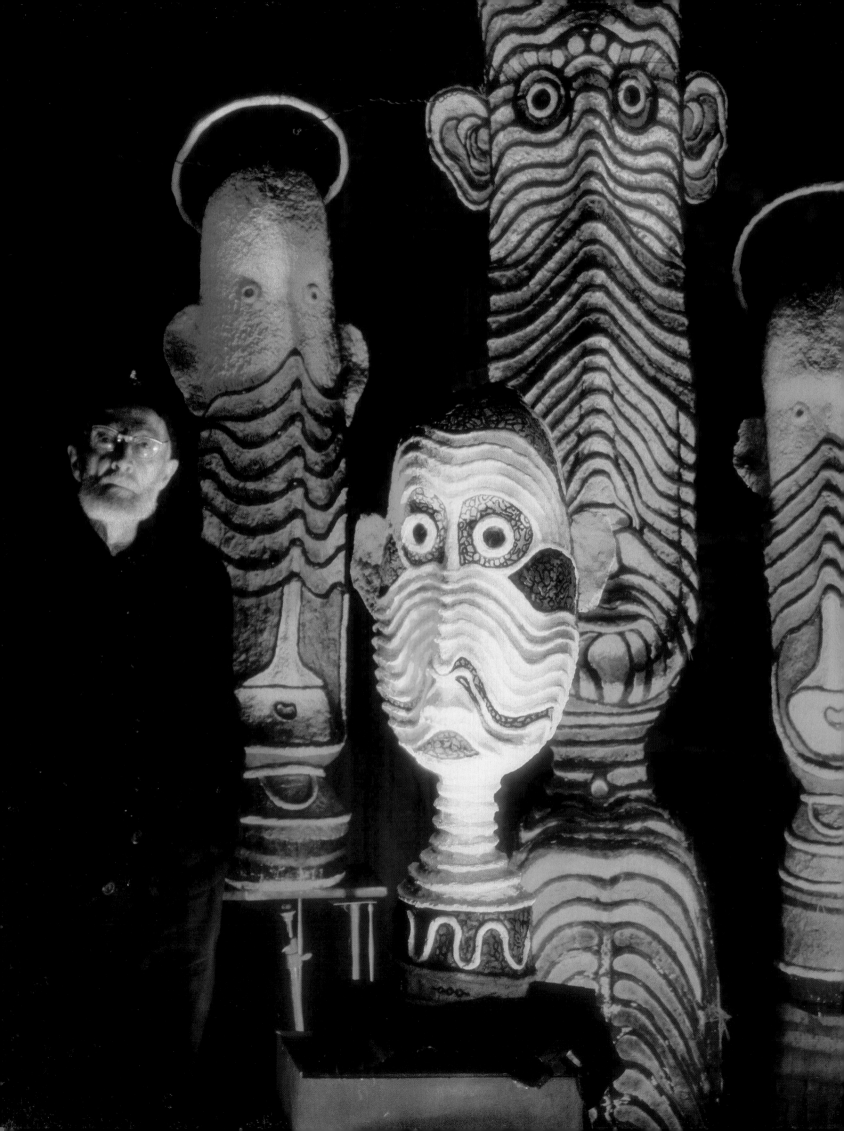

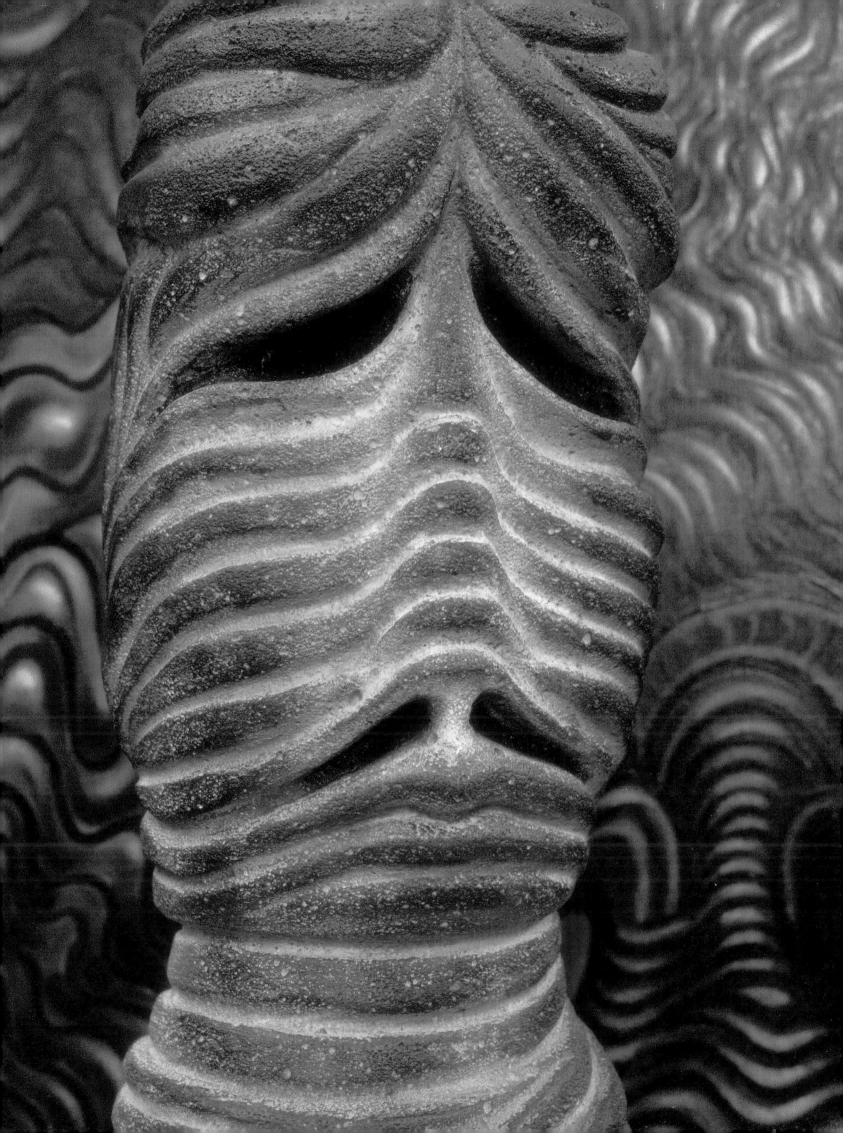

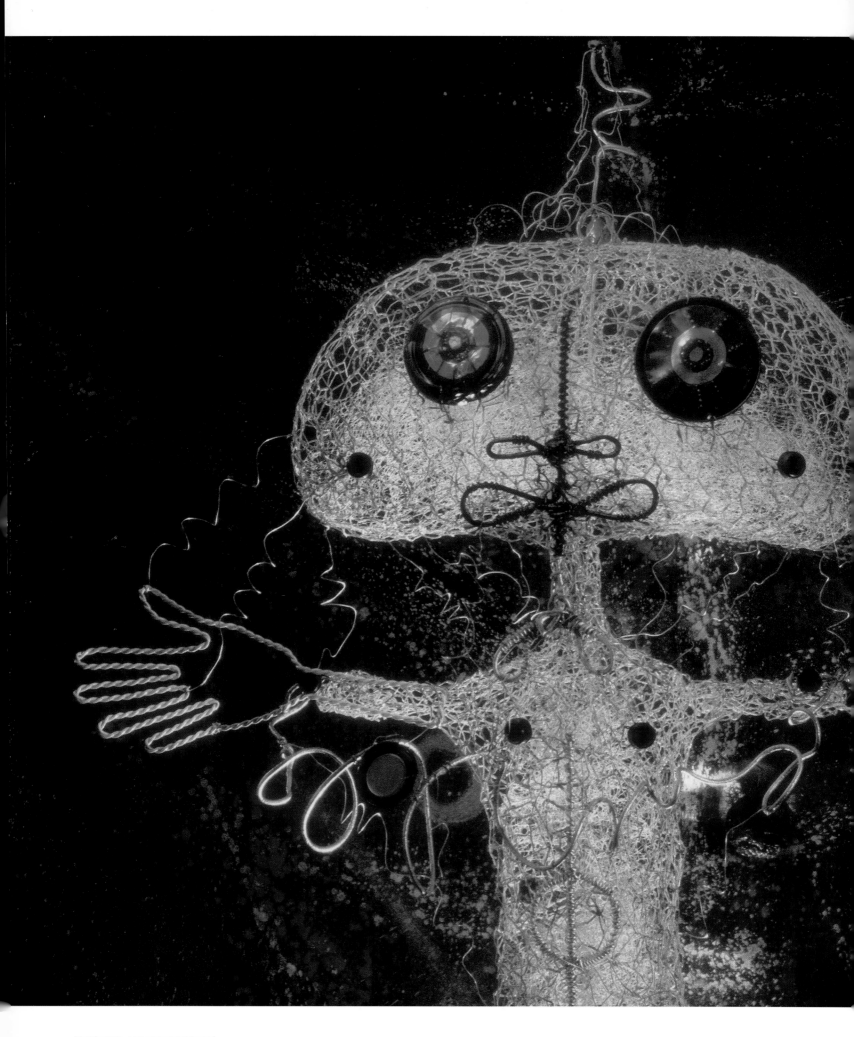

Chomo
PERSONNAGE
Detail. C. 1975, assemblage,
height c. 100 cm (40 in).
Achères-La-Forêt, Seine-et-Marne.

crosses, faces, vibrating lines, hands seen as if in a convex mirror, sarcophagi and "machâmes" ("clinkersouls") – are "crazy". They express a future world which will supersede our own industrial, scientific civilization when the latter meets its inevitable destruction, after having squandered the riches of the planet and wiped out all traces of human spirituality. The sarcophagi and "machâmes" are richly symbolic. The former are sorts of large, teated chrysalids, cocoons of men and women who have taken off to other planets or who are about to arrive on earth, while the latter, a composite mixture of anthracite, pebble agglomerates and clinker, are the "thought-prints" of vanished people.

His most spectacular creation is undoubtedly the monumental Lace Chapel, a compound surrounded by walls built out of old bikes and wheels, kiddies' toy cars and other bits of discarded mechanical junk, all piled up and tied together with wire. Chomo has fossilized the construction with a bizarre lace made out of strips of hessian steeped in plaster; this he regards as representing the quest for sublimation. His home-woven lace is meant to be endless and the arrows he has built out of superimposed bicycles are targetted on God. Because of the plaster, the construction is white. But Chomo's attitude to white has varied. As white is linked to death, his passion for creative darkness originally led him to opt for black. Then he changed his mind: "White is eternity, an everlasting wedding". Among the colours, blue represents giving oneself to others. "I've worked a lot with blue, I like it. This lofty blue, lacking all memory, which flees its own perspectives that scream of eternity, and unconsciously seeks the dark that the gaze cannot know."

Chomo cultivates a filthy appearance, much as Ligabue did. He confesses that he never takes a bath, rarely washes and doesn't like changing clothes. When he is spruced up and wearing fresh clothes, he complains that his bees and the farmyard poultry to be seen pecking about everywhere in the Village no longer recognize him. In 1989, when the Pompidou Centre in Paris invited him to take part in the *Magicians of the Earth* exhibition, featuring artists whose work is rarely shown in museums, he refused point-blank because the Centre was not prepared to include his cockerels and hens as exhibits. To have accepted the invitation would have been tantamount to a betrayal of his poultry, who share his yearning for a lost cosmic harmony.

Questions which concern us all

This book will have achieved its purpose if it has convinced the reader that the artists who feature in its pages cannot be dismissed as peripheral figures. Aloïse already ranks as one of the great twentieth-century colourists and, as we have seen, Prinzhorn unhesitatingly compared Pohl to Grünewald and Dürer. But we can go much farther: Sell is in no way inferior to Masson, nor Neter to Ernst, nor Schudel to Klee, nor Ligabue to Van Gogh; fewer and fewer people consider Chomo's prophetic message "insane". Their work forms an integral part of twentieth-century art, indeed one of its most vibrant chapters. So much so that, today, Nedjar's masks hang alongside their African counterparts on the walls of our museums.

Yet it would be mistaken to assume that this is merely a question of changing tastes. As a new millenium dawns, what is at stake is our vision both of ourselves and of society. The positivist conception of unlimited human progress has well and truly had its day. Deprived of spiritual values, at the mercy of unpredictable economic forces, we are all victims just like the artists who appear in the present volume, whether or not they were, or are, locked up in asylums. Shifts in aesthetic standards always occur as a result of transformations of the civilization in question. The chaos at the heart of psychotic art is a foreboding of our own chaos. By their very nature, Art Brut and the art of the mentally disordered raise questions which relate directly to our own lives.

CHOMO

Standing behind
one of his polished stones
in 1989.

BIBLIOGRAPHY

CHOMEAUX Robert, *Chomo*, edited by Laurent Danchin, Paris, 1978

DUBUFFET Jean, *Prospectus et tous écrits suivants*, 4 vol., Paris, 1967

FENOLI Marc, *Le Palais du Facteur Cheval*, Grenoble, 1990

PRÉVOST Claude, PRÉVOST Clovis, *Les bâtisseurs de l'imaginaire*,
 Jarville-la-Malgrange, 1990

MORGENTHALER Walter, *Adolf Wölfli* (English translation: *Madness
 and Art: The Life and Works of Adolf Wölfli*, Lincoln, Nebraska,
 1992)

PORRET-FOREL Jacqueline, *Aloïse et le théâtre de l'univers*, Geneva, 1993

PRINZHORN Hans, *Bildernei der Geistekranken*, Heidelberg, 1922
 (English translation: *Artistry of the Insane: A Contribution
 to the Psychology of Configuration*, New York, 1972)

RAGON Michel, *Du côté de l'art brut*, Paris, 1966

THÉVOZ Michel, *L'art brut*, Geneva, 1981 (English translation:
 Art Brut, London and New York, 1995)

THÉVOZ Michel, *Louis Soutter*, Lausanne, 1988

Collective Volume, *La beauté insensée, La collection Prinzhorn*,
 Palais des Beaux-Arts, Charleroi, 1995

Collective Volume, *La folie*, Paris, 1996

Collective Volume, *Art brut, collection de L'Aracine*, Musée d'art
 moderne de la communauté urbaine de Lille,
 Villeneuve-d'Ascq, 1997

Collective Volume, *Gaston Chaissac*, musée de l'abbaye
 Sainte-Croix, Les Sables-d'Olonne, 1993

In the same series: